SAN FRANCISCO'S
magnificent
STREETCARS

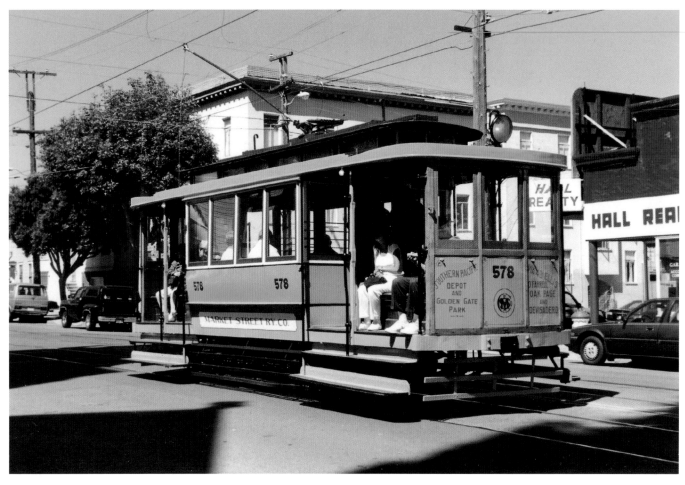

Basking in the sunshine of August 13, 2000 at Church Street near 17th Street, car No. 578 is the oldest surviving streetcar in the United States in operating condition. Weighing 20,300 pounds and seating 26, the single-truck car was built in San Francisco in 1896 by the Hammond Car Company for the original Market Street Railway Company. It was used from 1906 to 1955, during which it was converted into a work car. The San Francisco Municipal Railway acquired this car in 1944 as part of the purchase of the Market Street Railway.

SAN FRANCISCO'S
magnificent
STREETCARS

KENNETH C. SPRINGIRTH

FONTHILL

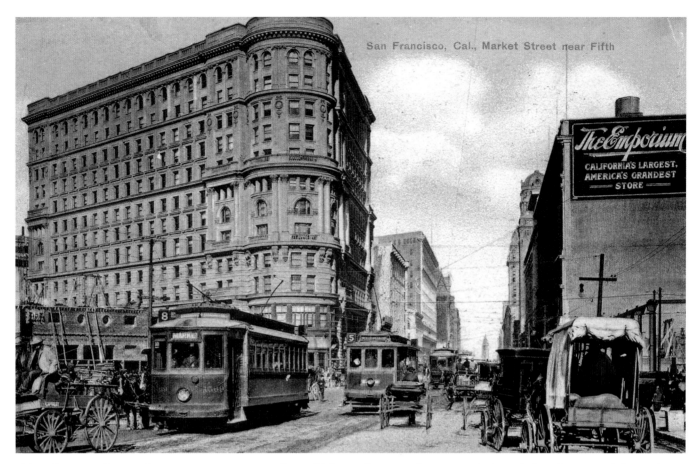

This early postcard scene shows numerous streetcars along with horse-drawn carriages on Main Street before the automobile era. Over the years, Market Street has been a major transportation artery for San Francisco, and has been served by horse-drawn streetcars, cable cars, electric streetcars, electric trolley coaches, and diesel buses. Today it has the F line heritage streetcars, trolley coaches, and buses at street level; below, the two-level Market Street subway has the San Francisco Municipal Railway Metro and the Bay Area Rapid Transit.

On the cover: San Francisco Municipal Railway car No. 1, built by the W. L. Holman Company in 1912, is at Mission Street and the Embarcadero on June 29, 2001. This was the first streetcar placed in service by the first municipally owned large city streetcar system in the United States. On December 28, 1912, San Francisco Mayor James Rolph, Jr operated this streetcar on Geary Street to formally inaugurate the municipal transit system. Rolph was mayor from January 8, 1912 to January 6, 1931 when he became the governor of California.

Back cover: On April 4, 2011, Presidents' Conference Committee car No. 1015, one of ten streetcars numbered 1006 to 1015 purchased from St. Louis Car Company during 1948, passes streetcar No. 162 built by Jewett Car Company in 1914 for the San Francisco Municipal Railway on the Embarcadero near the Ferry Plaza in San Francisco on the F line heavily used by commuters, residents, and tourists.

Fonthill Media Limited
Fonthill Media LLC
www.fonthillmedia.com
office@fonthillmedia.com

First published in 2015

Copyright © Kenneth C. Springirth 2015

ISBN 978-1-63499-001-1

Typeset in Utopia Std

Contents

Acknowledgments

Thanks go to the Market Street Railway, which has acquired streetcars for San Francisco, supported the F streetcar line of the San Francisco Municipal Railway, and established its own museum in the city. The Erie County Public Library system of Erie, Pennsylvania, with its excellent staff and the interlibrary loan program, was a source for a number of historical reference books. With the exception of postcard scenes, all of the photographs used in this book were taken by the author.

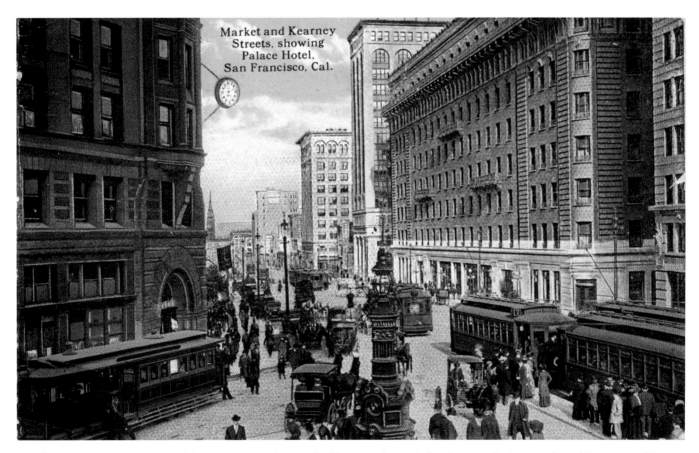

Lotta's Fountain is in the center of this 1905 postcard scene, looking east along Market Street at the intersection of Kearney and Geary Streets with plenty of streetcars in service. Dedicated on September 9, 1875, the fountain was given to the city of San Francisco by vaudeville performer Lotta Crabtree out of gratitude to the city where her career was launched. The fountain survived the April 18, 1906 earthquake, and in 1974 was relocated a short distance for the renovation of Market Street.

Introduction

On April 26, 1892, the San Francisco and San Mateo Railway opened the first electric streetcar line in San Francisco. It operated from Steuart and Market Streets to Harrison, 14th, Guerrero, 30th, Chenery, San Jose Avenue, Daly's Hill (later known as Daly City), and on to Holy Cross Cemetery. The second electric streetcar line in the city was opened on October 20, 1892 by the Metropolitan Railroad from Market and Eddy via Eddy, Hyde, O'Farrell, Scott, Fell, Baker, Page, Clayton, and Waller to 9th Avenue and Lincoln Way, and on August 22, 1893, the Metropolitan Railroad was taken over by the Market Street Railway. Another new streetcar company, the Sutter Street Railway, opened a line on February 1, 1896 from Central (later Presidio Avenue) and Sutter to Sutro Baths, a popular San Francisco recreational spot. Six years later, on March 8, 1902, United Railroads took over the Market Street Railway, Sutter Street Railway, and the San Francisco and San Mateo Railway.

The devastating San Francisco earthquake of April, 1906 resulted in a massive cleanup and reconstruction. Market Street cable car lines were quickly rebuilt for electric streetcar operation, which began on May 6, 1906; electric streetcar operation began on Sutter Street on June 4, 1906, and two new tracks were constructed on Market Street from Sutter Street to the Ferry Loop resulting in four tracks in that section of Market Street. On December 28, 1912, the San Francisco Municipal Railway, the first municipal large city street railway system in the United States, began operation of its new streetcar line on Geary Street, which had replaced the Geary Street cable railroad. Horse car service in San Francisco made its last run on June 3, 1913. The following year, construction began on the Twin Peaks tunnel on November 12. Completed at a cost of $4.25 million, its grand opening was on February 3, 1918, providing a through route from the western part of the city to downtown. The construction of the two outer tracks on Market Street to Van Ness was completed on June 1, 1918 and gave Market Street four streetcar tracks from Van Ness to the Ferry Loop.

On April 1, 1921, United Railroads was taken over by a newly formed Market Street Railway. Construction began on June 10, 1926 for the 4,232 foot long Sunset tunnel from Duboce and Scott on the east side to Cole and Carl on the west side, with the digging completed on August 27, 1927 and concrete lining finished two months later. New route N Judah made its inaugural run through that tunnel on October 21, 1928. The streetcar terminus at the East Bay Terminal, built for the electric rail service from the East Bay area, opened on January 15, 1939, and later that year, on October 31, five new streetcars similar to the Presidents' Conference Committee (PCC) car design were received, numbered 1001 to 1005, from the St. Louis Car Company.

World War II was a difficult time for the Market Street Railway and for transit systems throughout the United States as many employees were drafted into the armed forces. With voter approval, the Market Street Railway was purchased by the San Francisco Municipal Railway, which took over operation on September 29, 1944. Between January 20, 1945 and July 2, 1949, 25 of the former Market Street Railway streetcar lines were converted either to trolley coach or bus operation. Ten double-end PCC cars, numbered 1006 to 1015, were purchased from the St. Louis Car Company during 1948, and an order for single-end, center-entrance PCC cars, numbered 1016 to 1040, was delivered during the winter of 1951-52. Car No. 1040 was the last PCC car built in the United States. From March 27, 1949, streetcars no longer used the Ferry Loop, instead using the Bay Bridge East Bay Terminal.

In 1954, San Francisco voters approved one man operation for streetcars, and by January, 1955, streetcars numbered 1001 to 1040 were converted for this purpose. After streetcar lines B and C made their last run on December 29, 1956, the remaining lines were J, K, L, M, and N. The following year, 66 PCC cars were obtained from the St. Louis Public Service Company under a lease-purchase agreement. Built by the St. Louis Car Company, they were renumbered 1101 to 1166 and were eventually purchased during 1964. Four additional PCC cars, renumbered 1167 to 1170, were leased from the St. Louis Public Service Company in 1962 and were purchased two years later.

The Market Street subway construction resulted in a detour from Market to Duboce, Church, and 17th to the Twin Peaks

tunnel, which necessitated the purchase of 11 additional PCC cars from the Toronto Transit Commission in 1974. These cars, renumbered 1180 to 1190, had been built by the St. Louis Car Company for the Kansas City Public Service Company in 1946-47 and were sold to the Toronto Transit Commission in 1957. They were all out of service in San Francisco by 1979.

The Urban Mass Transportation Administration (UMTA) began a program during 1972 to develop a light rail vehicle that would replace the PCC car. On February 15, 1973, Boeing Vertol was awarded the contract to build 230 articulated light rail vehicles at about $230,000 per car. The San Francisco Municipal Railway ordered 80 (later changed to 100), and the Massachusetts Bay Transportation Authority ordered 150 (later changed to 175). On April 23, 1979, the new cars went into service on a portion of route K from West Portal to Balboa Park station. Under a $27.6 million federal grant, the M line was extended from Plymouth and Broad via Broad and San Jose Avenue to Balboa Park station, which was completed on August 30, 1980. From February 19, 1980, the N line operated with the new cars in the Market Street subway on weekdays and with PCC cars on weekends via the Market Street surface tracks. Weekday service with the new cars using the Market Street subway to reach St. Francis Circle began on June 11, 1980. A PCC car shuttle was established from the Phelan loop on the K line to 47th and Wawona on the L line via the West Portal where connections were made to the new cars for downtown San Francisco. The K-L PCC car shuttle ended on December 16, 1980, and from the following day the weekday service used the new cars operated on the K line via Ocean Avenue to Balboa Park station. PCC cars were used on that route for the weekends. Beginning June 17, 1981, the J line received the new cars for weekday operation, with PCC cars used on the weekends. September 19, 1982 was the last day of regular PCC car operation, with the new cars operating daily from September 20. During the reconstruction of Forest Hill station in the Twin Peaks tunnel, on weekends a shuttle operated on the K line from Balboa Park station to West Portal

and then on route L to 47th and Wawona, and buses were used between West Portal and downtown San Francisco. During that time route M operated as a bus line.

A devastating earthquake struck the San Francisco Bay Area on October 17, 1989 killing 63 people and injuring 3,757. It forced the closure of the Embarcadero Freeway, which was later demolished, and power outages shut down the J, K, L, M, and N lines; however, in two days normal operation was restored.

Problems with the Boeing Vertol articulated light rail vehicles, including derailments on tight curves and failure of the vehicles' motors and propulsion systems, resulted in the need for their replacement. On December 10, 1996, four new light rail vehicles, built by AnsaldoBreda, Inc. and each costing $2 million, were placed in service on the J line. The order for 151 new light rail vehicles from AnsaldoBreda was completed during 2003, all of the Boeing Vertol articulated light rail vehicles having been retired by the end of 2001.

The San Francisco Municipal Transportation Agency (SFMTA) was established by the passage of Proposition E in November, 1999, which enabled the authority to combine and run the San Francisco Municipal Railway and the Department of Parking and Traffic. Published reports have noted problems with the AnsaldoBreda cars, including faulty sliding doors and issues with emergency brakes that reportedly reduced allowable train speeds from 50 miles per hour to 30 miles per hour. On December 21, 2009, AnsaldoBreda won the contract to upgrade 143 light rail vehicles for SFMTA. The reconditioning project included rebuilding the door and steps system, the automatic couplers, the air supply units, and traction motors, as well as replacing the articulation pins in the center of the car and the articulation wire harnesses. Car No. 1412 was the first reconditioned car to be placed back in service, on October 14, 2010. For fiscal year 2011/12, the San Francisco Municipal Railway light rail lines had an average weekday ridership of 162,738, and the total light rail ridership for that period of a year was 51,445,000 according to the June, 2013 Statistical Summary of Bay Area Transit Operators.

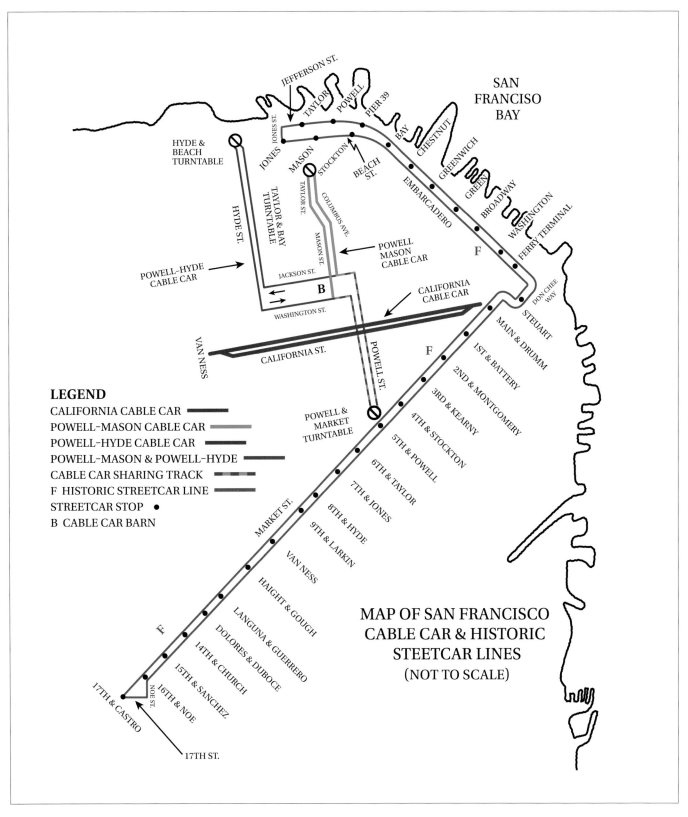

MAP OF SAN FRANCISCO
CABLE CAR & HISTORIC
STEETCAR LINES
(NOT TO SCALE)

LEGEND
CALIFORNIA CABLE CAR
POWELL-MASON CABLE CAR
POWELL-HYDE CABLE CAR
POWELL-MASON & POWELL-HYDE
CABLE CAR SHARING TRACK
F HISTORIC STREETCAR LINE
STREETCAR STOP •
B CABLE CAR BARN

This map shows the California, Powell-Hyde, and Powell-Mason cable car lines along with the F streetcar line. Since its beginning in December 28, 1912, the San Francisco Municipal Railway assigned letters to its streetcar lines to distinguish them from the numbered ones of its competitor, the Market Street Railway. After the Market Street Railway was purchased by the San Francisco Municipal Railway, which took over operation on September 29, 1944, each streetcar line converted to bus operation was assigned a number. As an example, the B Geary streetcar became the 38 Geary bus. After the Trolley Festival began operation on June 22, 1983, it became known as route F, because F could stand for Festival.

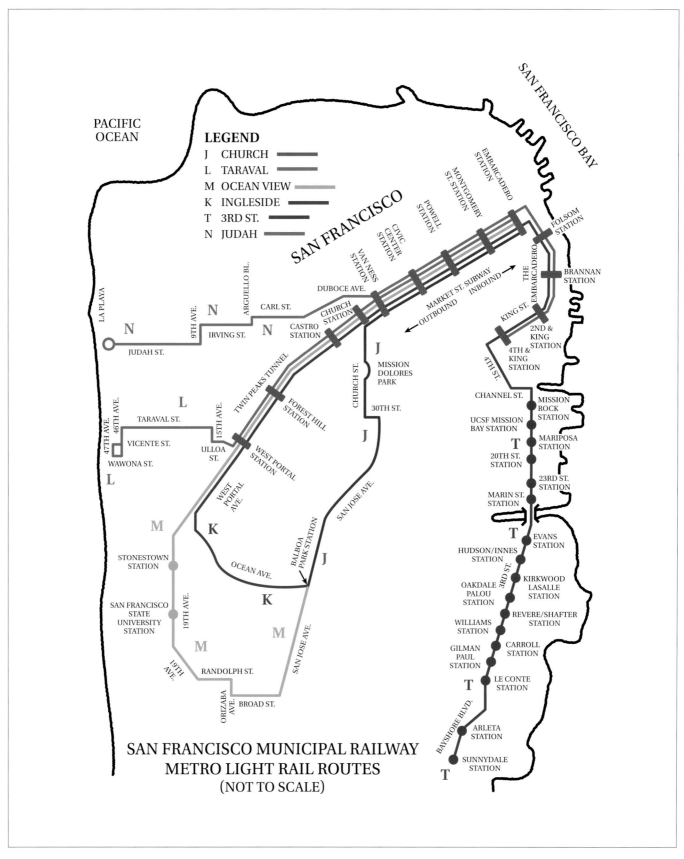

**SAN FRANCISCO MUNICIPAL RAILWAY
METRO LIGHT RAIL ROUTES**
(NOT TO SCALE)

San Francisco Municipal Railway Metro light rail lines J Church, L Taraval, M Ocean View, K Ingleside, T Third Street, and N Judah serve a significant area of the city. Based on the SFMTA Transit Effectiveness Project (TEP) issued in 2013, average weekday ridership for each line was as follows: route J – 14,767; route K/T – 33,752; route L – 28,816; route M – 26,920; route N – 41,439.

Chapter 1

F Line

Outbound, the F line operates from Jones, Beach, Embarcadero, Ferry Terminal Loop, Steuart, Market, Noe, and 17th to its terminus at Castro. Inbound, it operates from 17th, Market, Steuart, Ferry Terminal Loop, Embarcadero, Jefferson, and Jones to Beach. In November, 1962, voters in the counties of Alameda, Contra Costa, and San Francisco approved a bond issue to construct the Bay Area Rapid Transit system (BART), and construction began on September 11, 1972, BART completing a subway under Market Street in 1973. A second subway was constructed above the BART subway by the San Francisco Municipal Railway, which began a gradual replacement of the PCC streetcars with the new articulated light rail vehicles (LRV) built by Boeing Vertol. On February 18, 1980, the new LRVs began Monday to Friday operation on route N Judah into the subway. The last day of streetcar operation on Market Street in San Francisco was September 19, 1982.

With the concern that the 20-month shutdown of the cable car system beginning September 21, 1982 would affect tourism, a Trolley Festival began operation on June 22, 1983; the line was officially called F Market & Wharves, and operated every 15 minutes. That festival was a success, and in 1984 the festival operated with more streetcars available, providing a service every 12 minutes. Both Trolley Festivals in 1983 and 1984 did not operate on Tuesdays and Wednesdays; however, the 1985 Trolley Festival operated daily and proved that a daily service could be operated on a vintage streetcar line. The Trolley Festival in 1986 was confined to a route on Market Street from Transbay Terminal to 17th and Noe Street, with a service every 10 minutes which did not operate on Sundays.

With the final Trolley Festival held in 1987, the public was pleased with the service and beginning September 18, 1987 a special test was conducted on tracks of the State Belt Railroad of San Francisco that were no longer in use. Two streetcars, No. 189 from Portugal and Market Street Railway car No. 578, powered by a diesel generator on a flatcar coupled to the northward-facing ends of each streetcar, operated from the Ferry Building to Pier 39 under the Embarcadero Freeway.

It was an immediate success. Trackage was restored on Market Street, and the 3.5 mile F line began operation on September 1, 1995. Running on the schedule of the route 8 Market Street trolley coach line which it would eventually replace, headways were 9 minutes during rush hours, 15 minutes midday, 20 minutes at night, 12 minutes on Saturdays, and 15 minutes on Sundays. The route 8 trolley coaches made their last run in January, 1996. It is interesting to note that in July, 1949, trolley coaches had replaced streetcars on the Market Street Railway route 8.

On March 4, 2000, with the opening of the extension of the F line to Fisherman's Wharf, F line streetcars no longer operated a regular service to the Transbay Terminal, but the loop was occasionally used as an emergency cutback, the last day of operation into that loop being on August 8, 2000. Later that month the loop trackage was removed. A non-profit group, Market Street Railway, which began in 1976 with the aim of saving a 1950-built San Francisco trolley coach by the 1980s, became an advocacy group. It acquired streetcars and supported the San Francisco Municipal Railway by keeping the streetcars clean, plus pushed for the establishment of the F line and its extension to Fisherman's Wharf. In January, 2001, fifteen streetcars were assigned to the line, providing an 8 minute headway, with two extra streetcars for the rush hours to achieve a 6 to 7 minute headway, although accidents have since taken a number of the streetcars out of service. To meet the need for more streetcars, 11 former Newark, New Jersey PCC cars were purchased during 2003. However, these cars needed to be rewired by the Brookville Equipment Company to eliminate problems such as rear doors opening while the cars were moving. In 2007, the Market Street Railway opened the San Francisco Railway Museum at 77 Steuart Street in downtown San Francisco.

The 6 mile F line carries about 23,000 riders daily, running from the Castro neighborhood via Market Street through the Financial District and along the Embarcadero to Fisherman's Wharf, and provides a fun way to explore San Francisco.

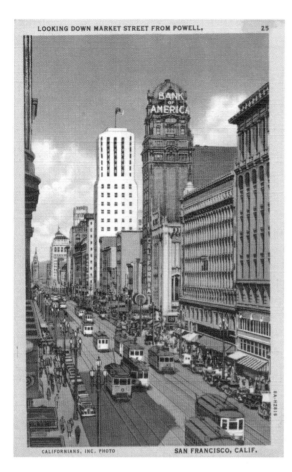

Left: Looking east toward the Ferry Building, Market Street is an imposing sight with four streetcar tracks in this 1918 postcard view. The 100 foot wide street also plays host to vehicular and pedestrian traffic.

Below: Facing east on Market Street at Grant Avenue, the clock tower is in the distance with numerous streetcars in sight in this postcard scene of the 1920s. A streetcar is distinguishable from a cable car in this way: if a car runs on steel rails with a trolley pole connected to an overhead wire, it is a streetcar; if it runs on steel rails with a middle third rail having an open slot, and there are no overhead wires, it is a cable car.

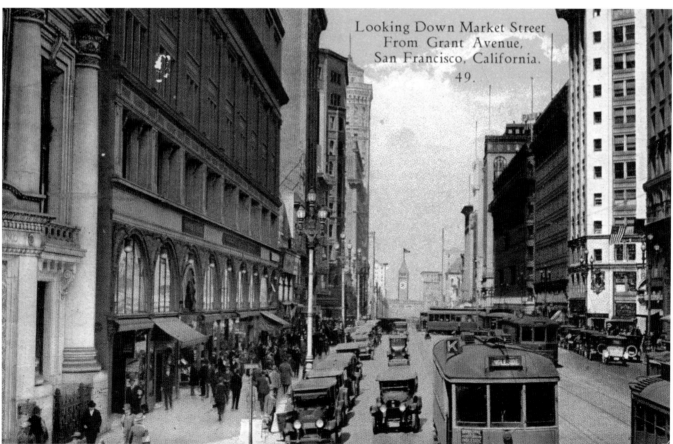

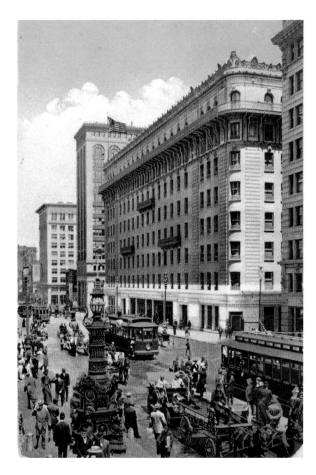

Right: In this postcard, postmarked July 5, 1910, the 8-story Palace Hotel, built of steel, granite, and concrete, is located across from Lotta's Fountain on the southwest corner of Market and New Montgomery Streets and was served by every streetcar line in the city. The original Palace Hotel, which opened October 2, 1875, was demolished after being ravaged by the fire caused by the 1906 earthquake. On December 19, 1909, the rebuilt hotel opened; it became the Sheraton-Palace Hotel in 1954, but later reverted to the Palace Hotel.

Below: San Francisco Municipal Railway streetcar No. 1 is westbound on Market Street on July 18, 1981. This was the first of 20 type A streetcars numbered 1 to 20 built by the W. L. Holman Company (which had earlier constructed cable cars) at a cost of $7,700 per car for the San Francisco Municipal Railway and went into service on Geary Street on December 28, 1912.

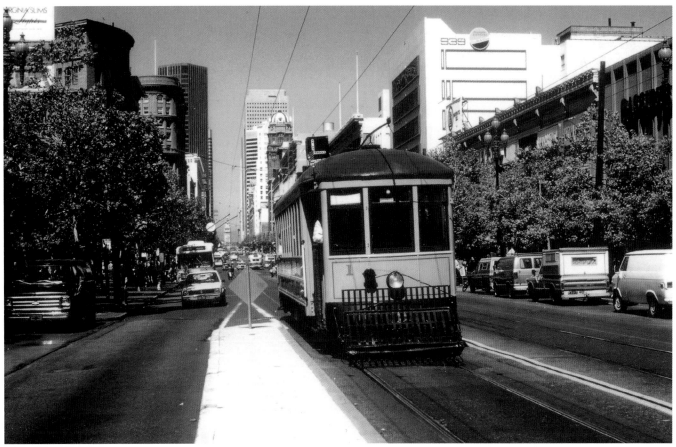

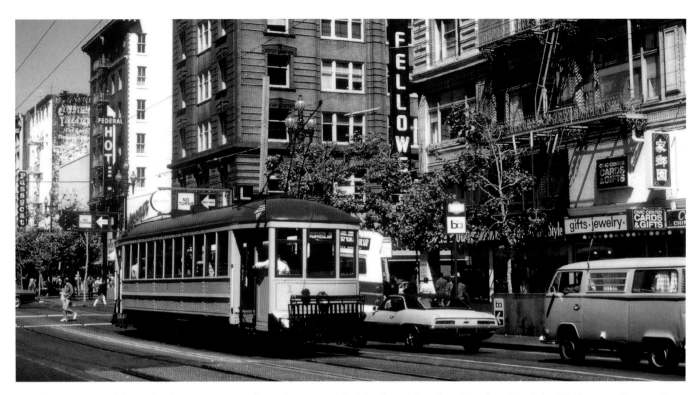

On July 18, 1981, in this Market Street scene, eastbound streetcar No. 1 is alongside a San Francisco Municipal Railway trolley coach model E800 built by Flyer Industries. These type A streetcars became known as "Arnold" cars, named for their designer, transit consultant Bion J. Arnold. Weighing 50,000 pounds and powered by four Westinghouse type 306CA motors, these cars were 47.08 feet long, 8.5 feet wide, and seated 48 passengers.

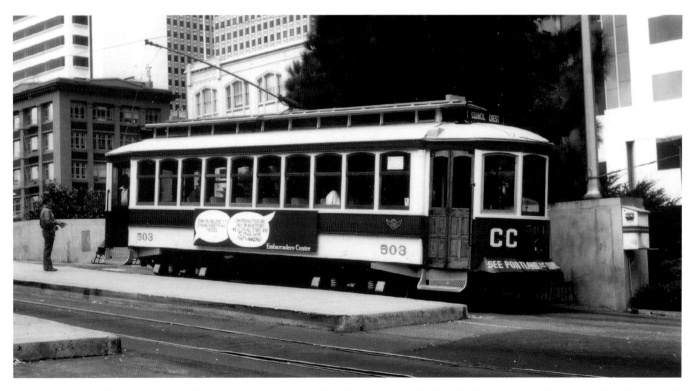

Former Portland, Oregon streetcar No. 503 is seen at the Transbay Terminal on July 18, 1983. It had previously operated on the Council Crest line and was one of ten cars, numbered 201 to 210, built by the American Car Company in 1904. These cars, later renumbered 501 to 510, were used until 1950 when Portland's remaining streetcar lines were converted to bus operation. Since the 1960s, this car has been at the Oregon Electric Museum, initially at Glenwood, Oregon before moving in 1996 to Brooks, Oregon (except when at the San Francisco Trolley Festivals in 1983 and 1984).

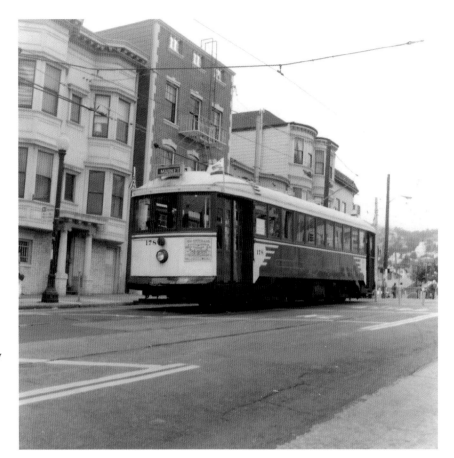

San Francisco Municipal Railway car No. 178 is at 17th and Castro Streets on July 22, 1983, operating in the Trolley Festival. This was one of 20 type K cars, numbered 169 to 188, built by the Bethlehem Shipyard in San Francisco and delivered from July through November, 1923. This car went to the Western Railway Museum in 1959. It was used in the San Francisco Trolley Festival beginning 1983 and was later returned to the Western Railway Museum.

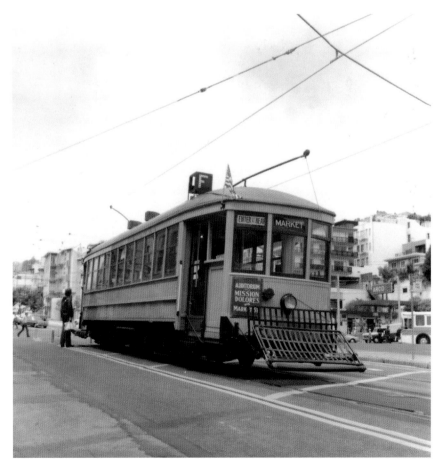

On July 24, 1983, streetcar No. 1 is at 17th and Castro Streets for the San Francisco Trolley Festival. This car was retired in 1951, and in 1962 it was restored to its original 1912 appearance for use in the 50th anniversary of the San Francisco Municipal Railway. During 2009-10, it was completely restored by the Brookville Equipment Corporation and was used in the San Francisco Municipal Railway's centennial during 2012.

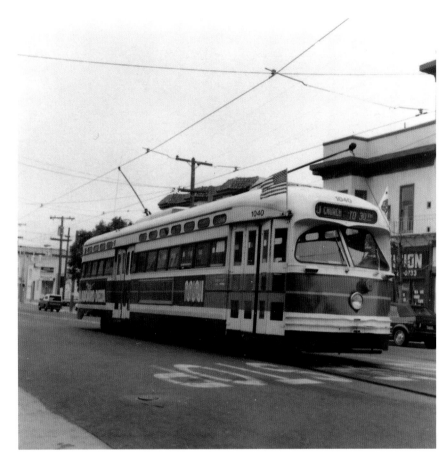

PCC car No. 1040 is at Church and 30th Streets, the terminus of route J, on July 24, 1983. This was one of 25 PCC cars built by the St. Louis Car Company in 1951 and numbered 1016 to 1040. Seating 58 and weighing 37,600 pounds, this car was 46.42 feet long by 9 feet wide, and was powered by four Westinghouse type 1432K motors. This was the last PCC-type streetcar built in the United States and was used in the 1983 Trolley Festival.

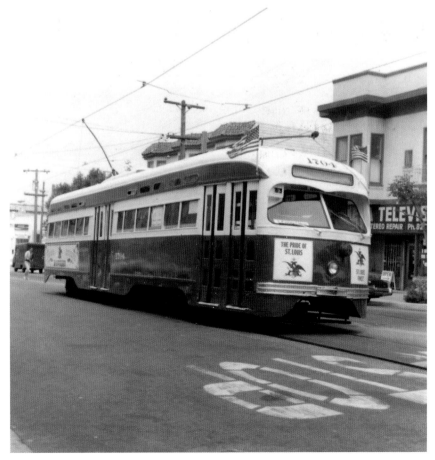

In its St. Louis paint scheme, PCC car No. 1704 (renumbered 1128 by the San Francisco Municipal Railway) is on Church at 30th Streets on July 24, 1983. This was one of 66 PCC cars (numbered in the 1700 series) built by the St. Louis Car Company in 1946 for the St. Louis Public Service Company. It was leased to the San Francisco Municipal Railway in 1957 and purchased along with four additional 1700 series PCC cars in 1962.

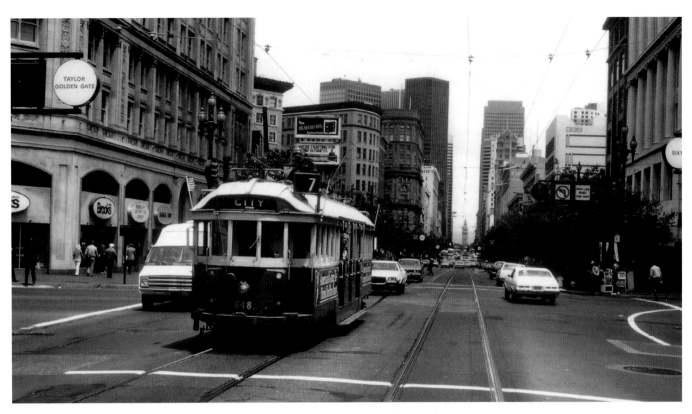

On July 22, 1983, former Melbourne and Metropolitan Tramways Board (Australia) streetcar No. 648 is westbound on Market Street at the intersection of Taylor Street and Golden Gate Avenue for the San Francisco Trolley Festival. This was one of 30 W2 class streetcars, numbered 624 to 653, built during 1930-31 at the Preston shops of the Melbourne and Metropolitan Tramways Board.

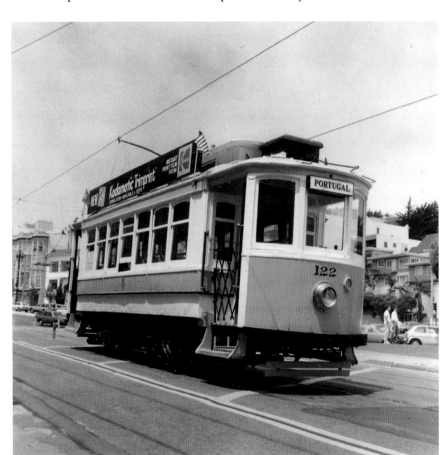

Former Porto, Portugal streetcar No. 122, built by the J. G. Brill Car Company in 1909, is at 17th and Castro Streets on July 28, 1983 for the San Francisco Trolley Festival. This car was retired by the Sociedade de Transportes Colectivos do Porto (STCP) of Portugal in 1978. Gales Creek Enterprises of Oregon brought the car to the United States in the early 1980s, refurbished it, and loaned it to the San Francisco Trolley Festival. Since 1985, it has been operated by the McKinney Avenue Transit Authority of Dallas, Texas.

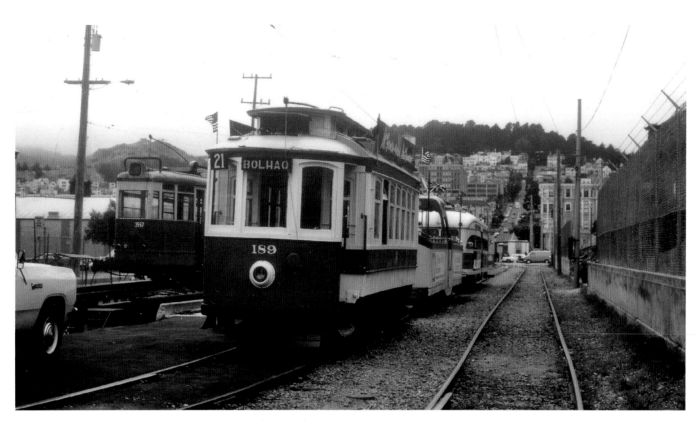

On July 24, 1983, car No. 189 is at the Market Street Railway yard on Duboce Avenue near Church Street. This single-truck car was built in 1929 for STCP of Porto, Portugal and was subsequently purchased by the San Francisco Municipal Railway for use in the Trolley Festival.

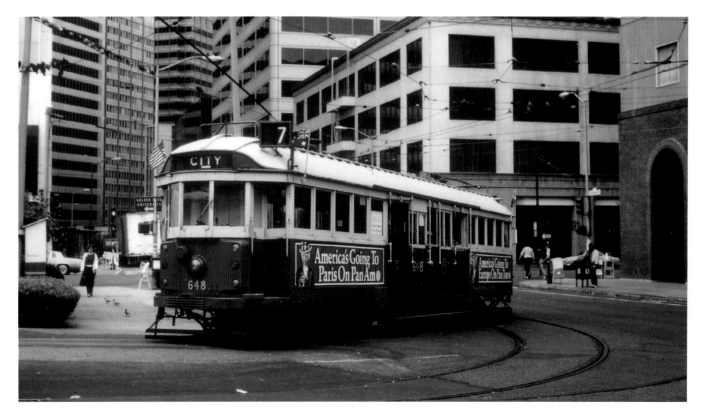

Leaving the East Bay Terminal on July 28, 1983, former Melbourne and Metropolitan Tramways Board streetcar No. 648 will soon be westbound on Market Street for the Trolley Festival. The success of the Trolley Festival, with commuters and tourists alike enjoying the variety of special streetcars, proved that the streetcar line on Market Street was important to the city and led to the establishment of the F line.

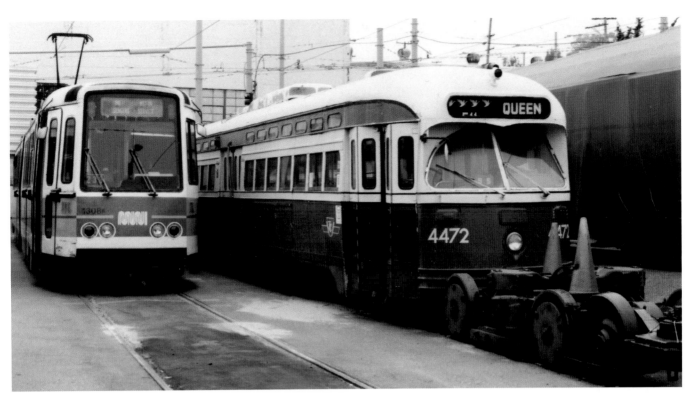

On July 30, 1997, San Francisco Municipal Railway Boeing Vertol articulated light rail vehicle No. 1308 (left) and former Toronto Transit Commission of Toronto PCC car No. 4472 (right) are at Geneva yard. The latter was one of 100 cars for multiple-unit operation; its body shell was fabricated by the St. Louis Car Company, the Canadian Car and Foundry Company completing the assembly and painting in 1949.

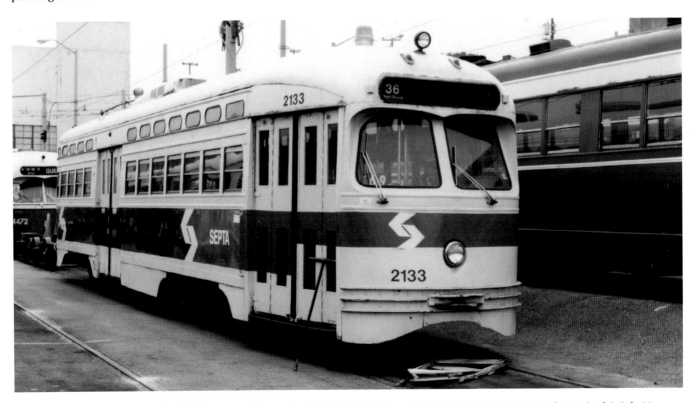

Former Southeastern Pennsylvania Transportation Authority (SEPTA) PCC car No. 2133 is at the Geneva car house in this July 30, 1991 view. This car was built by the St. Louis Car Company and was delivered to the Philadelphia Transportation Company in August, 1948. It was overhauled by SEPTA in April, 1981, and was sold to the San Francisco Municipal Railway in May, 1990. Currently, SEPTA operates significantly modified PCC cars on route 15 in Philadelphia.

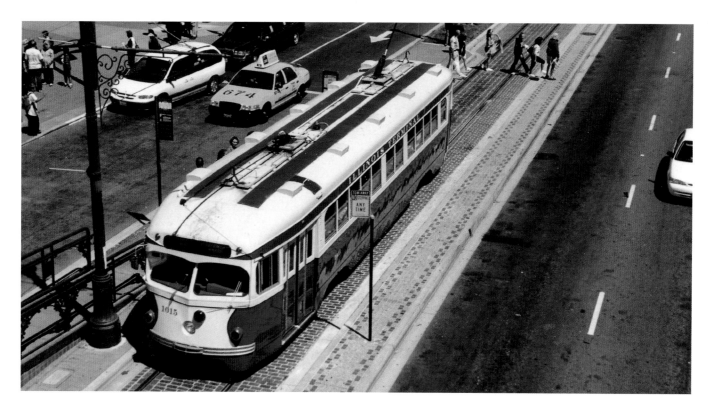

Streetcar No. 1015 is westbound on Jefferson Street near the end of the F line in the Fisherman's Wharf area of San Francisco on August 12, 2000. This was one of ten type D PCC streetcars, numbered 1006 to 1015, built by the St. Louis Car Company during 1948. Seating 60 and weighing 40,140 pounds, the 50.42 foot long by 9 foot wide car was powered by four General Electric type 1220E1 motors. In 1982, the car was taken out of service and placed in storage, and was restored by the Morrison-Knudsen Corporation in 1995.

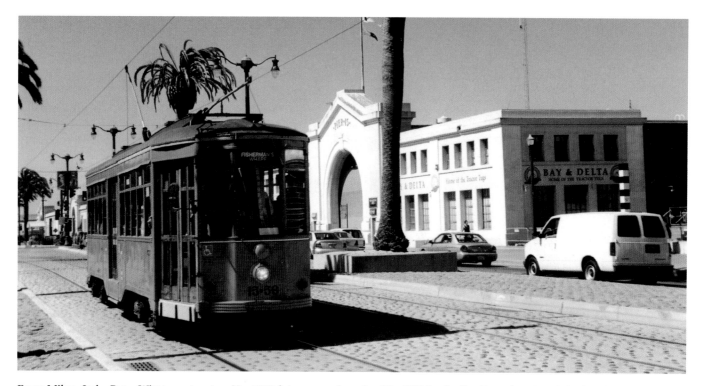

From Milan, Italy, Peter Witt type streetcar No. 1556, later renumbered as No. 1856 by the San Francisco Municipal Railway, is operating on the F line, passing by Pier 15 on the Embarcadero near Vallejo Street on August 12, 2000. This type of streetcar was named for Peter Witt, the Cleveland (Ohio) Street Railway commissioner, who designed the car to speed loading by having passengers enter via the front door and paying the conductor as they passed by the middle of the car.

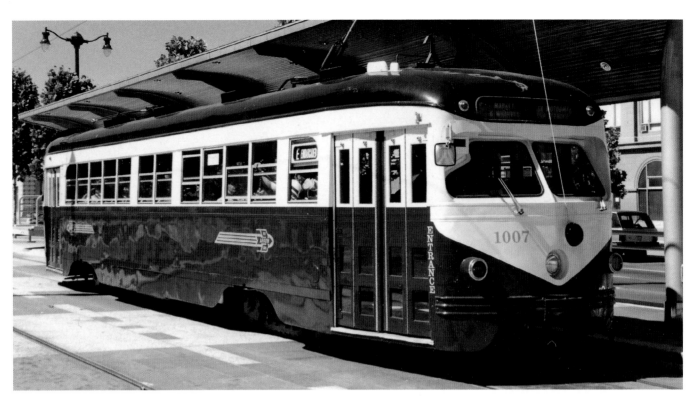

At the Ferry Building stop, car No. 1007 is ready to glide down the Embarcadero to the Fisherman's Wharf F line terminus on August 12, 2000. This type D car, built by the St. Louis Car Company in 1948 for the San Francisco Municipal Railway, was originally painted green and cream. It was retired in 1982 and stored. In 1995, it was restored by the Morrison-Knudsen Corporation for the F line. Since 1997, this car has been in the paint scheme of the Philadelphia Suburban Transportation Company (that served the western suburbs of Philadelphia).

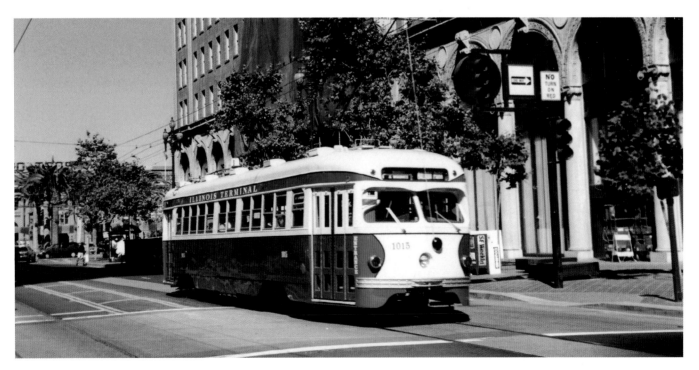

Market Street at Spear Street is the location of F line type D PCC streetcar No. 1015, built by the St. Louis Car Company in 1948, on August 13, 2000. This car is painted to represent the Illinois Terminal Railroad which operated eight PCC cars, numbered 450 to 457, built by the St. Louis Car Company and delivered in October, 1949. They were in service connecting St. Louis, Missouri to Granite City, Illinois from November, 1949 to June, 1958. The electric interurban Illinois Terminal Railroad once operated extensive passenger and freight service in central and southern Illinois.

Blackpool, England boat trolley No. 228 is at Mission Dolores Park on August 13, 2000. Having almost 16 acres, the park, situated on land that was once a Jewish cemetery, was purchased by the city in 1905. During 1906, the park served as a refugee camp for over 1,600 residents made homeless by the San Francisco earthquake and fire. Bounded by Church, Dolores, 18th and 20th Streets, the park has the J Church line running along its western edge and includes a soccer field, six tennis courts, one basketball court, and a dog play area.

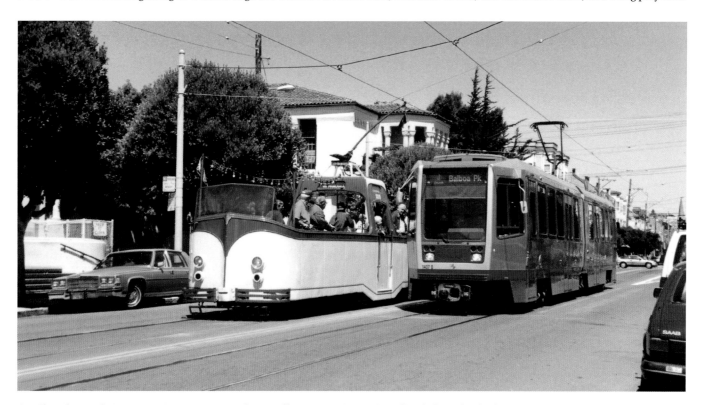

On Church at 17th Streets on August 13, 2000, boat trolley No. 228 is passing J line light rail vehicle No. 1407, built by AnsaldoBreda. In 1976, to celebrate the bicentennial of the United States, this car was used by SEPTA in Philadelphia on a portion of route 50 northbound on 5th Street and southbound on 4th Street between Girard Avenue and Catharine Street, plus in 1977 on route 15 from 63rd and Girard to the Cumberland loop.

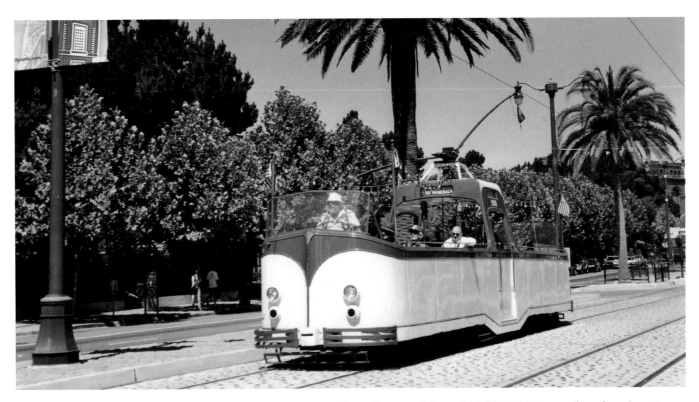

On August 13, 2000, boat trolley No. 228 is on the picturesque Embarcadero at 3rd Street. Weighing 20,000 pounds and seating 44, the 42.25 foot long by 7.5 foot wide car was powered by two English Electric type 305 motors. This was one of 12 boat trolleys built by English Electric for Blackpool Tramways in 1934.

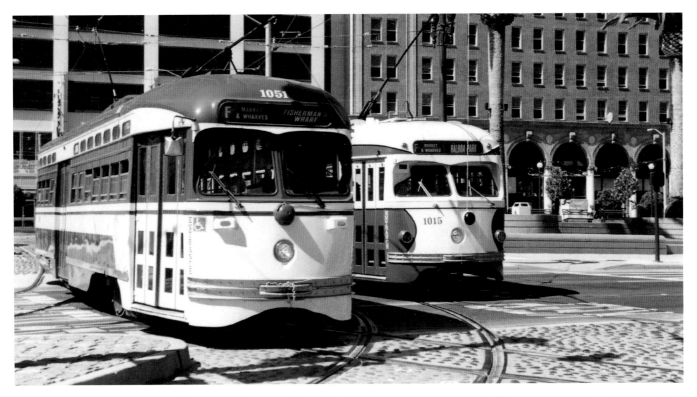

In a San Francisco Municipal Railway paint scheme, PCC car No. 1051 (built by the St. Louis Car Company and delivered in August, 1948 to the Philadelphia Transportation Company as car No. 2123) is heading for Fisherman's Wharf and passes type D PCC streetcar No. 1015 on Don Chee Way at the Embarcadero on August 13, 2000. Don Chee Way was named for Don Chee the project manager in charge of construction and later operation of the F streetcar line.

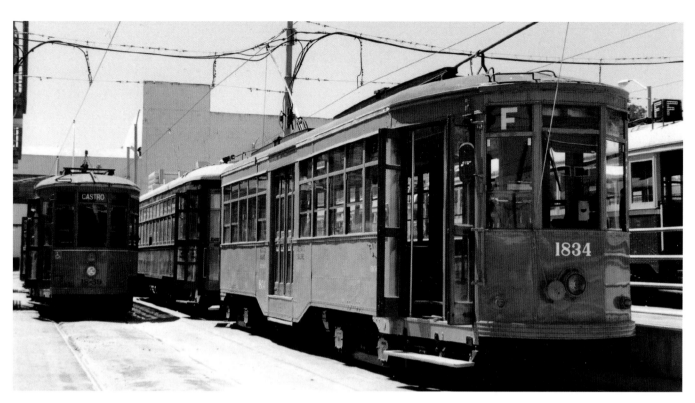

Former Milan, Italy Peter Witt type streetcar No. 1834 is in the lineup of cars at Geneva car barn on August 13, 2000. In 1965, the municipal transport company in Milan became known as Azienda Trasporti Municipali, which was changed in 1999 to Azienda Trasporti Milanesi. This type of streetcar was named for its designer Peter Witt who designed it to load passengers faster by letting passengers board through the front door and pay the conductor in the middle of the car.

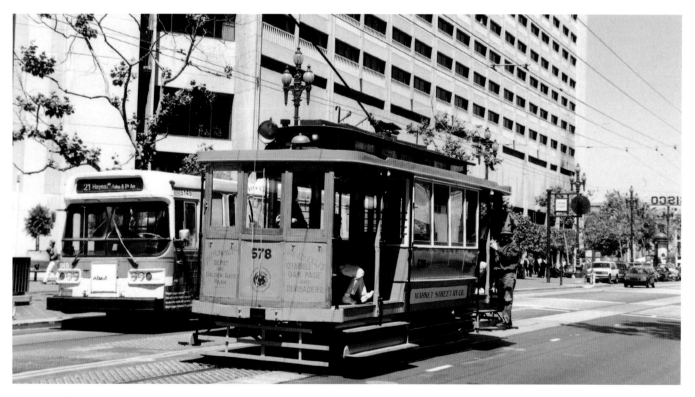

Along Market Street on a sunny August 13, 2000, streetcar No. 578 is passing by route 21 trolley coach No. 5145 model E800 built by Flyer Industries. Having survived the 1906 San Francisco earthquake, car No. 578 was renumbered as No. 0601 and converted to a work car to apply sand early in the morning on streetcar lines with heavy grades to improve traction. During 1956, the car was restored to commemorate the 50th anniversary of the earthquake.

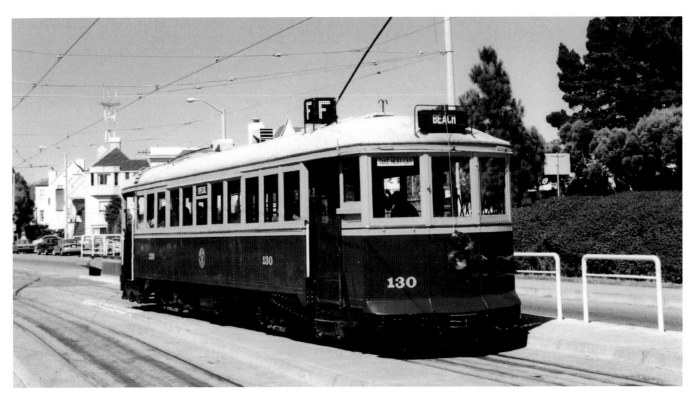

Built by the Jewett Car Company in 1914 for the San Francisco Municipal Railway, streetcar No. 130 is on Route L on Taraval Street at 46th Avenue on August 13, 2000. This car, weighing 48,000 pounds and powered by four Westinghouse type 532A motors, was retired in 1958 and was saved by San Francisco Municipal Railway shop foreman Charlie Smallwood. It became a tow car to bring disabled streetcars back to the car barn, and was restored to its 1939 appearance (using the original seats saved by Charlie Smallwood) for the San Francisco Trolley Festival.

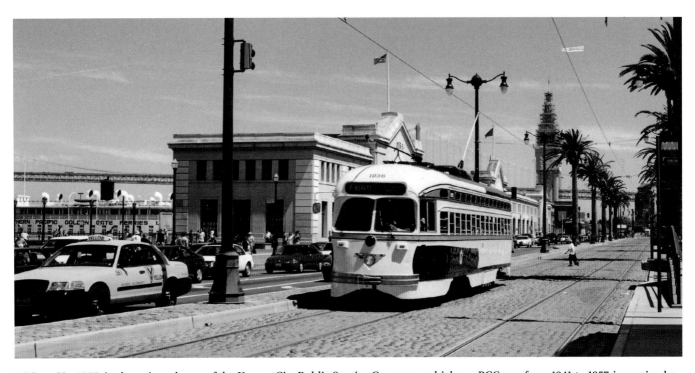

PCC car No. 1056, in the paint scheme of the Kansas City Public Service Company, which ran PCC cars from 1941 to 1957, is passing by Pier 5 on the Embarcadero near Pacific Avenue on June 30, 2001. Built by the St. Louis Car Company and delivered as car No. 2113 in August, 1948 for the Philadelphia Transportation Company, this car was overhauled by SEPTA in December, 1980. The San Francisco Municipal Railway acquired this car in October, 1992, restoration being carried out by the Morrison-Knudsen Corporation in 1993. Seating 47 and weighing 37,990 pounds, the 48.42 foot long by 8.33 foot wide car was powered by four Westinghouse type 1432J motors.

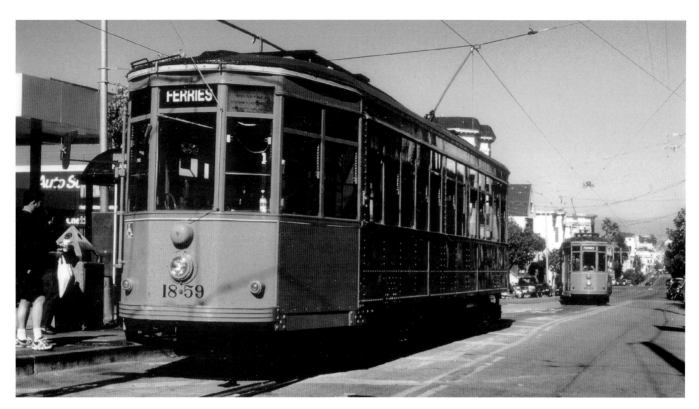

On August 13, 2000, two former Milan, Italy streetcars (No. 1859 followed by No. 1818) are at the 17th and Castro terminus of the F line. In 2014, the F line has 11 Peter Witt type streetcars from Milan, Italy. Some of Milan's Peter Witts were built in 1928 and are still in regular service, giving Milan the distinction of having the longest serving Peter Witt type streetcars in the world. Although the Toronto (Canada) Transit Commission Peter Witt No. 2766 (built in 1923) is older, it is used only for special celebrations.

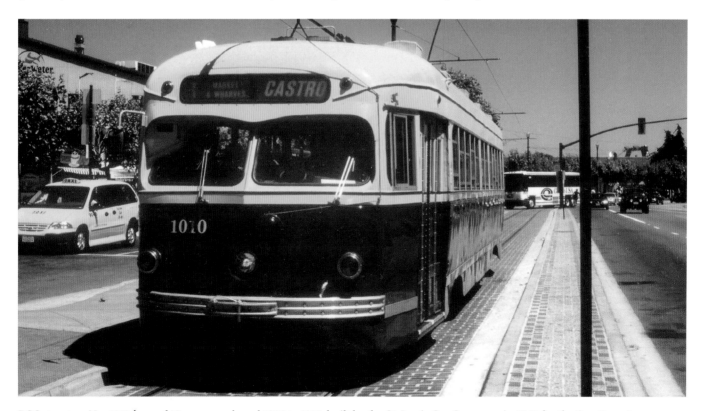

PCC streetcar No. 1010 (one of 10 cars, numbered 1006 to 1015, built by the St. Louis Car Company in 1948 for the San Francisco Municipal Railway) is on the Embarcadero for an F line trip on August 13, 2000. Seating 60 and weighing 40,140 pounds, this 50.42 foot long by 9 foot wide car was powered by four General Electric type 1220E1 motors.

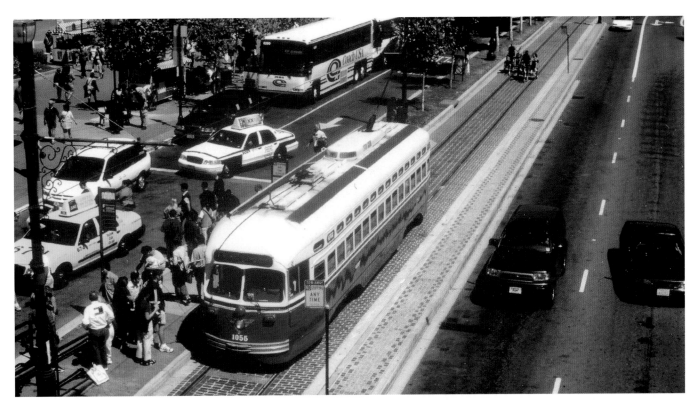

On Beach Street at Mason Street near Pier 43, F line PCC car No. 1055, seating 47 and weighing 37,990 pounds, is at a passenger stop on August 12, 2000. Originally built and delivered as car No. 2122 in September, 1948 by the St. Louis Car Company for the Philadelphia Transportation Company, the car was overhauled in February, 1981 by SEPTA. It was sold in October, 1992 to the San Francisco Municipal Railway and was restored the following year by the Morrison-Knudsen Corporation.

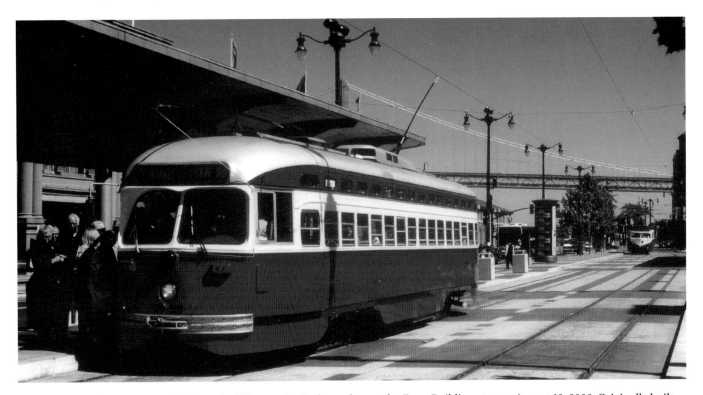

Brightly painted PCC car No. 1059 is on the F line on the Embarcadero at the Ferry Building stop on August 12, 2000. Originally built by the St. Louis Car Company and delivered in August, 1948 as car No. 2099 for the Philadelphia Transportation Company, the car was overhauled by SEPTA in July, 1981. It was acquired in October, 1992 by the San Francisco Municipal Railway and was refurbished by the Morrison-Knudsen Corporation in 1993.

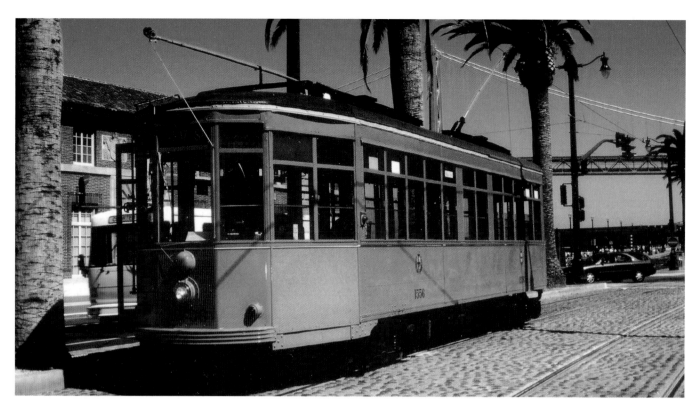

In bright sunshine on August 12, 2000, former Milan, Italy streetcar No. 1556, later renumbered as No. 1856, is serving the F line on the Embarcadero at Mission Street. The San Francisco Oakland Bay Bridge in the background opened for traffic on November 12, 1936 and consists of two sections. The western section connects downtown San Francisco with Yerba Buena Island, and the eastern section connects the island to Oakland.

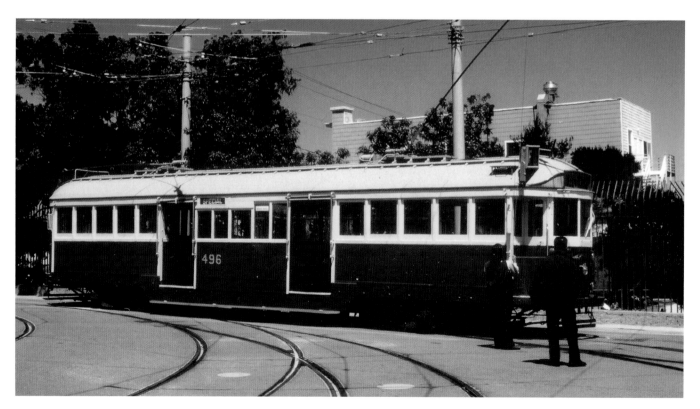

Former Melbourne and Metropolitan Tramway Board streetcar No. 496 is at the Geneva car barn on August 13, 2000. This was one of 30 class W2 cars, numbered 495 to 524, built from 1927 to 1929 by James Moore in Australia.

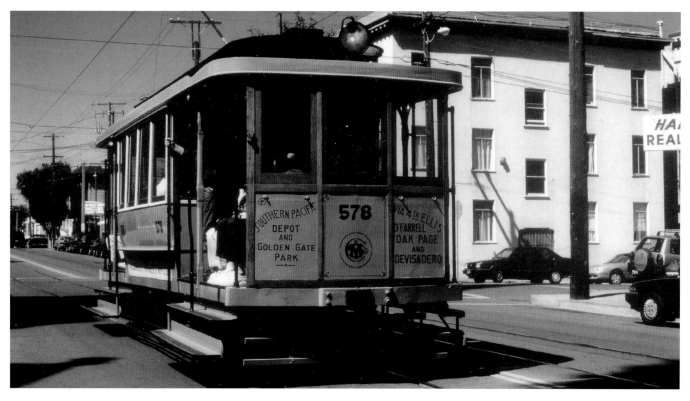

On August 13, 2000, streetcar No. 578 is at 17th and Church Streets. Seating 26, equipped with hand brakes and powered by two General Electric type 1000 motors, the single-truck car is 26.17 feet long by 8 feet wide. The car is used in revenue service only on special occasions.

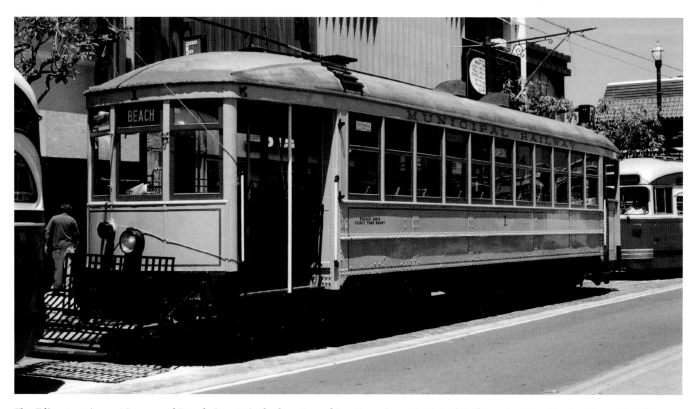

The F line terminus at Jones and Beach Streets is the location of San Francisco Municipal Railway streetcar No. 1 on June 29, 2001.

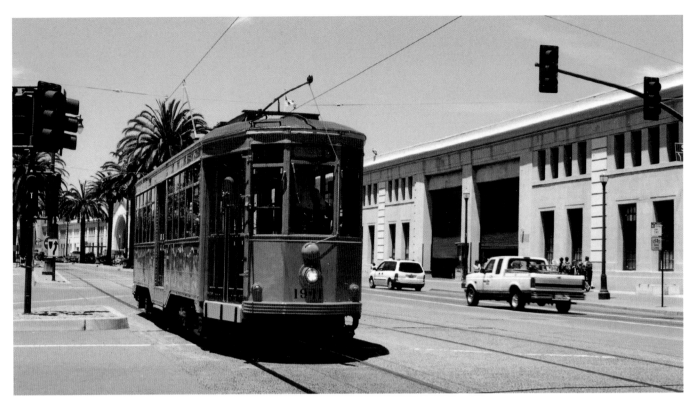

On a beautiful June 29, 2001, former Milan, Italy streetcar No. 1911, later renumbered as No. 1811, is travelling along the Embarcadero on the F line. The Embarcadero is a wide thoroughfare from Fisherman's Wharf to the South Beach Harbor where it turns onto King Street.

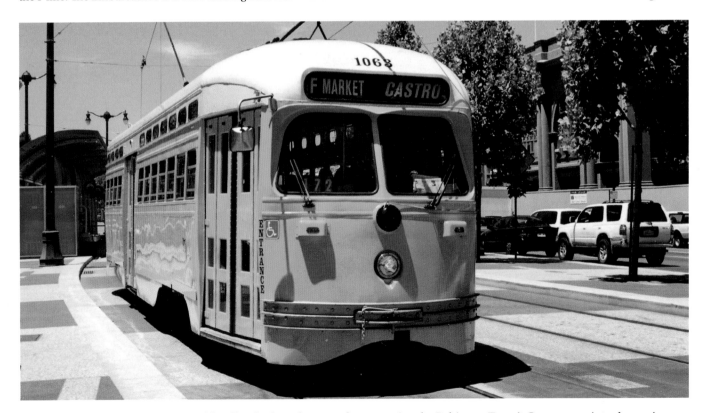

Seating 47, F line PCC car No. 1063, with yellow body and grey roof representing the Baltimore Transit Company paint scheme, is on the Embarcadero near Don Chee Way on June 29, 2001. It was originally built by the St. Louis Car Company and delivered in August, 1948 as car No. 2096 for the Philadelphia Transportation Company, and was subsequently overhauled by SEPTA in October, 1980. Acquired by the San Francisco Municipal Railway in 1992, it was restored by the Morrison-Knudsen Corporation in 1993. Weighing 37,990 pounds, the 48.42 foot long by 8.33 foot wide car was powered by four Westinghouse type 1432J motors.

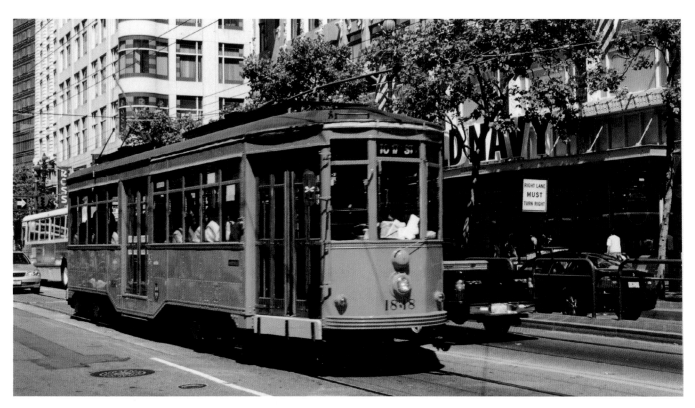

Market at Powell is the scene for F line streetcar No. 1818 (one of 11 Peter Witt type streetcars from Milan, Italy) on June 29, 2001.

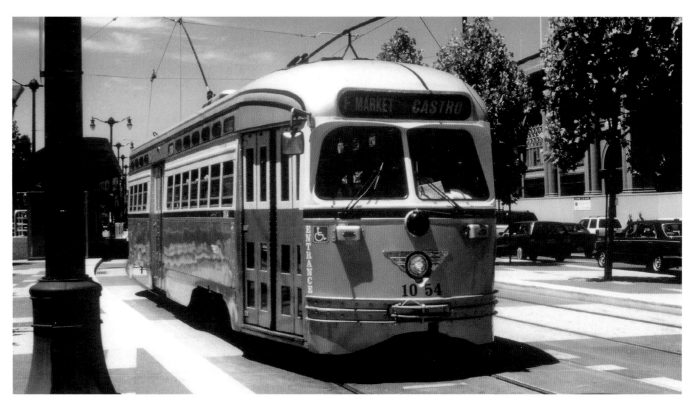

On June 29, 2001, PCC car No. 1054 is on the Embarcadero near Don Chee Way. This car was built by the St. Louis Car Company and delivered in September, 1940 as No. 2121 for the Philadelphia Transportation Company (PTC). It was overhauled by SEPTA in February, 1981, and was sold to the San Francisco Municipal Railway in October, 1992. Although this car was painted in one of the former PTC paint schemes, it never had that paint scheme in Philadelphia. Wrecked in a November 16, 2003 accident, the car was not returned to service.

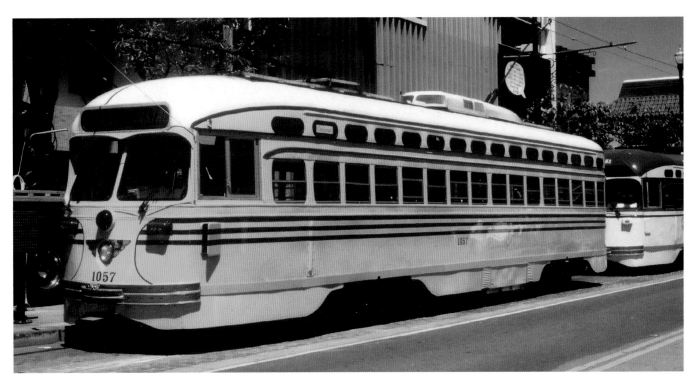

Weighing 37,990 pounds, F line PCC car No. 1057 is at Jones and Beach Streets on June 29, 2001 in a vivid canary yellow paint scheme with three green stripes around the car body representing the Cincinnati Street Railway Company. Originally built and delivered in September, 1948 as car No. 2138 by the St. Louis Car Company for the Philadelphia Transportation Company, it was overhauled by SEPTA in May 1981, acquired by the San Francisco Municipal Railway in October, 1992, and was restored by the Morrison-Knudson Corporation in 1993. Seating 47, the 48.42 foot long by 8.33 foot wide car was powered by four Westinghouse type 1432J motors.

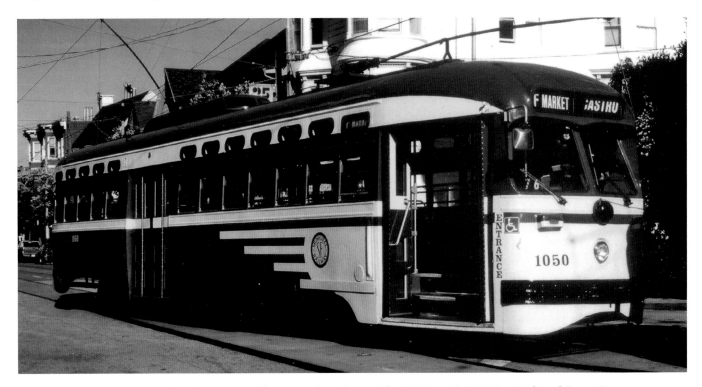

In the San Francisco Municipal Railway green and cream paint scheme, F line PCC car No. 1050 is at 17th and Castro Streets on June 30, 2001. This car was built and delivered in August, 1948 by the St. Louis Car Company as car No. 2119 for the Philadelphia Transportation Company. Following overhaul by SEPTA in September, 1981, it was acquired by the San Francisco Municipal Railway in October, 1992, with restoration by the Morrison-Knudsen Corporation in 1993. Seating 47 and weighing 37,990 pounds, the car was 48.42 feet long and 8.33 feet wide with four Westinghouse type 1432J motors.

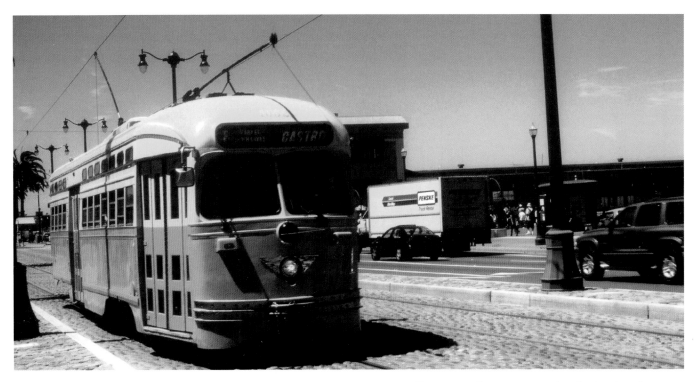

Seating 47 and weighing 37,990 pounds, F line PCC car No. 1052 in a two-tone yellow paint scheme representing the Los Angeles Railway of Los Angeles, California is on the Embarcadero on June 30, 2001. Originally built and delivered in August, 1948 as car No. 2110 by the St. Louis Car Company for the Philadelphia Transportation Company, it was overhauled by SEPTA in August, 1981 and was acquired by the San Francisco Municipal Railway in October, 1992, with restoration by the Morrison-Knudsen Corporation in 1993. With a length of 48.42 feet and width of 8.33 feet, the car was powered by four Westinghouse type 1432J motors.

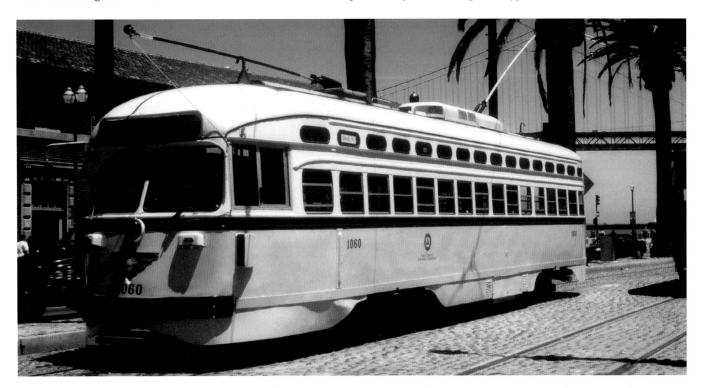

Weighing 37,990 pounds, seating 47, and in a Newark, New Jersey paint scheme, F line PCC car No. 1060 is on the Embarcadero at Mission Street on June 30, 2001. This car was built and delivered in February, 1947 by the St. Louis Car Company as car No. 2715 for the Philadelphia Transportation Company. It was overhauled by SEPTA in October, 1979 and restored by the Morrison-Knudsen Corporation in 1993. With a length of 48.42 feet and width of 8.33 feet, the car was powered by four Westinghouse type 1432D motors.

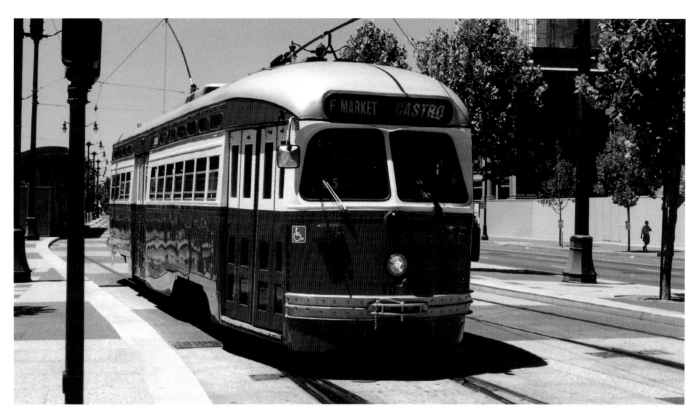

In a Boston Elevated Railway paint scheme, F line PCC car No. 1059 is on the Embarcadero near Don Chee Way on June 30, 2001. The Boston Elevated Railway, which later became the Metropolitan Transit Authority and still later the Massachusetts Bay Transportation Authority (MBTA), received its first PCC car, No. 3001, from the St. Louis Car Company in May, 1937 which went into service in July, 1937. The MBTA still uses PCC cars on its Mattapan-Ashmont line.

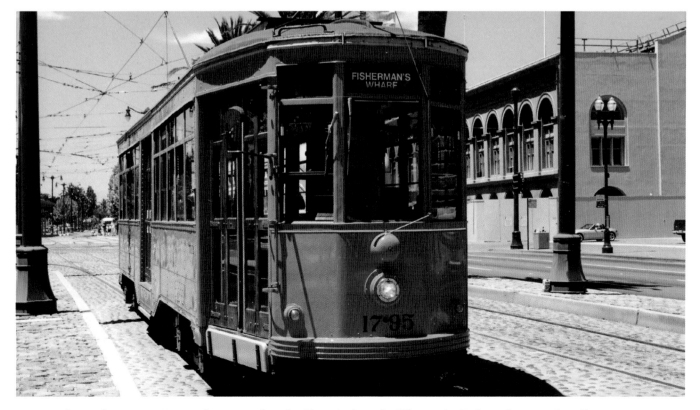

Former Milan, Italy streetcar No. 1795, later renumbered as No. 1895, is on the F line on the Embarcadero near Don Chee Way on June 30, 2001. While these streetcars have been very reliable, they are noisier and with their wooden seats are not as comfortable as the PCC cars.

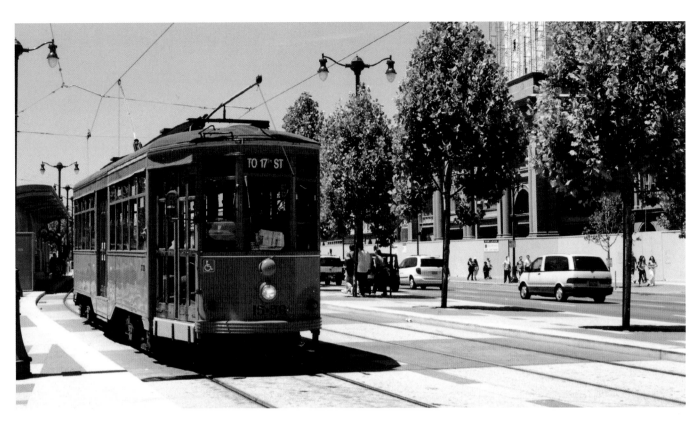

Above: Bound for 17th and Castro Streets on the F line, former Milan, Italy streetcar No. 1556, later renumbered as No. 1856, is on the Embarcadero near the Ferry Building stop on June 30, 2001. During 2001, all Milan, Italy streetcars that were not already numbered as 1800s were renumbered into the 1800 series.

Right: Maintenance work is being done on former Milan, Italy streetcar No. 1834 at the Geneva car barn on July 30, 1991. This Peter Witt type streetcar came to San Francisco in 1984 for the summer Trolley Festival and proved so reliable that the San Francisco Municipal Railway acquired ten more from Milan in 1998.

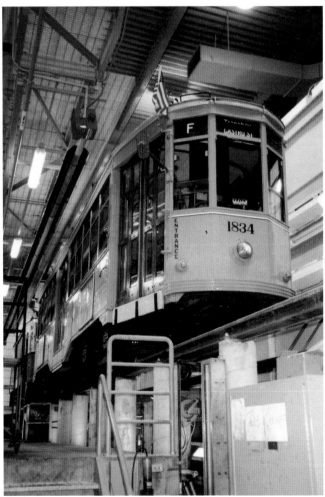

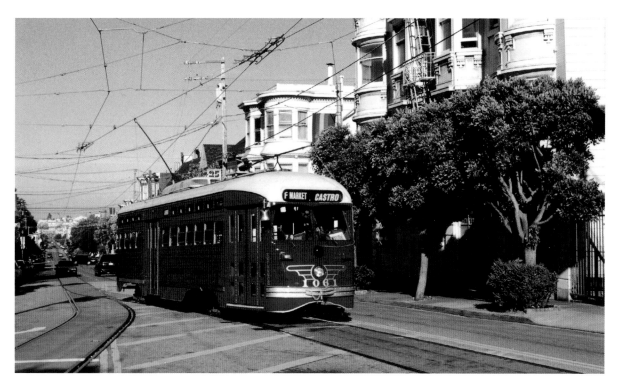

In a bright red Pacific Electric Railway Company paint scheme, PCC car No. 1061, seating 47 and weighing 37,990 pounds, is arriving at the 17th and Castro terminus of the F line on June 30, 2001. This car was originally No. 2116, built and delivered in August, 1948 by the St. Louis Car Company for the Philadelphia Transportation Company. Overhauled in December, 1981 by SEPTA, it was acquired by the San Francisco Municipal Railway in October, 1992 and restored by the Morrison-Knudsen Corporation in 1993. With a length of 48.42 feet and a width of 8.33 feet, the car was powered by four Westinghouse type 1432J motors.

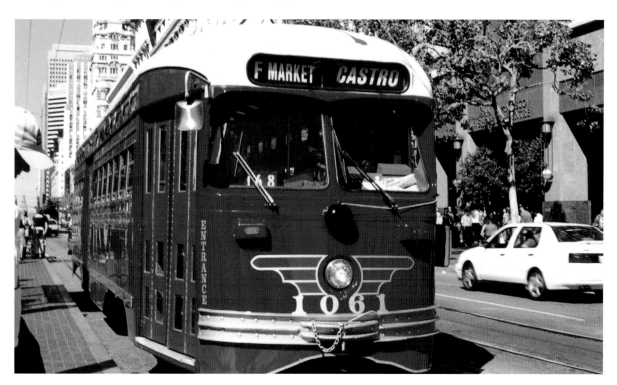

Westbound F line PCC car No. 1061 is at Market and Powell Streets on July 1, 2001. The paint scheme commemorates the 30 PCC cars numbered 5000 to 5029 and built by the Pullman Standard Manufacturing Company for the Pacific Electric Railway Company that operated in Los Angeles, California from November 24, 1940 to June 19, 1955. These cars were sold to Ferrocarril General Urquiza in Buenos Aires, Argentina in August, 1959 and were renumbered 1500 to 1529.

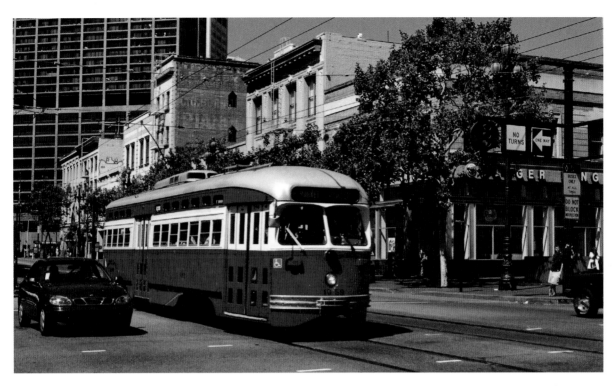

F line PCC car No. 1059 is at Market and Turk Streets on July 1, 2001. The car was painted in a Boston Elevated Railway Company paint scheme to commemorate that private operator's PCC car operation in Boston, Massachusetts. Seating 47 and weighing 37,990 pounds, the 48.42 foot long by 8.33 foot wide car was powered by four Westinghouse type 1432J motors.

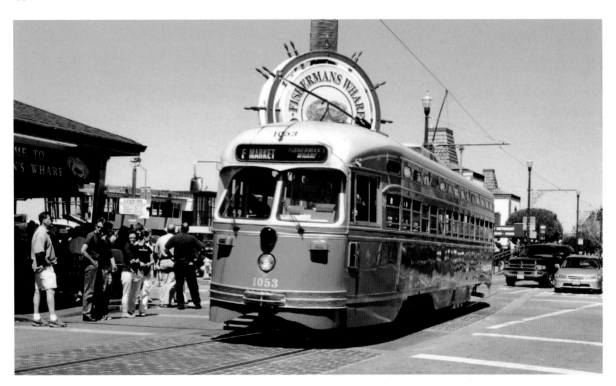

In a light green and silver paint scheme of the Brooklyn and Queens Transit Corporation of New York City, PCC car No. 1053 is on Jefferson Street at Fisherman's Wharf on July 1, 2001. Built and delivered in March, 1947 as car No. 2721 by the St. Louis Car Company for the Philadelphia Transportation Company, this car was overhauled by SEPTA in October, 1981. It was acquired by the San Francisco Municipal Railway in 1992, and restored the following year by the Morrison-Knudsen Corporation. Seating 47 and weighing 37,990 pounds, the 48.42 foot long by 8.33 foot wide car was powered by four Westinghouse type 1432D motors.

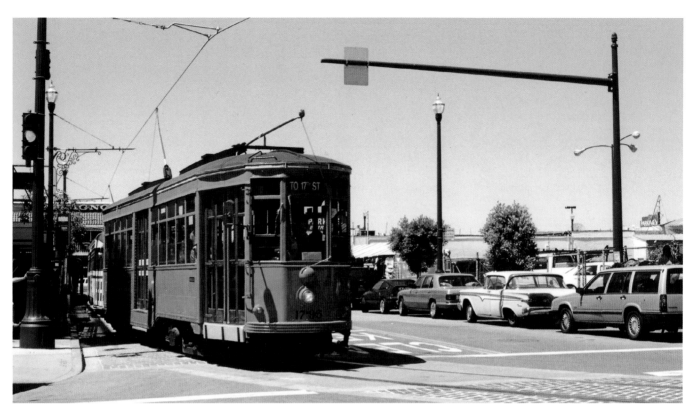

Former Milan, Italy Peter Witt type streetcar No. 1793, later renumbered as No. 1893, is turning from Jones Street onto Beach Street on July 1, 2001 for an F line trip to 17th and Castro Streets. This type of streetcar was used in a number of United States cities including Baltimore, Chicago, Cleveland, Dallas, Detroit, Los Angeles, Louisville, New York, Philadelphia, and St. Louis.

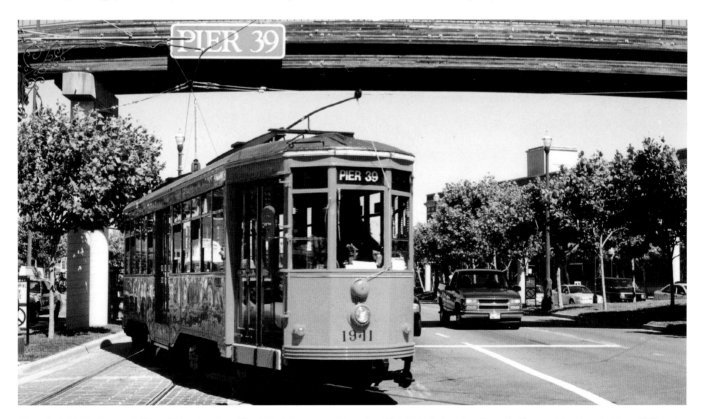

On July 1, 2001, former Milan, Italy streetcar No. 1911, later renumbered as No. 1811, is turning from Jefferson Street onto Powell Street under the Pier 39 pedestrian bridge on a cutback of the F line. Carrying commuters and tourists, the F line has become an important part of San Francisco's transportation network, linking residential, business, and tourist areas.

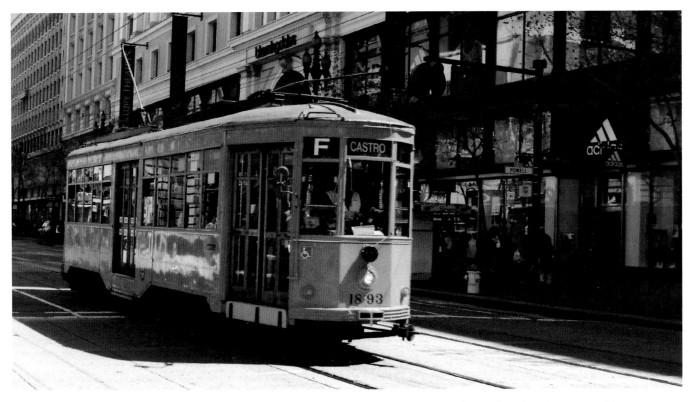

Westbound on Market Street at 5th Street is former Milan, Italy streetcar No. 1893, originally numbered as No. 1793, making a run to 17th and Castro Streets on the F line on April 3, 2011.

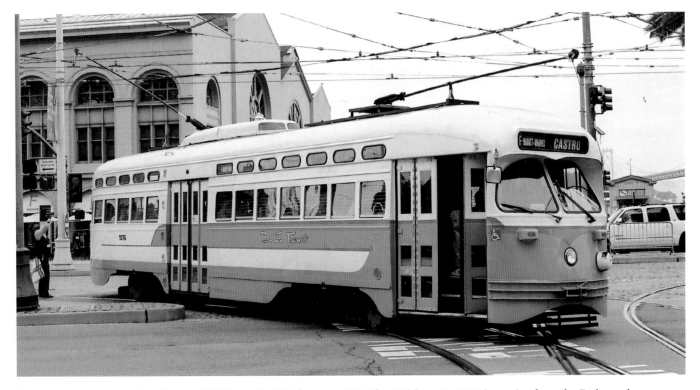

Commemorating the paint scheme of DC Transit of Washington, DC, F line PCC car No. 1076 is turning from the Embarcadero onto Don Chee Way on April 5, 2011. Originally built in 1946 by the St. Louis Car Company as car No. 331 for the Twin City Rapid Transit Company of Minneapolis-St. Paul, Minnesota, the car was sold in 1953 to Public Service Coordinated Transport for use on the City Subway of Newark, New Jersey and became car No. 12. In 2004, it was purchased from New Jersey Transit and following restoration by the Brookville Equipment Corporation was placed in service in 2011. Seating 50 and weighing 37,600 pounds, the 46.42 foot long by 9 foot wide car was powered by four General Electric type 1220 motors.

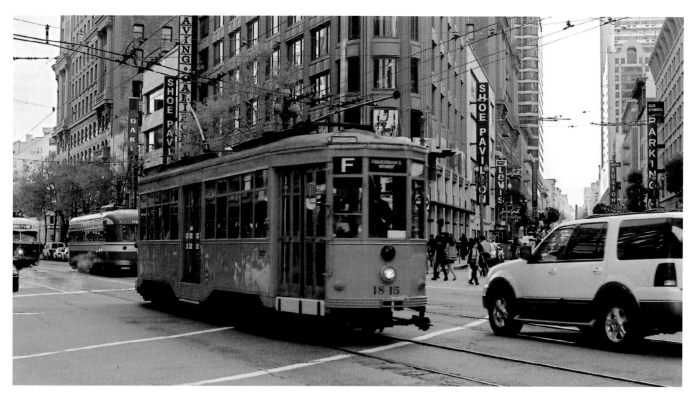

On April 3, 2011, former Milan, Italy streetcar No. 1815 is at Market and Stockton Streets on the F line. Market Street is a major transit artery for San Francisco and features heritage streetcars, electric trolley coaches, and diesel buses. Below the street is the two-level Market Street subway, with the San Francisco Municipal Railway on the upper level and the Bay Area Rapid Transit on the lower level.

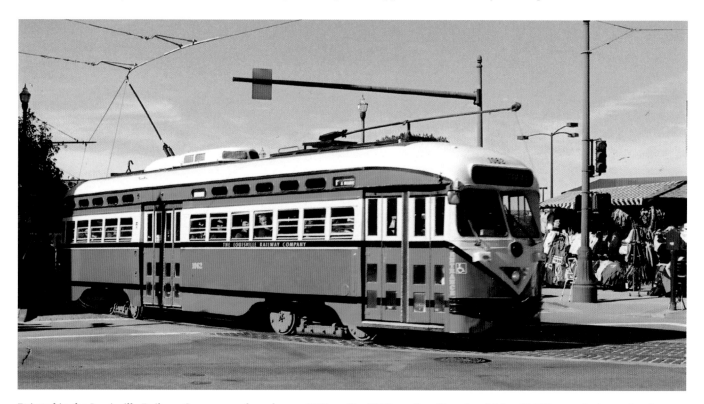

Painted in the Louisville Railway Company color scheme, PCC car No. 1062, seating 47 and weighing 37,990 pounds, is turning from Jones Street onto Beach Street on April 4, 2011. Originally built and delivered as No. 2101 in August, 1948 by the St. Louis Car Company for the Philadelphia Transportation Company, this car was overhauled by SEPTA in November, 1980. It was purchased by the San Francisco Municipal Railway in October, 1992 and was restored by the Morrison-Knudsen Corporation in 1993. The 48.42 foot long by 8.33 foot wide car was powered by four Westinghouse type 1432J motors.

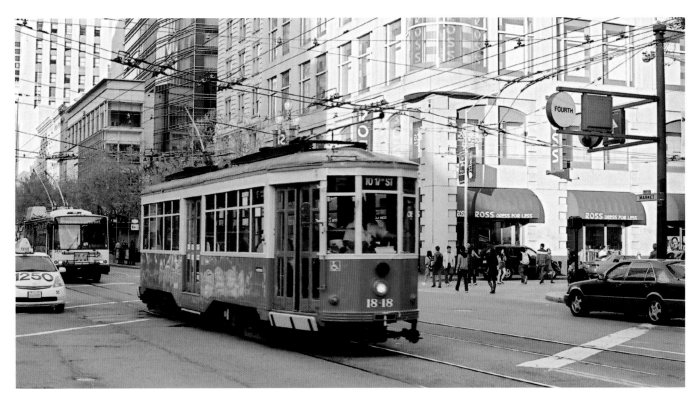

F line former Milan, Italy streetcar No. 1818 is followed by a route 6 model 14TrSF trolley coach, built by Electric Transit, Inc., on Market Street passing by 4th and Stockton Streets on April 3, 2011.

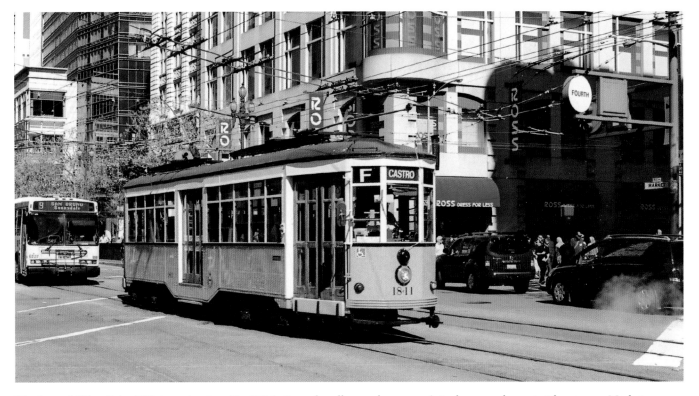

Westbound F line Peter Witt type streetcar No. 1811 in its early yellow and cream paint scheme and a route 9 bus are on Market Street at the intersection of 4th and Stockton Streets on April 4, 2011. Built by Carminati and Toselli and weighing 33,000 pounds, the streetcar is 45.58 feet long and 7.75 feet wide.

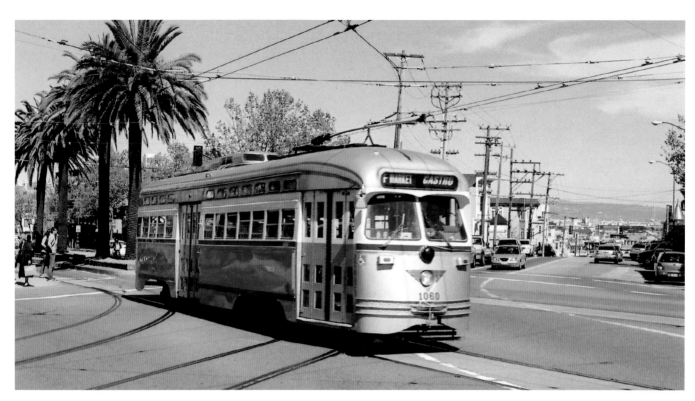

On Market Street at Buchanan Street and Duboce Avenue, where the tracks lead off to the left, F line PCC car No. 1060 (former Philadelphia Transportation Company car No. 2715) is westbound for 17th and Castro Streets on April 4, 2011. When this car went into San Francisco Municipal Railway service during 1995, it was painted to represent Public Service Coordinated Transport City Subway line in Newark, New Jersey. Following a November, 2002 derailment requiring extensive repairs, the car was repainted in a 1938 Philadelphia Transportation Company silver and blue paint scheme.

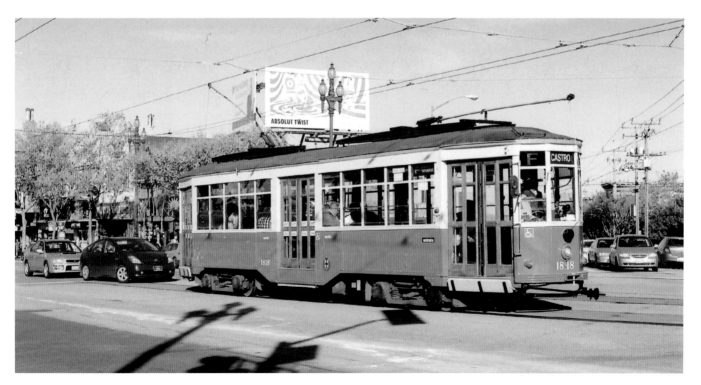

On April 4, 2011, former Milan, Italy streetcar No. 1818 is westbound on Market Street at 16th Street near the 17th and Castro terminus. This car was painted in the two-tone green paint scheme used in Milan from the 1930s to the 1970s.

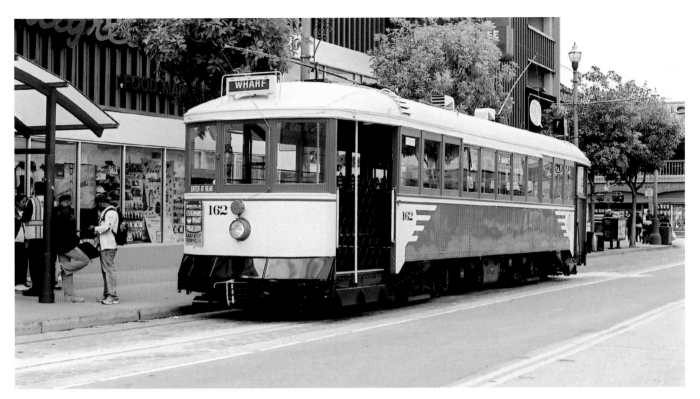

Car No. 162 is at Jones and Beach Streets on April 5, 2011. Seating 50 and weighing 48,000 pounds, it was built by the Jewett Car Company in 1914 for the San Francisco Municipal Railway. The 47.08 foot long by 9.16 foot wide car was powered by four Westinghouse type 532A motors. After its initial retirement, it spent 45 years at the Orange Empire Railway Museum in Perris, California before being reacquired in 2003 by the Market Street Railway and the San Francisco Municipal Railway.

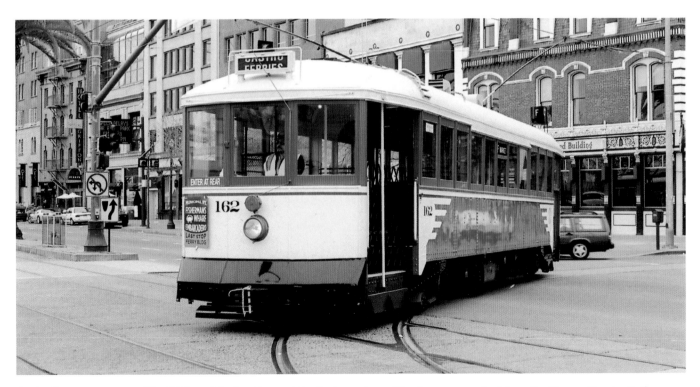

On April 5, 2011, streetcar No. 162 is on Mission Street at the Embarcadero. After it was reacquired from the Orange Empire Railway Museum in 2003, Market Street Railway volunteers replaced the roof canvas and made body repairs, and the following year the car went to the San Francisco Municipal Railway shops where workers completed the restoration, it being returned to service on April 19, 2008. This car was damaged in a collision on January 4, 2014.

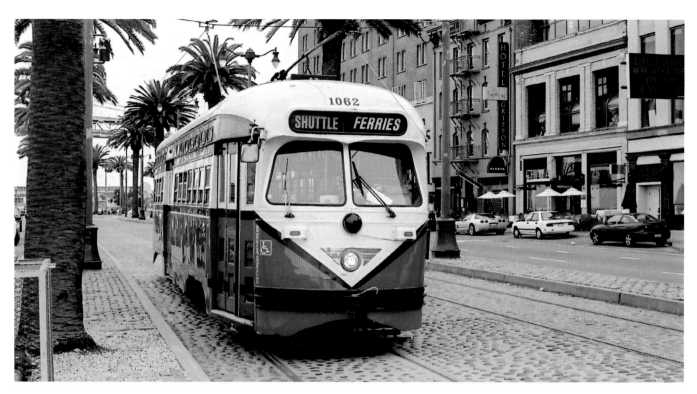

In the paint scheme of the Louisville (Kentucky) Railway Company, PCC car No. 1062 (originally Philadelphia Transportation Company No. 2101) is on the Embarcadero at Ferry Plaza on April 5, 2011. The Louisville Railway Company ordered 25 PCC cars, numbered 501 to 525, from the St. Louis Car Company; however only 15 cars, numbered 501 to 515, were delivered to Louisville. The other ten cars were shipped direct to the Cleveland Transit System. None of these PCC cars operated in Louisville, Kentucky.

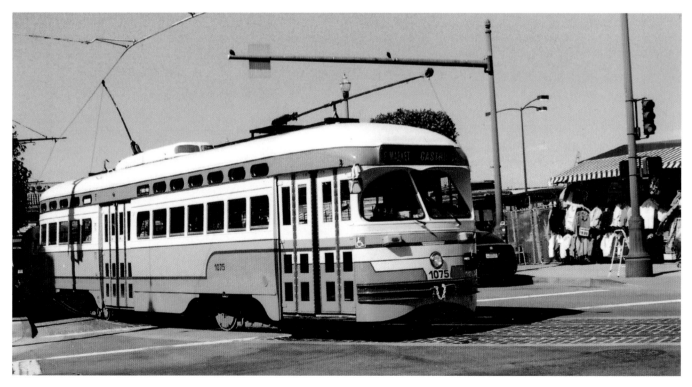

Featuring a Cleveland Transit System paint scheme, PCC car No. 1075, seating 50 and weighing 37,600 pounds, is turning from Jones Street onto Beach Street on April 6, 2011. Originally car No. 336, built in 1946 by the St. Louis Car Company for the Twin City Rapid Transit Company of Minneapolis-St. Paul, it was purchased by Public Service Coordinated Transport in 1953 and renumbered car No. 17 for use on the City Subway in Newark, New Jersey. The 46.42 foot long by 9 foot wide car was powered by four General Electric type 1220 motors. It was acquired in 2004 from New Jersey Transit and restored by the Brookville Equipment Corporation before being placed in service during 2011.

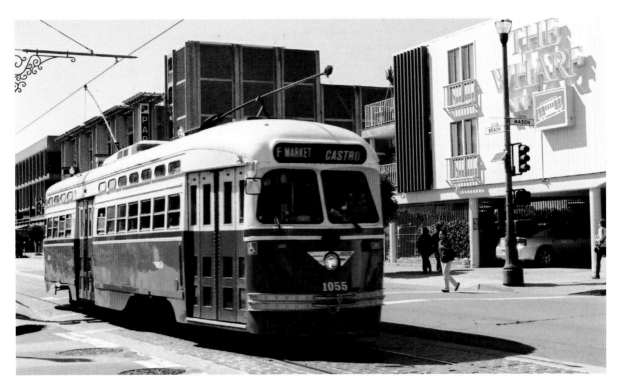

At Beach and Mason Streets in the Fisherman's Wharf area, F line PCC car No. 1055 (originally car No. 2122 from the Philadelphia Transportation Company) is heading back to 17th and Castro Streets on April 6, 2011. The car is painted in the Philadelphia Transportation Company paint scheme of cream and green with a red stripe below the windows. The Philadelphia Rapid Transit Company received its first PCC cars, numbered 2001 to 2005, in July, 1938. The 48.42 foot long by 8.33 foot wide car was powered by four Westinghouse type 1432J motors.

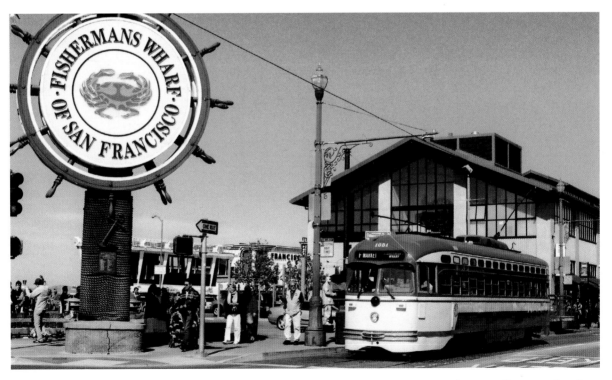

San Francisco Municipal Railway PCC car No. 1051, seating 47 and weighing 37,990 pounds, is at Jefferson and Taylor Streets, Fisherman's Wharf, on April 6, 2011. Originally delivered in August, 1948 by the St. Louis Car Company as car No. 2123 for the Philadelphia Transportation Company, the car was overhauled by SEPTA in October, 1981. It was purchased by the San Francisco Municipal Railway in October, 1992 and was restored by the Morrison-Knudsen Corporation in 1993. The 48.42 foot long by 8.33 foot wide car was powered by four Westinghouse type 1432J motors.

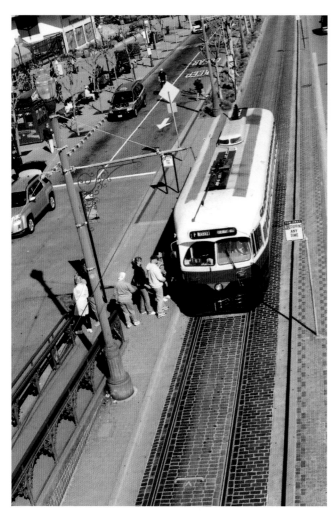

Left: In a Birmingham (Alabama) Electric Company paint scheme on April 6, 2011, PCC car No. 1077, seating 50 and weighing 37,600 pounds, is on the Embarcadero at Pier 39. Originally car No. 360, built in 1947 by the St. Louis Car Company for the Twin City Rapid Transit Company, it was sold in 1953 to Public Service Coordinated Transport where it became car No. 21 for the City Subway of Newark, New Jersey. Acquired in 2004 and restored by the Brookville Equipment Corporation, it was placed in service during 2011. The 46.42 foot long by 9 foot wide car was powered by four General Electric type 1220 motors.

Below: Former Milan, Italy streetcar No. 1859 is on Market Street at the intersection with 2nd Street on the southeast side (Post and Montgomery Streets on the northwest side of Market Street) on April 5, 2011 for an F line trip. Market Street is the boundary of two street grids. Streets on its southeast side are parallel or perpendicular to Market Street, while those on the northwest side are nine degrees off from the north, east, south, and west directions.

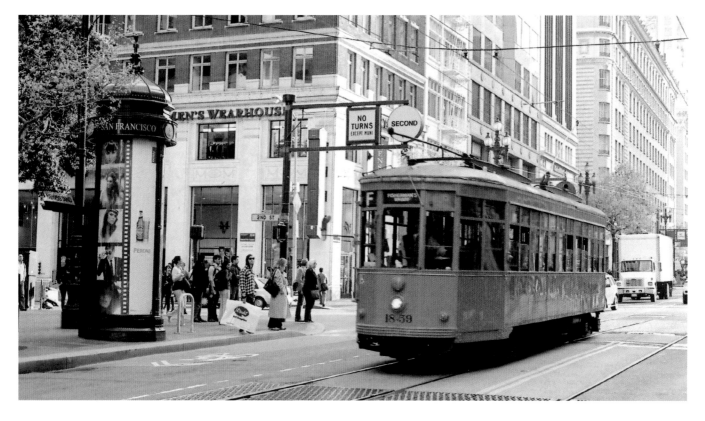

J Church Line

Outbound, the J Church light rail line operates from Embarcadero station via the Market Street subway to Duboce, Church, private right of way from 18th to 22nd, Church, 30th, and San Jose Avenue to Geneva (Balboa Park station). Inbound, the J line operates from Balboa Park station via San Jose Avenue, 30th, Church, private right of way from 22nd to 18th, Church, Duboce, and the Market Street subway to Embarcadero station. The J Church line began streetcar operation from Van Ness via Market to Church and south on Church to 30th on August 11, 1917.

Because of the 19.2 percent steep grade on Church Street between 18th and 22nd Streets, that portion of the line is on private right of way. While many San Francisco streetcar routes were converted to trolley coach and bus operation after World War II, that private right of way avoiding the steep grade on Church Street was an important factor in retaining streetcars

on the J line. It was extended on Market Street to the Ferry Loop on June 1, 1918. The terminal was changed from the Ferry Loop to the East Bay Terminal on March 27, 1949. Beginning December 3, 1972, operation on Market Street between Church and Duboce was rerouted on Duboce to Church because of subway construction, and on June 17, 1981, light rail vehicles began using the subway Monday through Friday, PCC cars operating on the surface on Saturday and Sunday. However, from September 20, 1982, light rail vehicle service was daily and PCC cars were no longer used. The outer end of the line at 30th and Church was a Y to facilitate reversal of direction. During 1991, tracks were extended to the Balboa Park BART station and Metro Center (light rail maintenance and operations base). The extension was initially used for J line light rail vehicles starting or ending their runs. All-day J line service was extended to Balboa Park station on June 19, 1993.

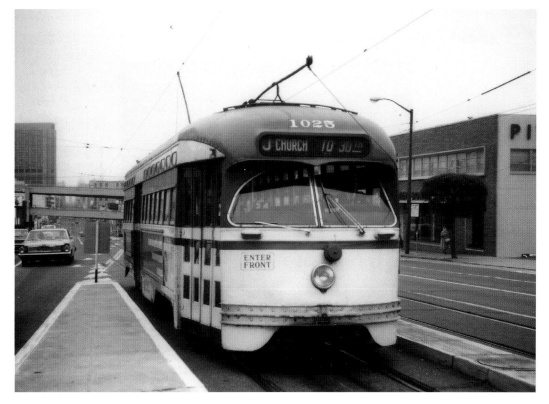

San Francisco Municipal Railway PCC car No. 1025 is on route J on Market Street on August 8, 1967. This was one of 25 PCC cars built by the St. Louis Car Company, numbered 1016 to 1040 and delivered in October and November, 1951. Seating 58 and weighing 37,600 pounds, the 46.46 foot long by 9 foot wide cars were powered by four Westinghouse type 1432 motors.

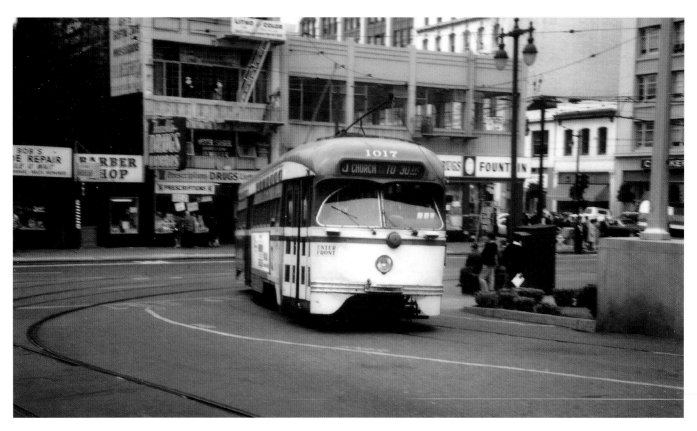

Route J PCC car No. 1017 was built by the St. Louis Car Company in 1951 and is in downtown San Francisco, turning into the East Bay Terminal on August 9, 1967.

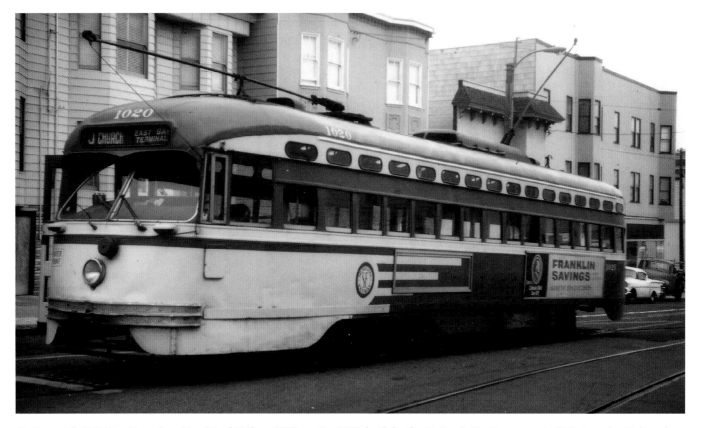

On August 8, 1967, San Francisco Municipal Railway PCC car No. 1020, built by the St. Louis Car Company in 1951, is at the 30th and Church terminus of route J.

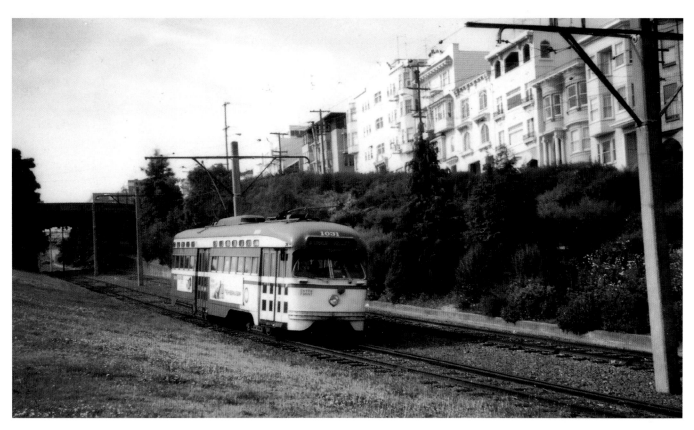

The private right of way of route J, on August 8, 1977, is the location of San Francisco Municipal Railway PCC car No. 1031, which was built by the St. Louis Car Company in 1951.

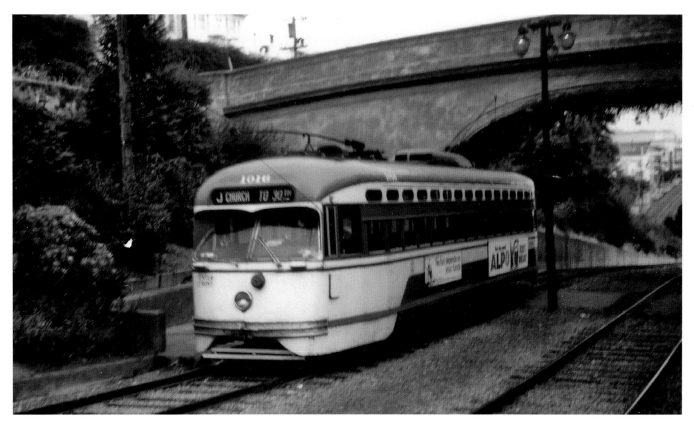

Southbound route J PCC car No. 1016 quickly passes through Mission Dolores Park on August 8, 1967. The first of the 25 new PCC cars in the number series 1016 to 1040 (built by the St. Louis Car Company at a cost of $34,940 per car) arrived on October 24, 1951.

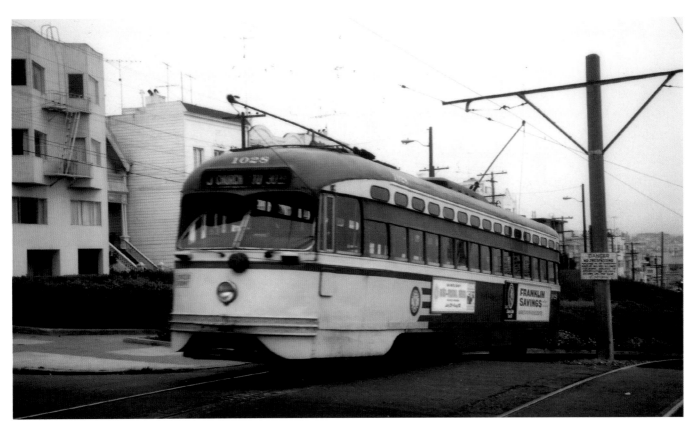

Route J San Francisco Municipal Railway PCC car No. 1028, built by the St. Louis Car Company in 1951, has left the private right of way of Mission Dolores Park and is now back on Church Street on August 8, 1967.

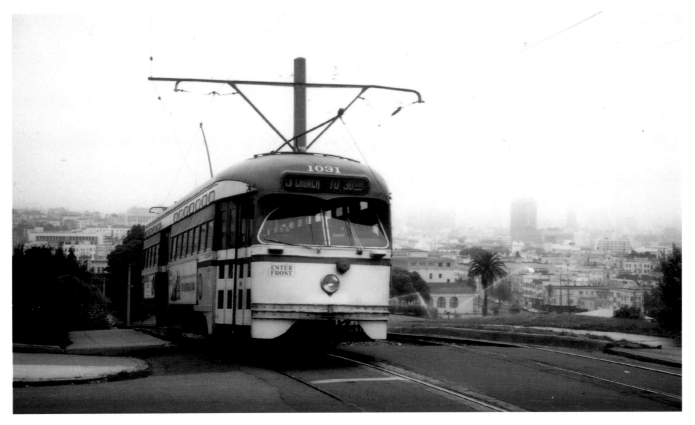

Built by the St. Louis Car Company in 1951, PCC car No. 1031 is on the most scenic part of the San Francisco Municipal Railway at Mission Dolores Park on August 8, 1967.

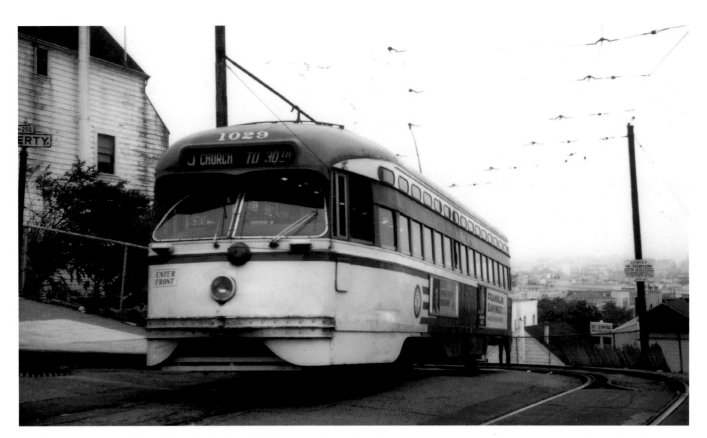

Southbound route J PCC car No. 1029, built in 1951 by the St. Louis Car Company, is coming off the private right of way through Mission Dolores Park onto Church Street at the intersection with Liberty Street on August 8, 1967.

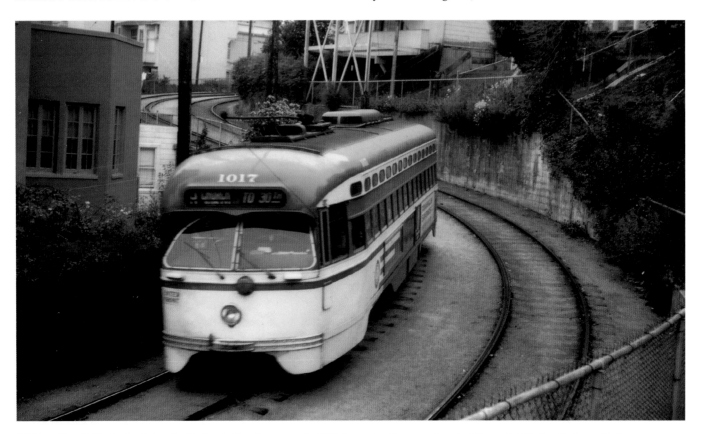

PCC car No. 1017, also built by the St. Louis Car Company in 1951, is on the S curve of route J through Mission Dolores Park on August 8, 1967.

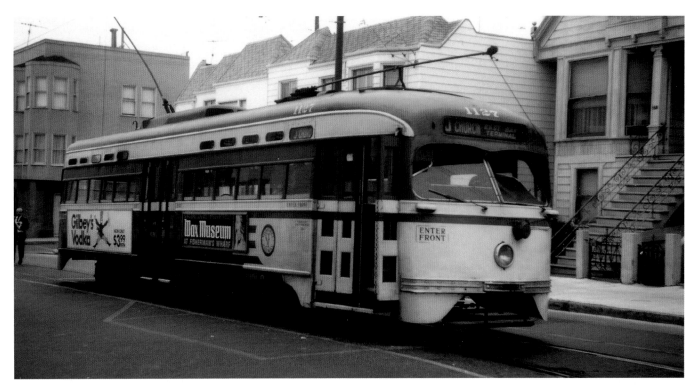

At the 30th and Church terminus of route J, PCC car No. 1127 (originally built in 1946 by the St. Louis Car Company as car No. 1705 for the St. Louis Public Service Company) is awaiting departure time on August 8, 1967. This was one of 80 PCC cars, numbered 1700 to 1779, that were delivered between September and November, 1946. The San Francisco Municipal Railway leased 66 of these cars in 1957 (renumbered 1101 to 1166) and purchased them in 1964. Four additional PCC cars, renumbered 1167 to 1170, were leased from the St. Louis Public Service Company in 1962 and were purchased two years later. Weighing 36,420 pounds and seating 55, the cars were 46 feet long by 9 feet wide.

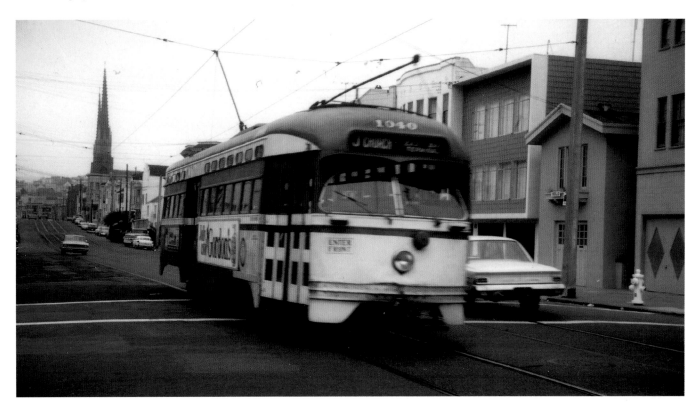

Route J PCC car No. 1040 is at Church and 30th Streets ready to enter the Y to reverse direction for the next trip to downtown San Francisco on August 8, 1967. This car was briefly used on the route B Geary line but spent most of its career on routes J, K, L, M, and N.

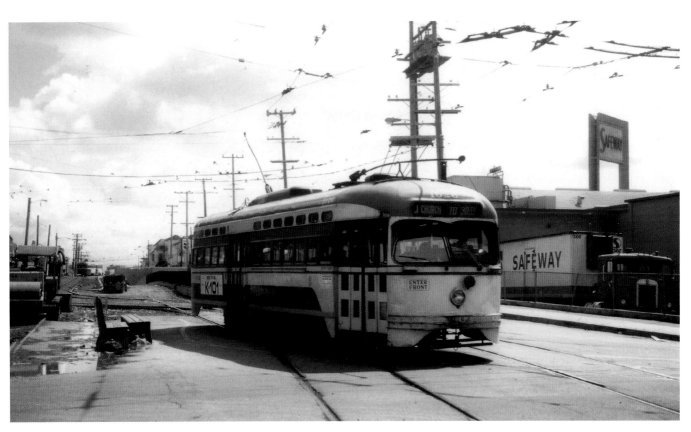

Built by the St. Louis Car Company in 1951, PCC car No. 1026 is on Duboce Avenue turning onto Church Street for a route J trip to 30th and Church Streets on April 3, 1975.

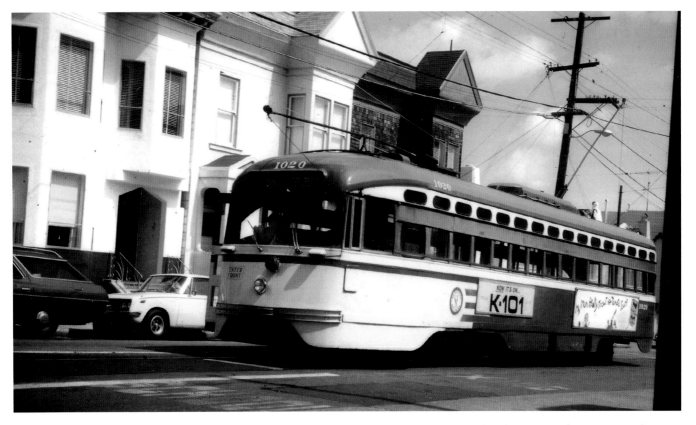

PCC car No. 1020 was also built by the St. Louis Car Company in 1951 and is seen at the 30th and Church terminus of route J on April 3, 1975.

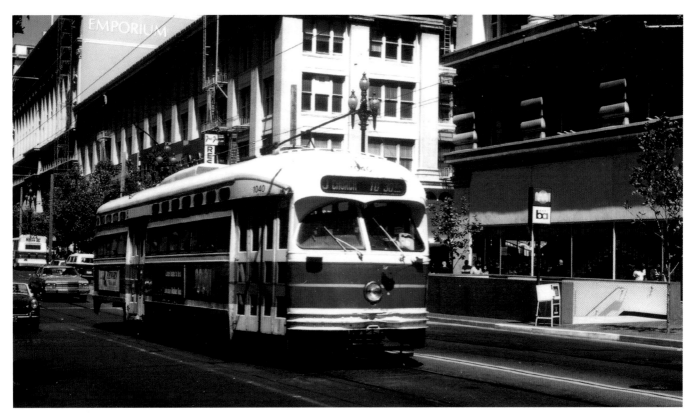

Market Street is the scene for PCC car No. 1040 operating on route J on July 18, 1981. Since this car was the last PCC car produced in the United States, it received special attention including a special white, orange, and yellow paint scheme designed by William Landor and Associates, a San Francisco industrial design firm.

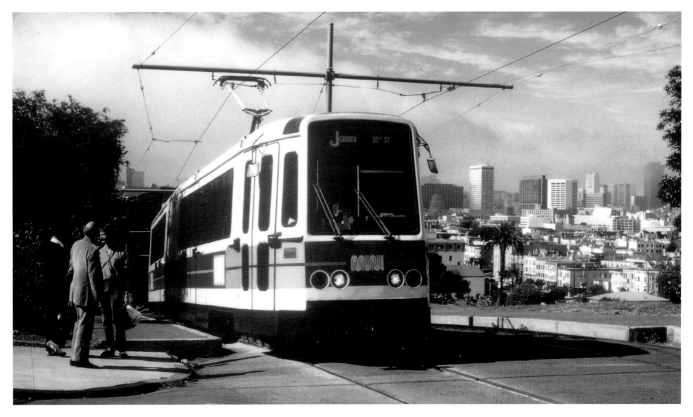

On July 22, 1981, with the San Francisco skyline in the background, route J articulated light rail vehicle No. 1232, built by Boeing Vertol, is at a passenger stop on the private right of way portion of the line.

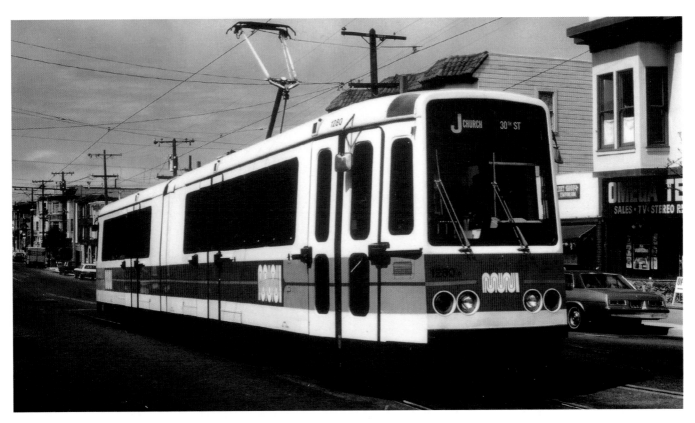

Boeing Vertol articulated light rail vehicle No. 1280 is operating on route J along Church Street on July 22, 1981.

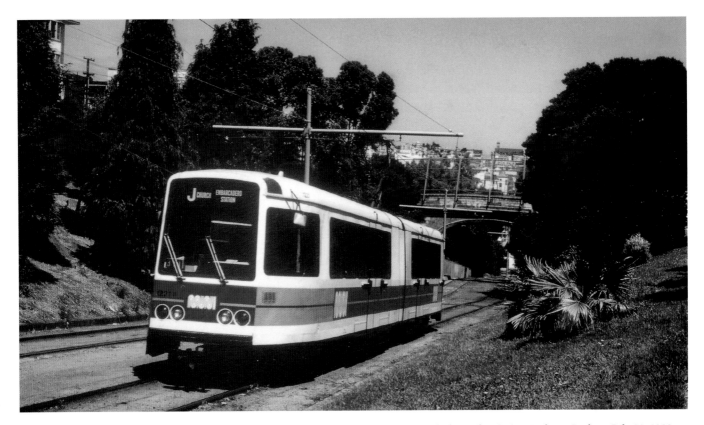

Route J articulated light rail vehicle No. 1221, built by Boeing Vertol, is heading north through Mission Dolores Park on July 22, 1983.

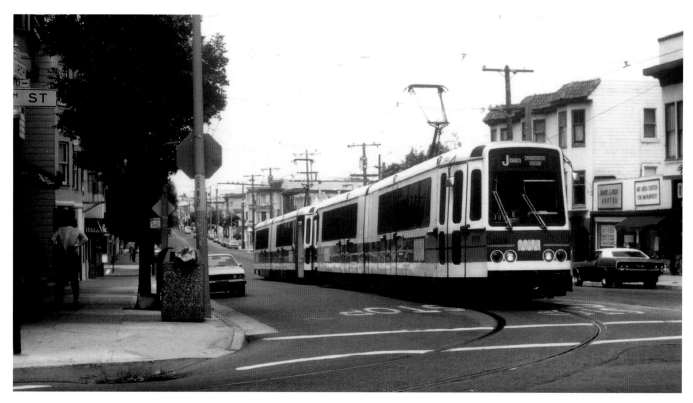

On July 24, 1983, articulated light rail vehicle No. 1237 is in a two-car train at the Church and 30th terminus of route J.

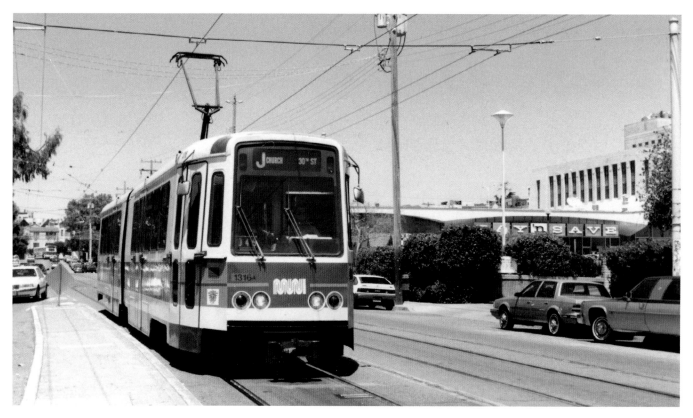

Route J articulated light rail vehicle No. 1316, built by Boeing Vertol, is on Church Street for a passenger stop at Market Street on July 17, 1988.

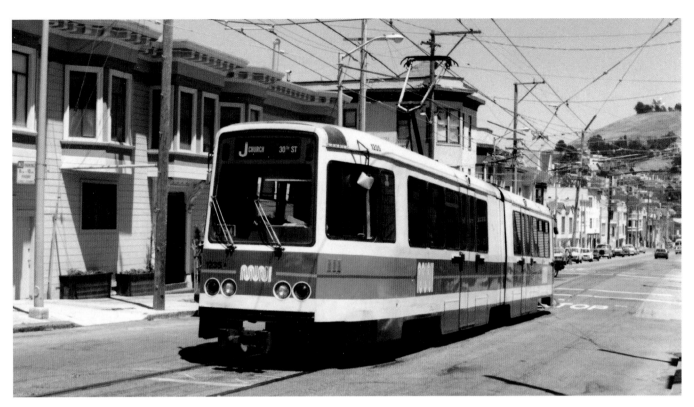

On July 17, 1988, route J articulated light rail vehicle No. 1235 is on 30th Street where it will reverse on the Y back to Church Street. The separate double wires are for the route 24 Divisadero trolley coach line. From 1996, the San Francisco Municipal Railway began replacing the Boeing Vertol light rail vehicles with new vehicles built by AnsaldoBreda.

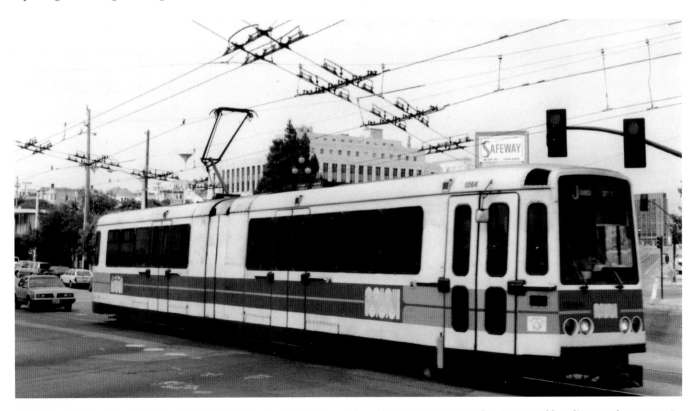

Articulated light rail vehicle No. 1264, built by Boeing Vertol, is on Church Street crossing Market Street and heading south on route J to 30th Street on July 27, 1991. The double wire parallel to the light rail vehicle on Church is for trolley coach route 22; the double wire that was on Market Street was used by route 8 trolley coach line until January, 1996 when it was replaced by the route F streetcar line. Church and Market is the only intersection in San Francisco where two streetcar lines cross.

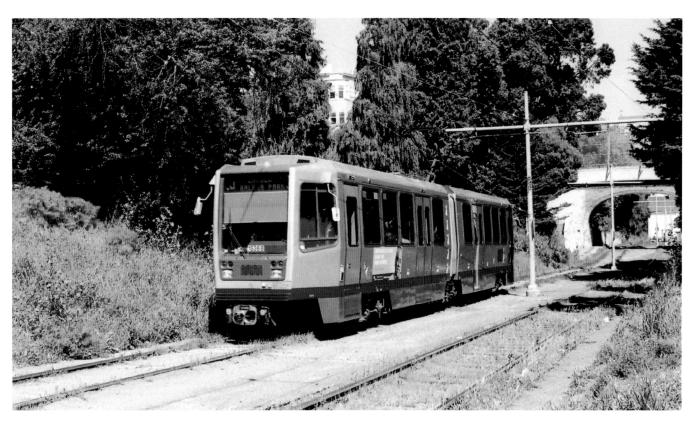

On April 6, 2011, articulated light rail vehicle No. 1536, built by AnsaldoBreda, is operating a route J trip through Mission Dolores Park. There were 151 new light rail vehicles built by AnsaldoBreda, numbered 1400 to 1550 and completed during 2003.

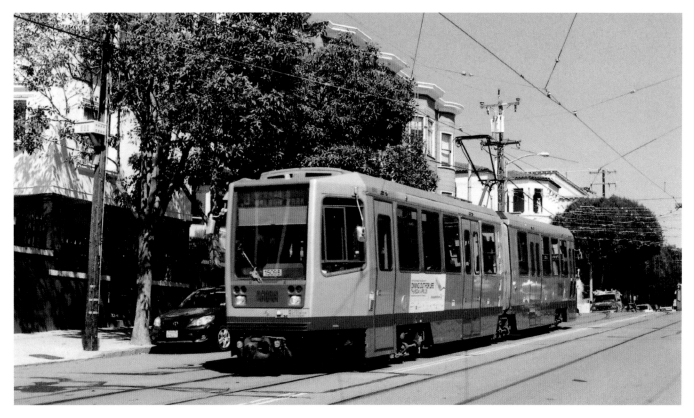

Southbound route J articulated light rail vehicle No. 1509 is at Church and 18th Streets on April 6, 2011. In addition to the regular routes J, K/T, L, M, and N, there is a Castro Shuttle that operates a limited number of peak period trips between Embarcadero station and St. Francis Circle according to the May 19, 2014 schedule.

Chapter 3

K/T Ingleside/Third Line

From Sunnydale station the T Third Street light rail line operates via Bayshore, 3rd, Channel, 4th, King, Embarcadero, the Market Street subway to Embarcadero station (where the head sign changes to K Ingleside) continuing via the Twin Peaks tunnel, West Portal Avenue, Junipero Serra, Ocean Avenue, and San Jose Avenue to Geneva (Balboa Park station). Inbound, the line operates as route K from Balboa Park station via San Jose Avenue, Ocean Avenue, Junipero Serra, West Portal Avenue to West Portal station (where the head sign changes to T Third Street) continuing via the Twin Peaks tunnel, the Market Street subway, Embarcadero, King, 4th, Channel, 3rd, and Bayshore to Sunnydale station.

On February 3, 1918, route K began operating from Pine on Van Ness to Market through the Twin Peaks tunnel to St. Francis Circle. Effective June 1, 1918, the Ferry Loop became the downtown terminal. On January 1, 1941, the downtown terminus became the East Bay Terminal for all route K cars. The outer terminal was extended to the new Phelan loop at Phelan and Ocean on May 18, 1952. Beginning April 23, 1979, the new Boeing Vertol light rail vehicles operated a shuttle service from West Portal to the Balboa Park BART station, and from December 17, 1980, the K line operated weekdays with light rail vehicles from Embarcadero station to Balboa Park. Weekend service continued with PCC cars until September 20, 1982 when full light rail vehicle service was inaugurated.

Replacing the route 15 bus line, route T began full service on April 7, 2007 operating on new trackage along 3rd Street and Bayshore Boulevard. Effective June 30, 2007, the T Third and K Ingleside operated as one route from Balboa through downtown to Bayshore and Sunnydale. At West Portal station, inbound K trains heading through downtown to 3rd Street change their signs to the T line. Trains from the T line that are outbound to Ingleside change their signs to the K line at Embarcadero station.

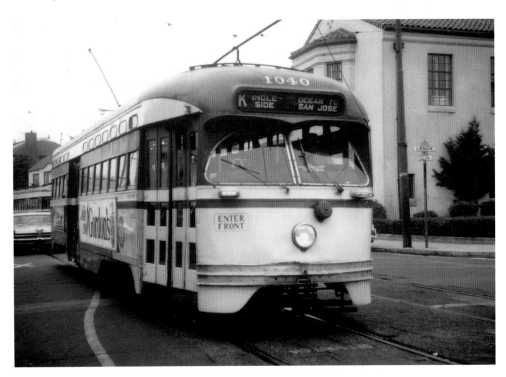

On August 8, 1967, route K PCC car No. 1040 (the last PCC car built in the United States by the St. Louis Car Company) is on Ulloa Street at Lenox Way near the entrance to the West Portal tunnel where streetcar routes K, L, and M come together. Ulloa Street trackage is normally used by route L.

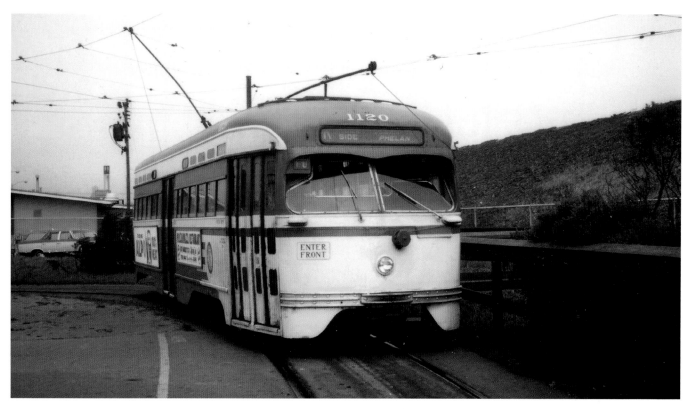

Route K PCC car No. 1120, originally built in 1946 by the St. Louis Car Company as car No. 1724 for the St. Louis Public Service Company, is at the Ingleside loop on August 8, 1967. The first of the PCC cars purchased from the St. Louis Public Service Company arrived in San Francisco on July 8, 1957 and were renumbered in the 1100 series, beginning with 1101.

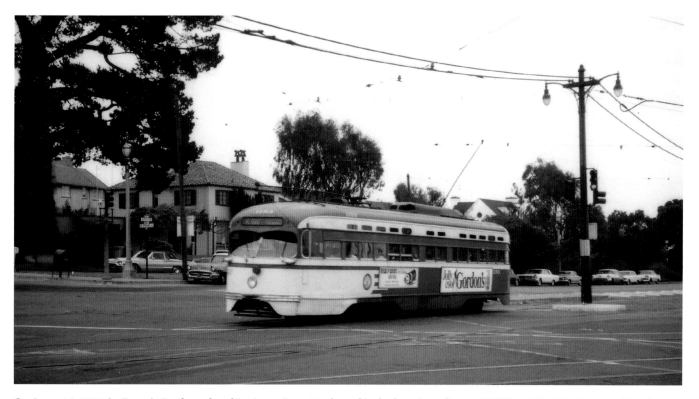

On August 8, 1967, St. Francis Boulevard and Junipero Serra Boulevard is the location of route K PCC car No. 1133. It was originally built in 1946 by the St. Louis Car Company as car No. 1735 for the St. Louis Public Service Company.

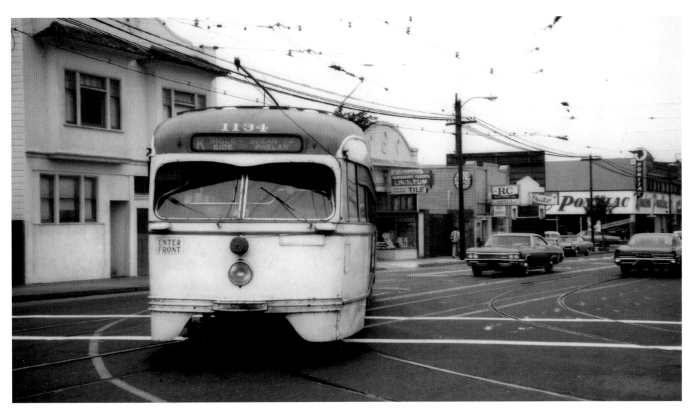

Route K PCC car No. 1134, built in 1946 by the St. Louis Car Company as car No. 1748 for the St. Louis Public Service Company, is turning from Ocean Avenue into the Ingleside loop on August 8, 1967.

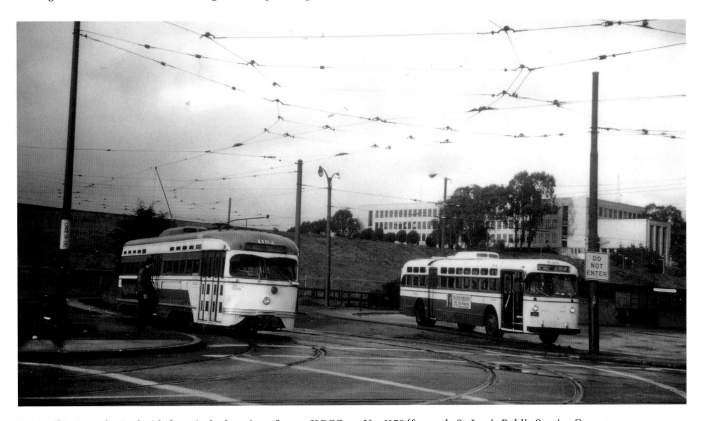

On April 4, 1975, the Ingleside loop is the location of route K PCC car No. 1152 (formerly St. Louis Public Service Company car No. 1750, built in 1946) and route 12 trolley coach No. 748 (one of 110 model TC48 trolley coaches seating 48 and built by Marmon-Herrington). These trolley coaches were delivered during 1950-51, with numbers 740 to 789 General Electric equipped and numbers 790 to 849 Westinghouse equipped.

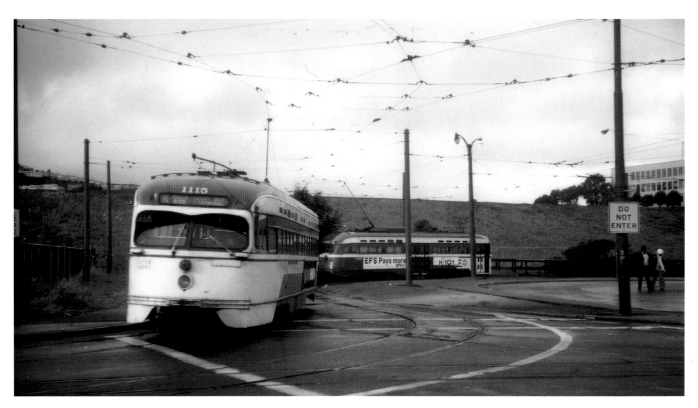

On a rainy April 4, 1975, route K PCC car No. 1115, built in 1946 by the St. Louis Car Company as car No. 1703 for the St. Louis Public Service Company, is seen leaving the Ingleside loop.

PCC car No. 1189 (former Toronto Transit Commission car No. 4777) is handling a route K run on Market Street on April 3, 1975. This was one of 11 PCC cars built by the St. Louis Car Company (ten in 1946 and one in 1947) for the Kansas City Public Service Company and sold to the Toronto Transit Commission in 1957. The San Francisco Municipal Railway purchased these cars in 1974, renumbering them 1180 to 1190. Nine were scrapped in 1979, and car No. 1183 was acquired by a museum in 1980.

On a busy April 2, 1975, route K car No. 1007 is westbound on Market Street. This PCC car was built by the St. Louis Car Company in 1948. Market Street is a major thoroughfare in downtown San Francisco that begins at the Embarcadero in front of the Ferry Building and runs about 3 miles, passing the Financial District, Civic Center, Castro District, and ending in the Twin Peaks neighborhood.

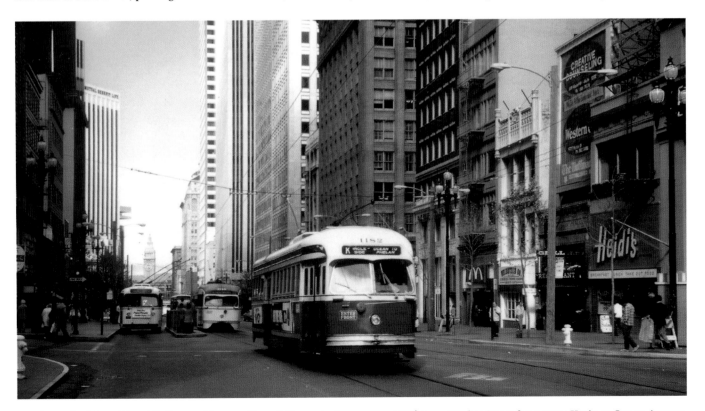

Westbound PCC car No. 1182 (former Toronto Transit Commission car No. 4758) is on Market Street for a route K trip to Ocean Avenue and Phelan Avenue on April 2, 1975. This streetcar, one of 11 purchased second hand from the Toronto Transit Commission in 1974, was briefly used in San Francisco retaining its Toronto maroon and cream paint scheme. It had originally been built by the St. Louis Car Company for the Kansas City Public Service Company.

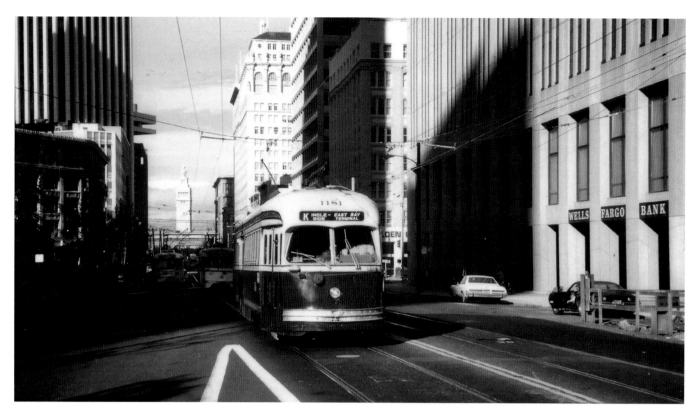

On April 2, 1975, route K PCC car No. 1181 (former Toronto Transit Commission car No. 4757) is proceeding west on Market Street in downtown San Francisco. Originally built by the St. Louis Car Company for the Kansas City Public Service Company, this car later operated in Toronto and retained its former Toronto Transit Commission paint scheme except that the lower panel was repainted red.

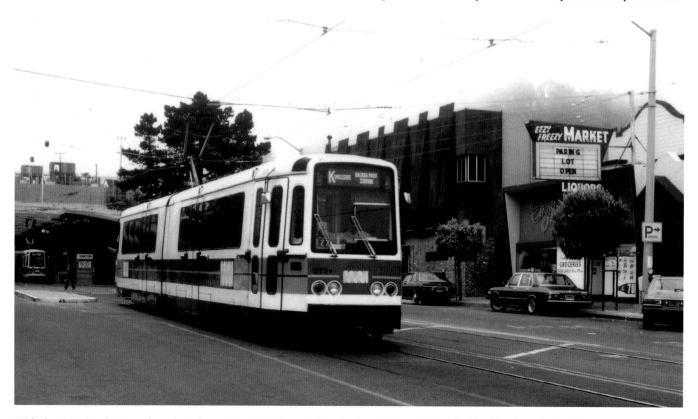

With the Twin Peaks tunnel on the left, on July 21, 1981, route K articulated light rail vehicle No. 1273, built by Boeing Vertol, is on West Portal Avenue on its way to the Ingleside neighborhood (in the southwestern part of San Francisco), bordered on the north by Ocean Avenue, Ashton Avenue on the west, Lakeview Avenue on the south, and Interstate 280 on the east.

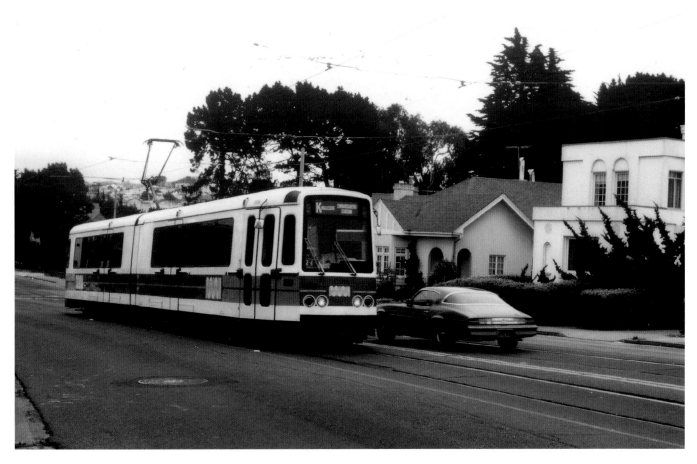

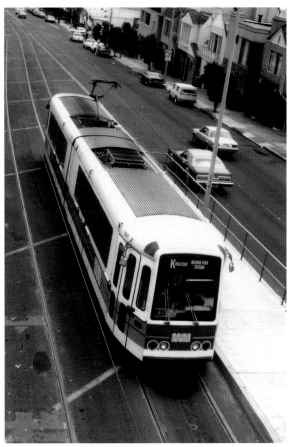

Above: Route K articulated light rail vehicle No. 1209, built by Boeing Vertol, is seen passing through a picturesque residential area on July 21, 1981.

Right: On July 23, 1981, having passed under a pedestrian bridge, Boeing Vertol articulated light rail vehicle No. 1247 is on route K at Ocean Avenue.

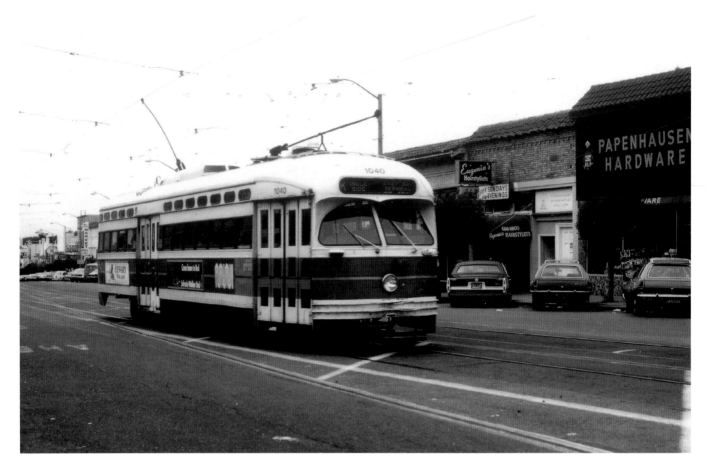

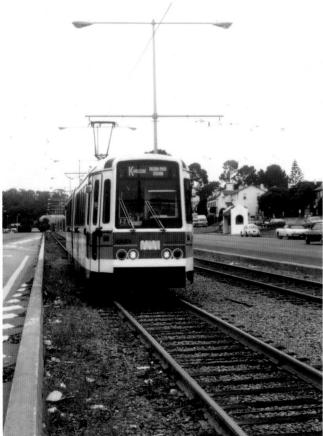

Above: On West Portal Avenue between Ulloa and Vicente Streets just west of West Portal tunnel station on July 18, 1981, route K PCC car No. 1040 is passing Papenhausen Hardware store, a typical local store, which has been on West Portal Avenue since 1936.

Left: Route K articulated light Rail vehicle No. 1212, built by Boeing Vertol, is on the reserved right of way on its way to Balboa Park station on July 21, 1981.

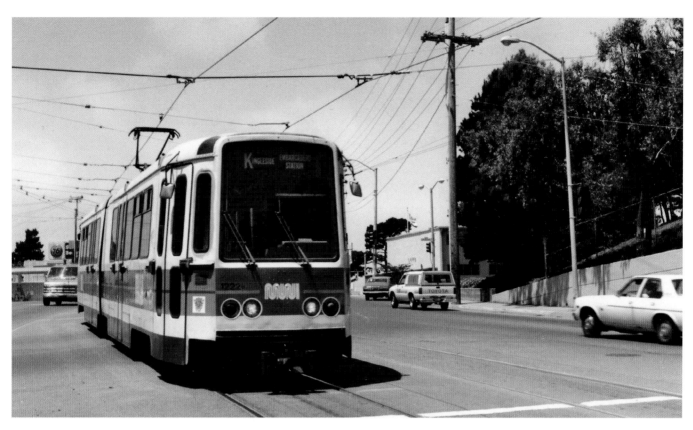

On a sunny July 20, 1988, route K articulated light rail vehicle No. 1222, built by Boeing Vertol, is traversing Ocean Avenue on its trip to Balboa Park station.

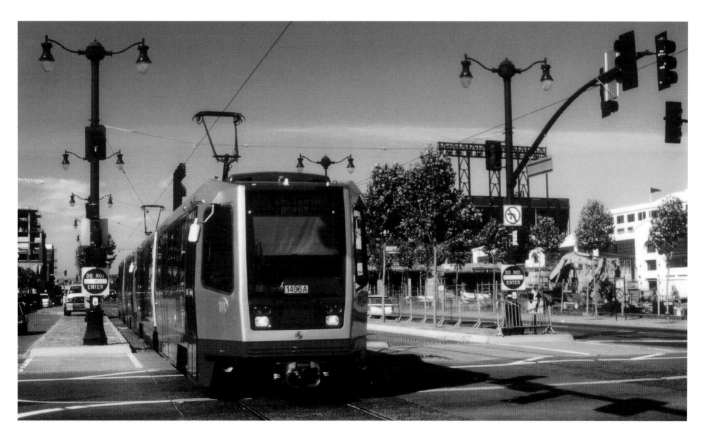

Light rail vehicle No. 1496, built by AnsaldoBreda, is at 4th and King Streets on June 29, 2001. Route T Third and K Ingleside operate as one route from Balboa through downtown to Bayshore and Sunnydale.

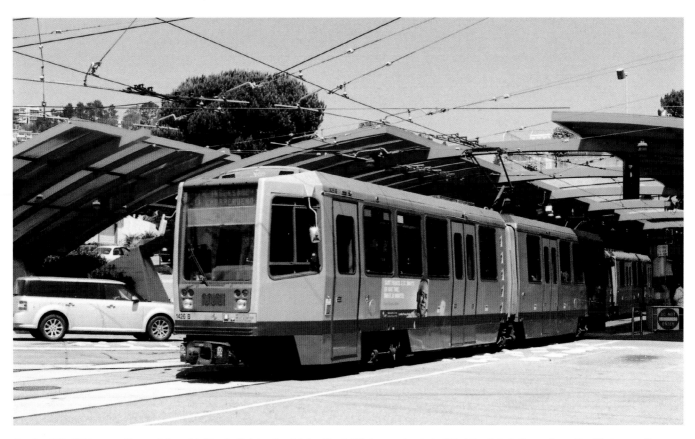

On April 6, 2011 an eastbound AnsaldoBreda light rail vehicle, No. 1426, is coming into West Portal station where it will change its route sign from K to T.

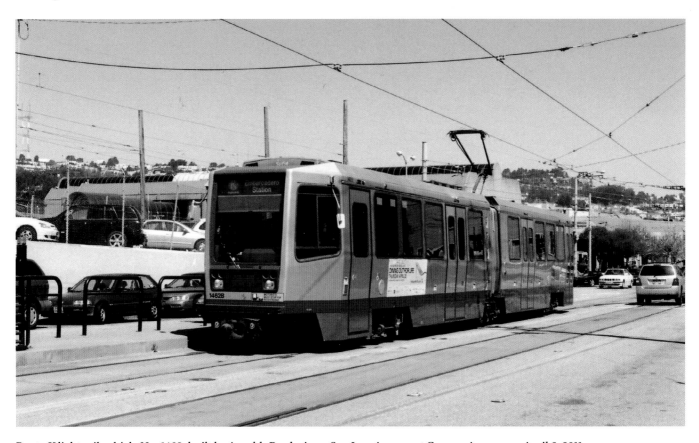

Route K light rail vehicle No. 1462, built by AnsaldoBreda, is on San Jose Avenue at Geneva Avenue on April 6, 2011.

Chapter 4

L Taraval Line

Outbound, the L Taraval light rail line operates from Embarcadero station via the Market Street subway and the Twin Peaks tunnel to West Portal station, then via Ulloa, 15th Avenue, Taraval, 46th Avenue, Vicente, 47th Avenue, and Wawona to 46th Avenue. Inbound, the L Taraval line operates via Wawona, 46th Avenue, Taraval, 15th Avenue, and Ulloa to West Portal station, then via the Twin Peaks tunnel and the Market Street subway to Embarcadero station.

The line opened on April 12, 1919 from West Portal to Taraval Street at 33rd Avenue. On January 14, 1923, it was extended on Taraval from 33rd to 48th Avenue. The L line worked as a shuttle from West Portal until October 15, 1923 when it was extended through the Twin Peaks tunnel and Market Street to the downtown Ferry Loop. It reached the current Zoo loop (46th Avenue, Vicente, 47th Avenue, Wawona, 46th Avenue, and back to Taraval) on September 15, 1937.

While many San Francisco streetcar lines were converted to trolley coach and bus operation after World War II, the L line remained as a streetcar line because of its use of the Twin Peaks tunnel. On June 6, 1948, the downtown loop was changed to the East Bay Terminal.

Monday to Friday service using the new light rail vehicles in the subway began on December 17, 1980, with weekend service using PCC cars. Between June 11 and December 16, 1980 the L line operated as a K-L shuttle (created by combining the outer ends of the L and K lines) using PCC cars which connected with the Boeing Vertol light rail vehicles at West Portal station. Beginning December 17, 1980, route L had full weekday operation with light rail vehicles into the subway, PCC cars operating on the route only on weekends. On September 20, 1982, regular PCC car service ended and all service was by light rail vehicles.

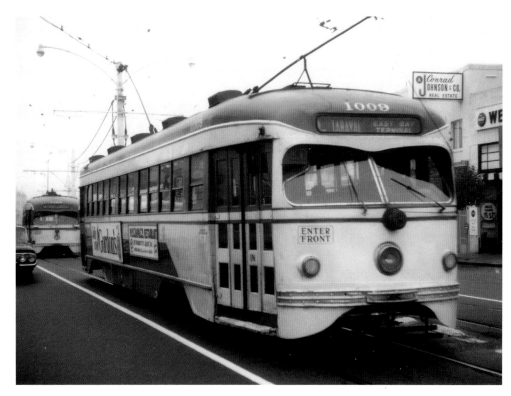

On August 8, 1967, West Portal Avenue just west of West Portal station is the location of streetcar No. 1009, a type D PCC car built by the St. Louis Car Company, signed route L, followed by an 1100 series PCC car (formerly a St. Louis Public Service 1700 series PCC car built by the St. Louis Car Company).

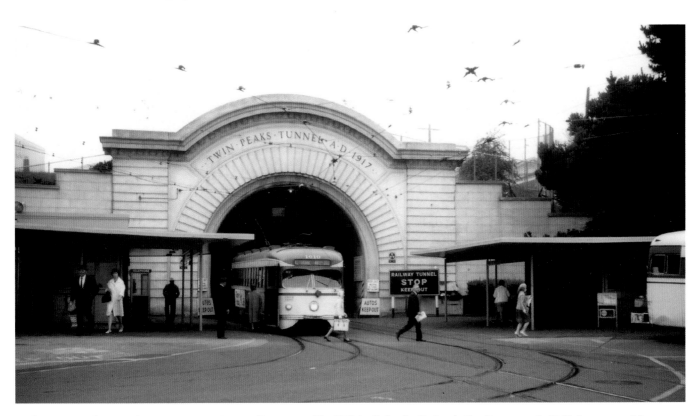

At the Twin Peaks tunnel on August 8, 1967, type D streetcar No. 1010, built by the St. Louis Car Company in 1948, has paused for a passenger stop on a westbound run on route L. The 2.27 mile tunnel runs under the Twin Peaks that are hills, which have elevations of 904 and 922 feet. In 1967, this tunnel was used by streetcar routes J, K, L, M, and N.

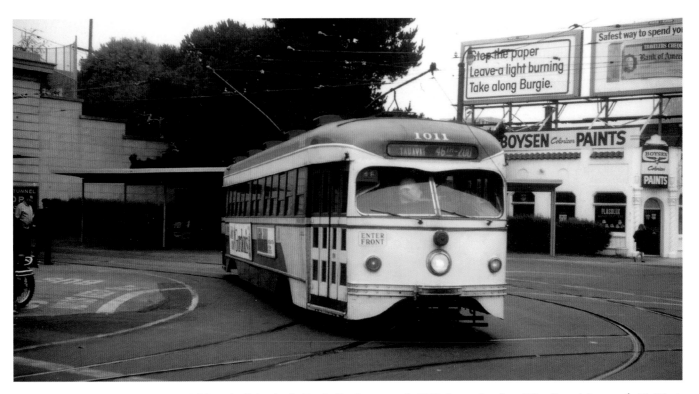

Route L streetcar No. 1011, a type D PCC car built by the St. Louis Car Company in 1948, is turning from West Portal Avenue (with West Portal station on the left) onto Ulloa Avenue on August 8, 1967.

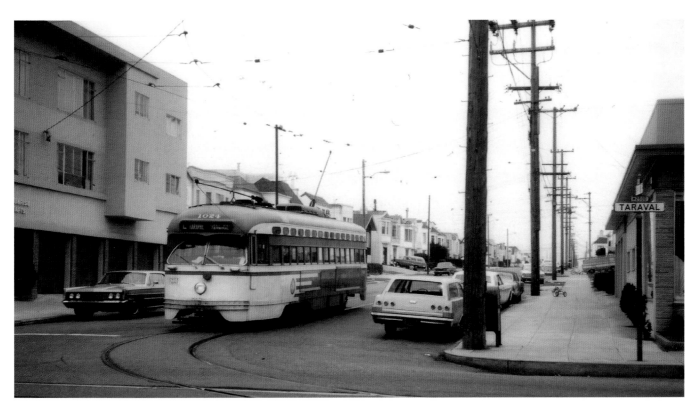

In this residential area, route L PCC car No. 1024, built by the St. Louis Car Company in 1951, is ready to turn onto Taraval Street on August 8, 1967.

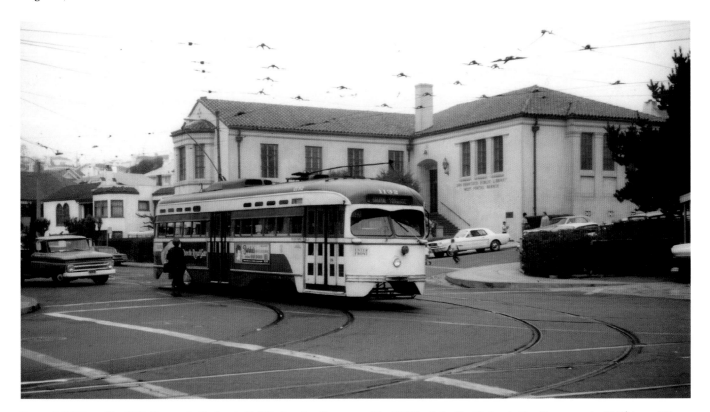

Route L PCC car No. 1132 (formerly St. Louis Public Service Company No. 1755 built by the St. Louis Car Company in 1946) is on Ulloa Street at Lenox Way, passing by San Francisco's West Portal Branch Library on August 8, 1967. Designed by architect Frederick H. Meyer and constructed by the Works Progress Administration at a cost of $108,000, this beautiful library was dedicated on Sunday May 7, 1939 and features red ceramic roof tiles in a Mediterranean style. Three light rail (streetcar) lines converge at the nearby Twin Peaks tunnel, which makes the library easy to reach by public transportation.

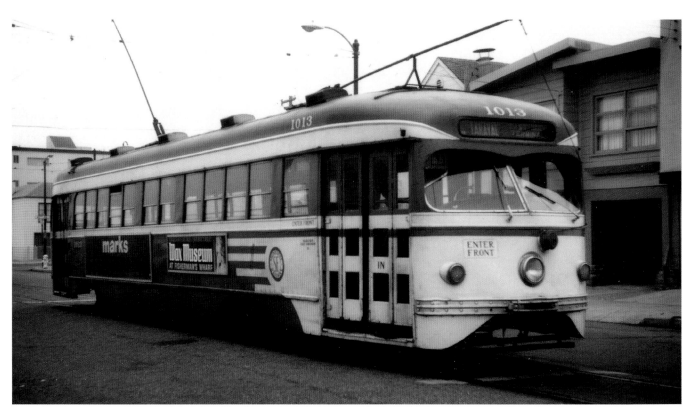

On August 8, 1967, route L streetcar No. 1013, a type D PCC car built by the St. Louis Car Company in 1948, is at the San Francisco Zoo end of the line on 47th Avenue at Wawona Street awaiting departure time.

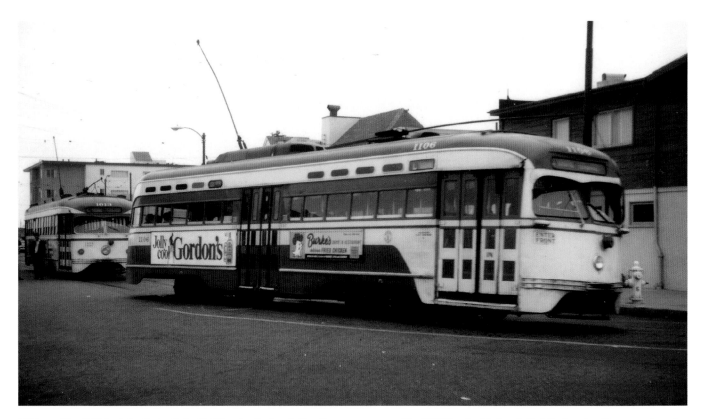

PCC car No. 1106 (originally built in 1946 by the St. Louis Car Company as car No. 1733 for the St. Louis Public Service Company) and type D PCC car No. 1013 (built in 1948 by the St. Louis Car Company) are at the San Francisco Zoo end of route L on Wawona Street between 47th Avenue and 46th Avenue on August 8, 1967.

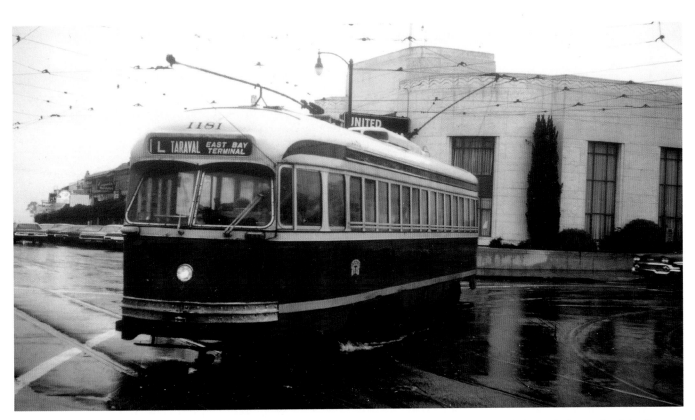

On a rainy April 4, 1975, route L PCC car No. 1181 (purchased as car No. 4757 from the Toronto Transit Commission and originally built in 1946 by the St. Louis Car Company for the Kansas City Public Service Company) is turning from Ulloa Street onto West Portal Avenue just west of West Portal station and the Twin Peaks tunnel.

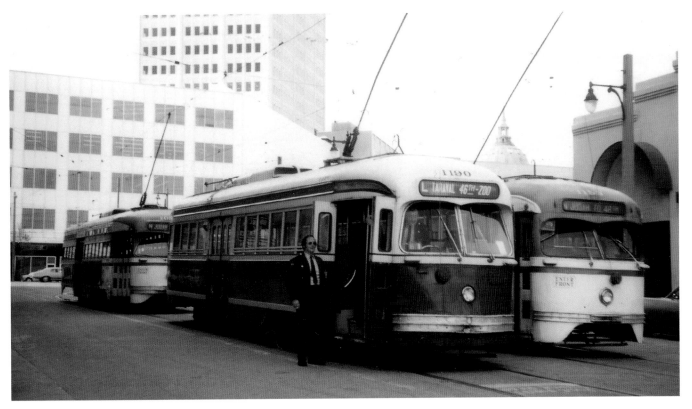

PCC car No. 1190 was purchased as car No. 4752 from the Toronto Transit Commission and was originally built in 1947 by the St. Louis Car Company for the Kansas City Public Service Company. It is signed for route L at the 11th and Market Streets layover point on April 3, 1975.

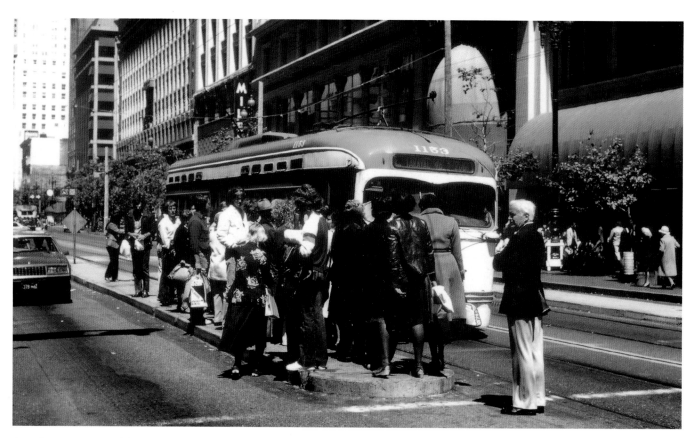

On July 18, 1981, a rush hour crowd greets route L PCC car No. 1153, built in 1946 by the St. Louis Car Company as car No. 1742 for the St. Louis Public Service Company, on a Market Street traffic island.

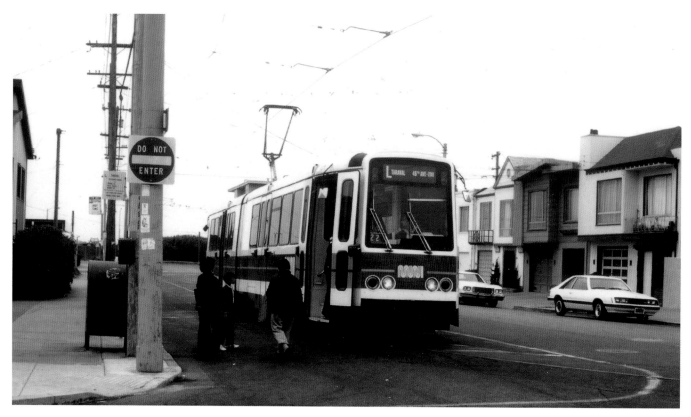

Light rail vehicle No. 1277, built by Boeing Vertol, is at the 46th Avenue and Wawona Street terminus of route L on July 21, 1981.

Boeing Vertol articulated light rail vehicle No. 1216 is eastbound on route L on July 21, 1981 at Taraval Street crossing 25th Avenue.

On Taraval Street crossing 32nd Avenue, eastbound articulated light rail vehicle No. 1295, built by Boeing Vertol, is signed "NO PASSENGERS – NOT IN SERVICE" as it travels along route L on July 21, 1981.

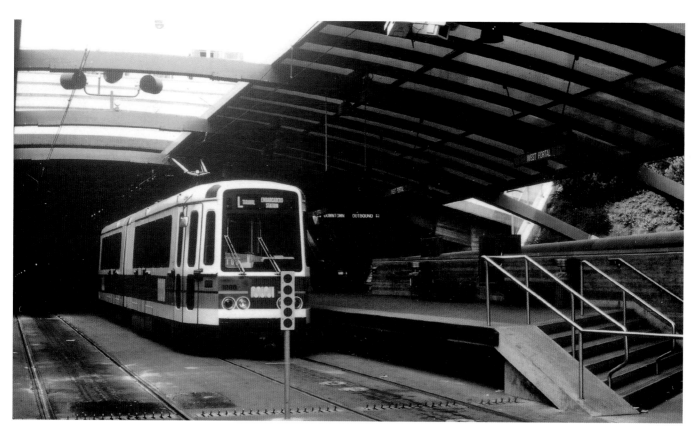

On July 21, 1981, route L articulated light rail vehicle No. 1296, built by Boeing Vertol, is at West Portal station and will shortly enter the Twin Peaks tunnel and the Market Street subway on its eastbound trip to Embarcadero station.

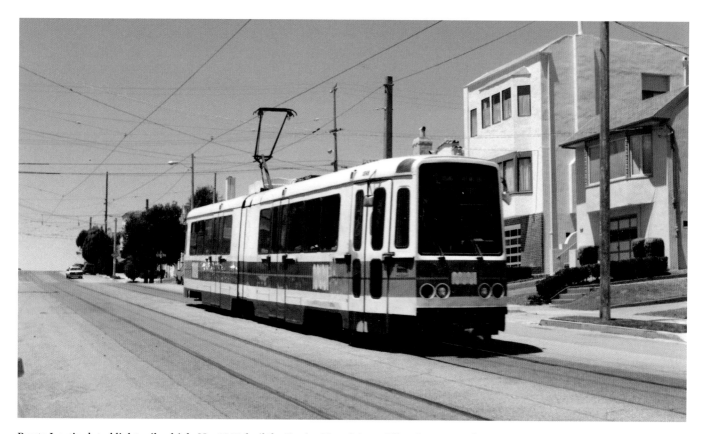

Route L articulated light rail vehicle No. 1245, built by Boeing Vertol, is on Ulloa Street at 15th Avenue on July 17, 1988.

On Taraval Street crossing 19th Avenue, Boeing Vertol articulated light rail vehicle No. 1296 is eastbound on route L for Embarcadero station in downtown San Francisco on July 27, 1991.

At the route L terminus on 47th Avenue at Wawona Street on July 27, 1991, articulated light rail vehicle No. 1316, built by Boeing Vertol, is awaiting departure time.

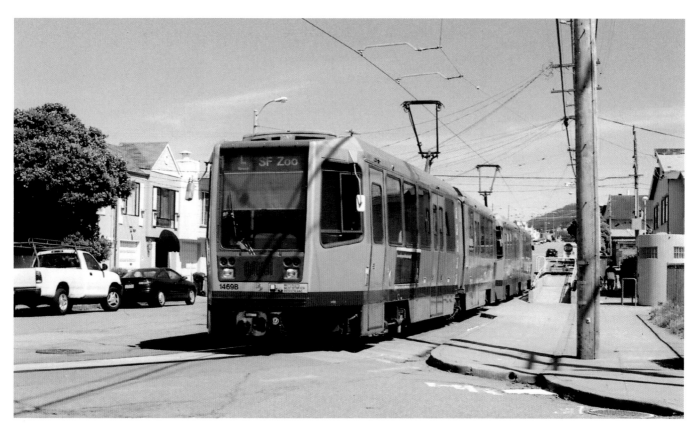

On April 4, 2011 at 46th Avenue and Wawona Street, the two-car route L train, with articulated AnsaldoBreda light rail vehicle No. 1469 at the rear, will shortly leave for downtown San Francisco.

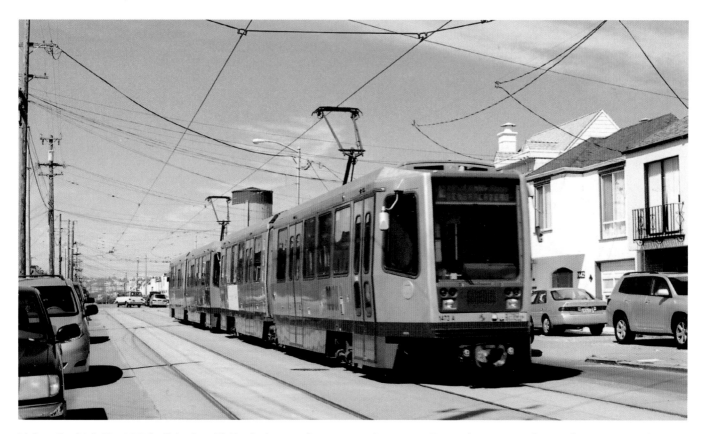

Light rail vehicle No. 1473, built by AnsaldoBreda, is part of a two-car train on route L at 46th Avenue and Taraval Street on April 4, 2011.

M Ocean View Line

Outbound, the M Ocean View light rail line operates from Embarcadero station via the Market Street subway and Twin Peaks tunnel to West Portal station, then via West Portal Avenue, private right of way, 19th Avenue, Randolph, Orizaba, Broad, and San Jose Avenue to Geneva (Balboa Park station). Inbound, route M operates from Balboa Park station via San Jose Avenue, Broad, Orizaba, Randolph, 19th Avenue, private right of way, West Portal Avenue to West Portal station, then via the Twin Peaks tunnel and Market Street subway to Embarcadero station.

On October 6, 1925, route M began operating as a shuttle from West Portal of the Twin Peaks tunnel to Broad Street and Plymouth Avenue. The line was replaced by buses on August 6, 1939, because of low ridership. However, the track was kept in place, and streetcar service was reinstated on December 17, 1944. Effective June 6, 1948, the downtown terminal was changed from the Ferry Loop to the East Bay Terminal. The line was replaced by buses between January 13, 1974 and December 3, 1978 due to a rail replacement project and difficulty in meeting car requirements for the five streetcar lines, and was extended from the outer terminal at Broad and Plymouth to the Balboa Park BART station on August 30, 1980. Beginning December 17, 1980, light rail vehicles operated weekdays to Balboa Park BART, with PCC cars operating to Broad Street and Plymouth Avenue on weekends. When full daily light rail vehicle operation began on September 20, 1982, regular PCC car service ended on this line.

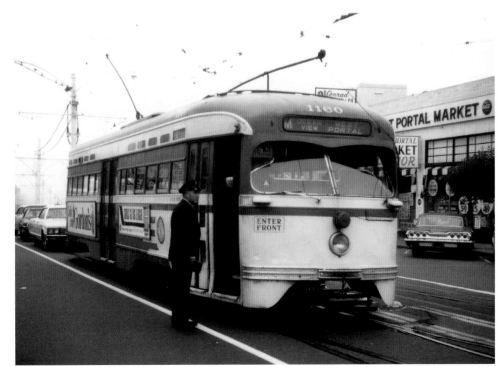

Route M PCC car No. 1160, built in 1946 by the St. Louis Car Company as car No. 1761 for the St. Louis Public Service Company, is on West Portal Avenue just west of the Twin Peaks tunnel on August 8, 1967. West Portal Avenue is the principal shopping district for the West Portal neighborhood in southwestern San Francisco.

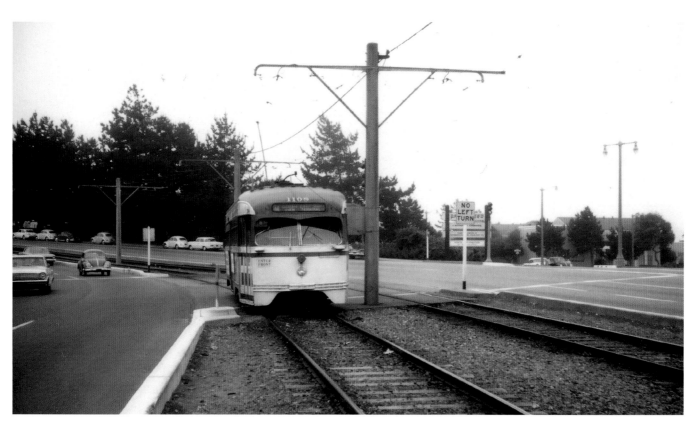

PCC car No. 1108 was originally built by the St. Louis Car Company in 1946 as car No. 1737 for the St. Louis Public Service Company. It is seen on the traffic-free center of the private right of way part of route M on August 8, 1967.

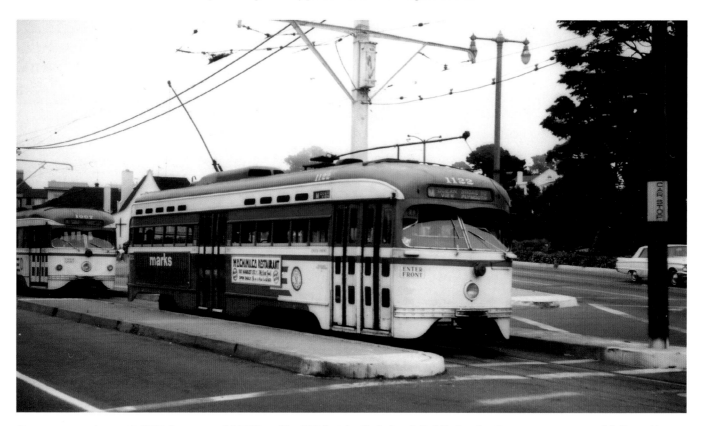

On an overcast August 8, 1967 along route M, PCC car No. 1122 (originally St. Louis Public Service Company car No. 1716) followed by car No. 1007 (type D PCC car built by the St. Louis Car Company in 1948) are heading for the Broad Street and Plymouth Avenue terminus.

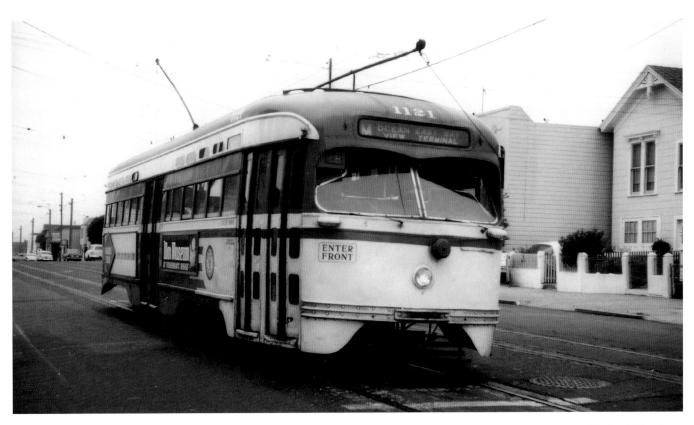

On a street-running section of route M, PCC car No. 1121, built in 1946 by the St. Louis Car Company as car No. 1713 for the St. Louis Public Service Company, is arriving at a passenger stop on August 8, 1967.

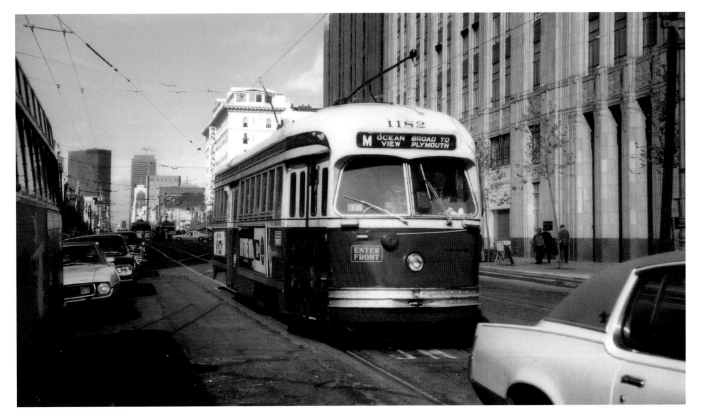

PCC car No. 1182 was originally built for the Kansas City Public Service Company in 1946, and was acquired in 1957 by the Toronto Transit Commission where it became car No. 4758. On April 4, 1975, it is westbound on Market Street for a route M trip to Broad Street and Plymouth Avenue in the Ocean View neighborhood of San Francisco.

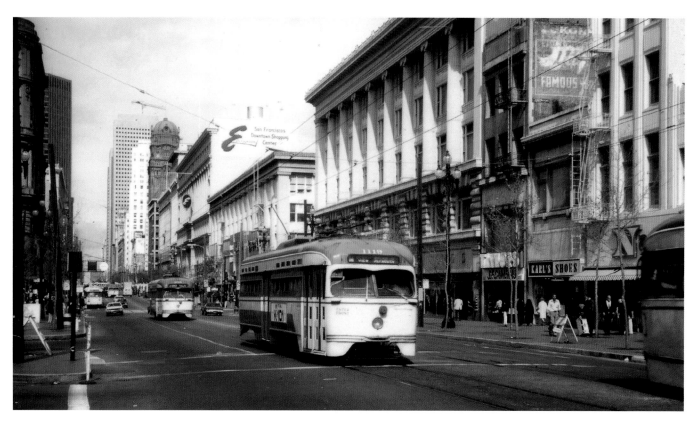

Built in 1946 by the St. Louis Car Company as car No. 1712 for the St. Louis Public Service Company, PCC car No. 1119 is handling a westbound route M trip along Market Street on April 3, 1975.

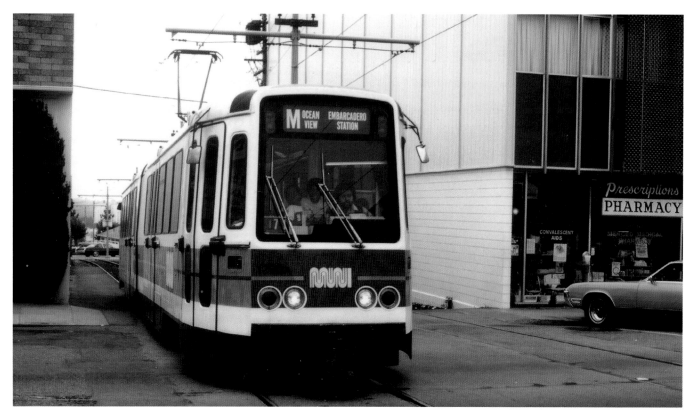

Route M articulated light rail vehicle No. 1290, built by Boeing Vertol, is on the private right of way that traverses streets at grade on July 23, 1981.

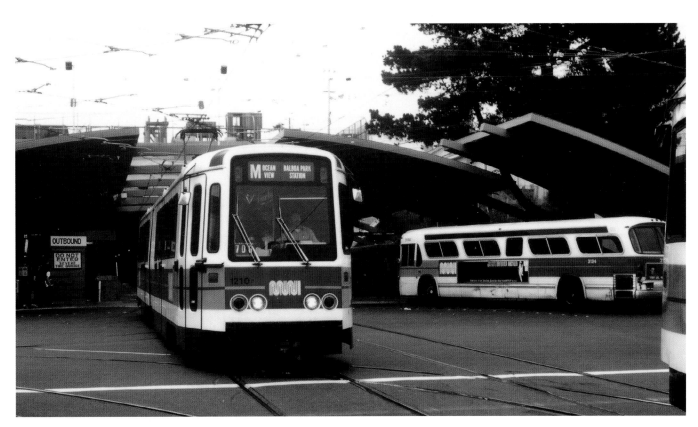

On July 21, 1981, Boeing Vertol articulated light rail vehicle No. 1210 is leaving West Portal station, at the western end of the Twin Peaks tunnel, heading for Balboa Park station on route M.

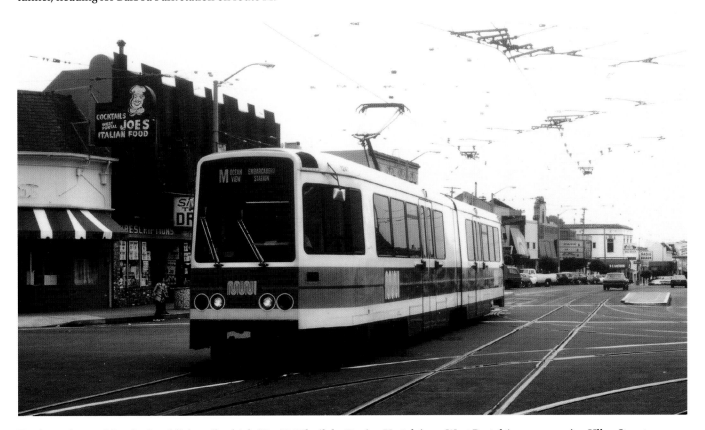

Eastbound route M articulated light rail vehicle No. 1247, built by Boeing Vertol, is on West Portal Avenue crossing Ulloa Street on July 21, 1981. It will shortly enter West Portal station and proceed through the Twin Peaks tunnel and Market Street subway to Embarcadero station in downtown San Francisco.

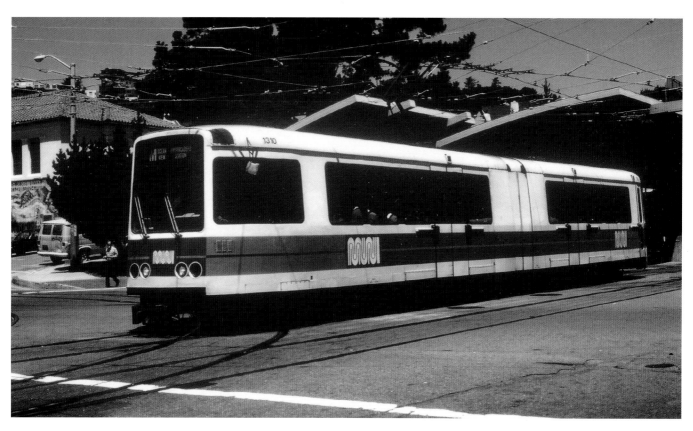

Boeing Vertol articulated light rail vehicle No. 1310 is leaving West Portal station on route M, at the western entranceway of the Twin Peaks tunnel, on West Portal Avenue crossing Ulloa Street on July 20, 1988.

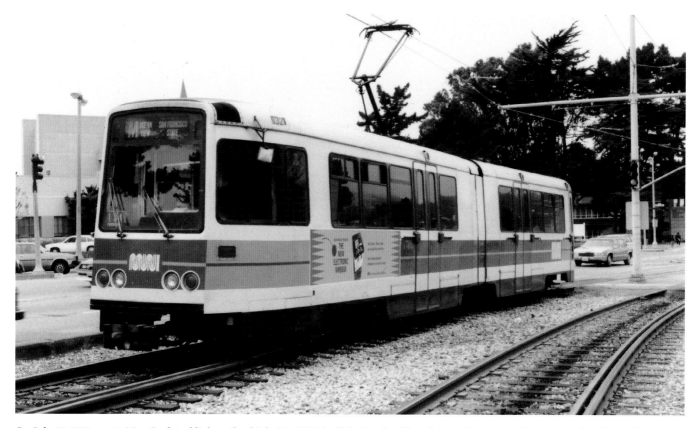

On July 27, 1991, route M articulated light rail vehicle No. 1321, built by Boeing Vertol, is on the reserved private right of way along 19th Avenue.

Chapter 6

N Judah Line

Judah Street and the N Judah line were named for Theodore D. Judah, chief engineer of the Central Pacific Railroad, who worked to get the First Transcontinental Railroad built. He was involved with its survey, helped get passage of the 1862 Pacific Railroad Act which authorized its construction, and was in charge of its construction. Outbound, the N Judah light rail line operates from King and 4th (Caltrain station) via King, Embarcadero, the Market Street subway, Duboce, Sunset tunnel, Carl, Arguello, Irving, 9th Avenue, and Judah to La Playa where there is a turnaround loop. Inbound, the line operates from La Playa via Judah, 9th Avenue, Irving, Arguello, Carl, Sunset tunnel, Duboce, the Market Street subway, Embarcadero, and King to 4th.

The N line, featuring the 4,232 foot long Sunset tunnel, began streetcar service on October 21, 1928 on Judah to La Playa just east of the Great Highway and the beach recreational area along the Pacific Ocean. Route N would be the last new streetcar line in San Francisco until the F line began operation on September 1, 1995. Effective January 1, 1941, the downtown terminal was changed from the Ferry Loop to the East Bay Terminal. While many San Francisco streetcar lines after World War II were converted to trolley coach and bus operation, route N continued as a streetcar line because of its use of the Sunset tunnel. Weekday light rail vehicle service began on this route on February 19, 1980, with PCC cars on weekends. Daily light rail vehicle service began on September 20, 1992 when regular PCC car service ended.

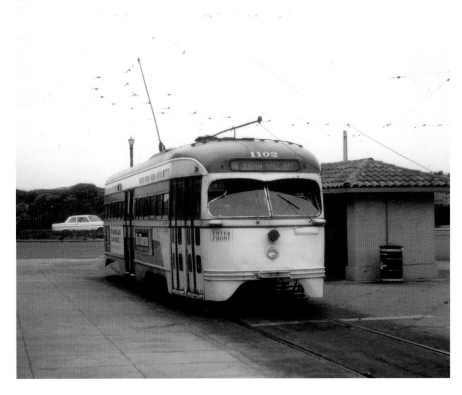

Route N PCC car No. 1102, built in 1946 by the St. Louis Car Company as car No. 1702 for the St. Louis Public Service Company, is at the end of the line loop at La Playa Street on August 8, 1967. This is the Outer Sunset neighborhood bounded by Lincoln Way to the north, Sunset Boulevard to the east, Sloat Boulevard to the south, and Ocean Beach to the west. The Outer Sunset neighborhood is the foggiest section in San Francisco due to its close proximity to the Pacific Ocean.

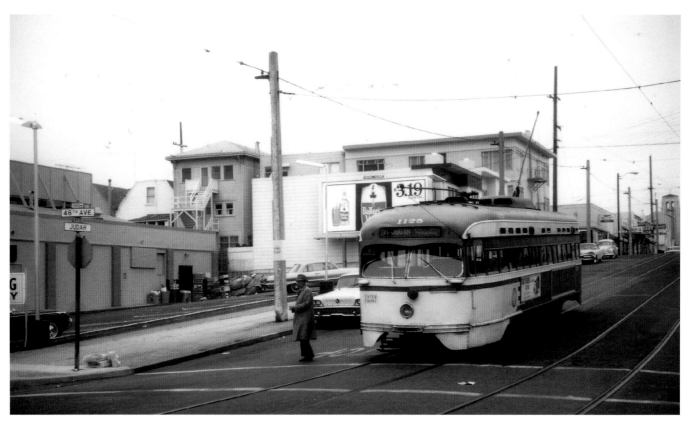

One passenger has departed from route N PCC car No. 1125, built in 1946 as car No. 1715 for the St. Louis Public Service Company, on Judah Street at 46th Avenue on August 8, 1967.

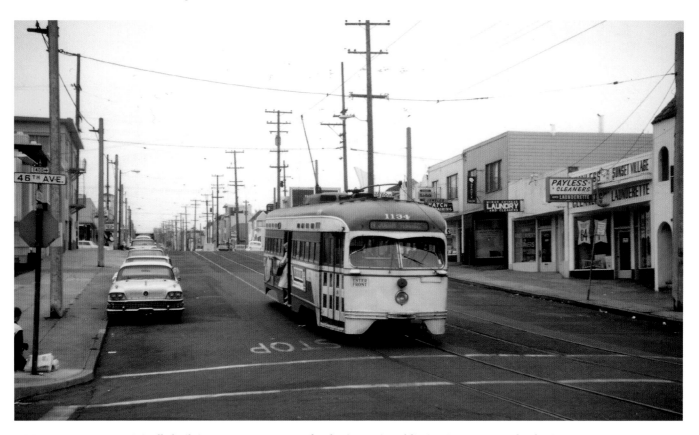

PCC car No. 1134 was originally built in 1946 as car No. 1748 for the St. Louis Public Service Company by the St. Louis Car Company. It is seen on route N on Judah Street at 46th Avenue on August 8, 1967.

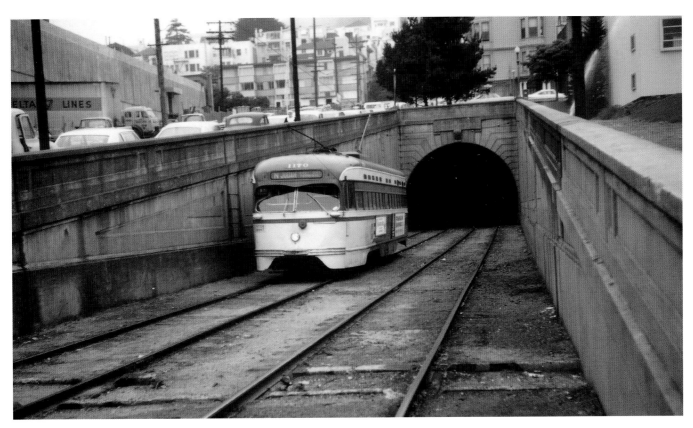

At the eastern end of the Sunset tunnel on August 8, 1967, PCC car No. 1170, built in 1946 as car No. 1777 for the St. Louis Public Service Company, is eastbound on route N for the East Bay Terminal.

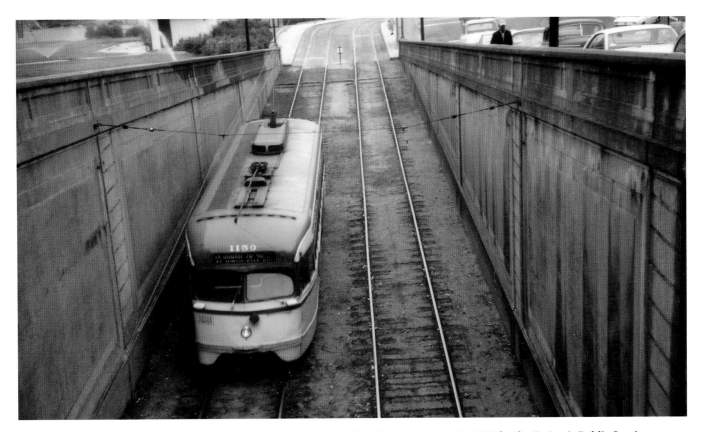

Westbound route N PCC car No. 1150, built in 1946 by the St. Louis Car Company as car No. 1740 for the St. Louis Public Service Company, is about to enter the Sunset tunnel on August 8, 1967.

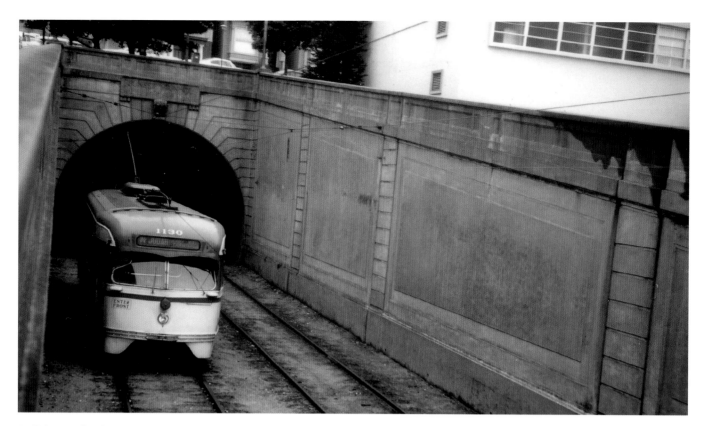

Built in 1946 by the St. Louis Car Company as car No. 1754 for the St. Louis Public Service Company, PCC car No. 1130 emerges from the Sunset tunnel on August 8, 1967, handling an eastbound trip on route M.

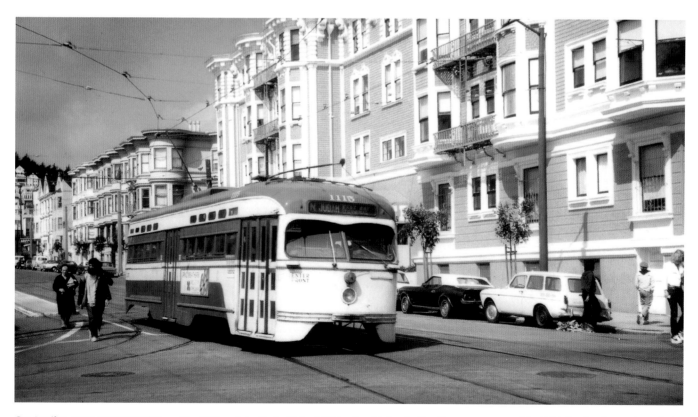

On April 3, 1975, route N PCC car No. 1115, originally built in 1946 by the St. Louis Car Company as car No. 1703 for the St. Louis Public Service Company, is on Duboce Avenue crossing Church Street.

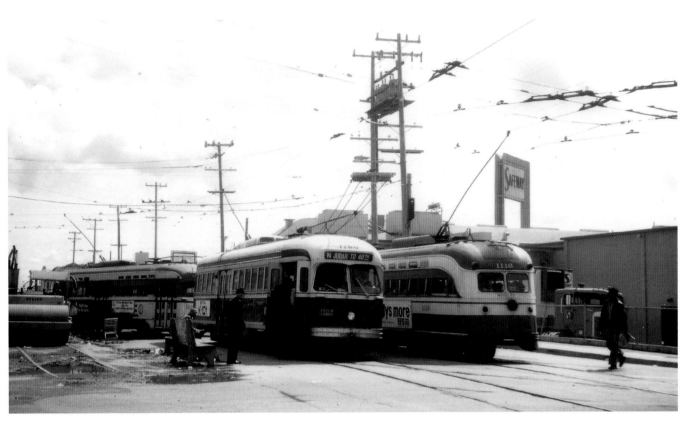

Duboce Avenue at Church Street is the scene for route N PCC car No. 1186 (built in 1946 by the St. Louis Car Company for the Kansas City Public Service Company and acquired in 1957 by the Toronto Transit Commission where it became car No. 4770) passing PCC car No. 1116 (built in 1946 as car No. 1730 for the St. Louis Public Service Company) on April 3, 1975 during construction of the Market Street subway.

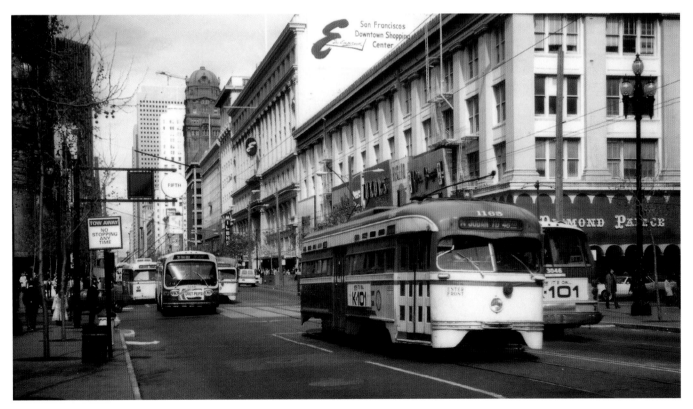

Route N PCC car No. 1165, originally built by the St. Louis Car Company as car No. 1736 for the St. Louis Public Service Company in 1946, is westbound on Market Street on April 3, 1975.

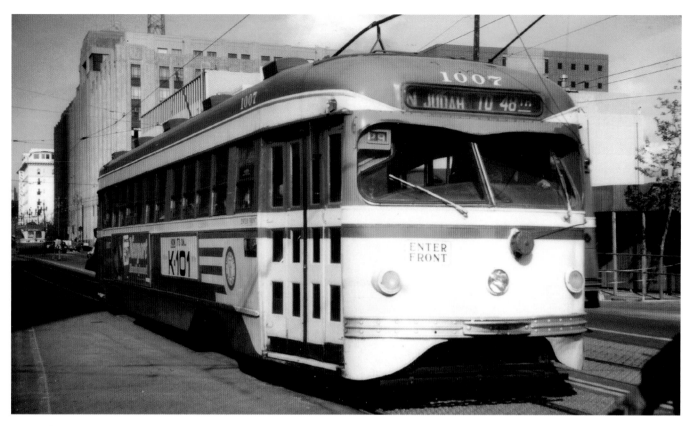

On Market Street at 11th Street, type D PCC car No. 1007, built in 1948 by the St. Louis Car Company, is handling a westbound route N trip on April 3, 1975.

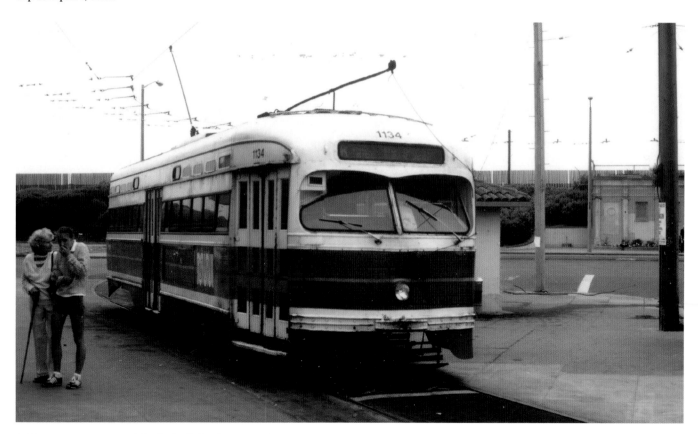

PCC car No. 1134 was originally built by the St. Louis Car Company in 1946 as car No. 1748 for the St. Louis Public Service Company and is at the route N terminus at La Playa Street on July 18, 1981.

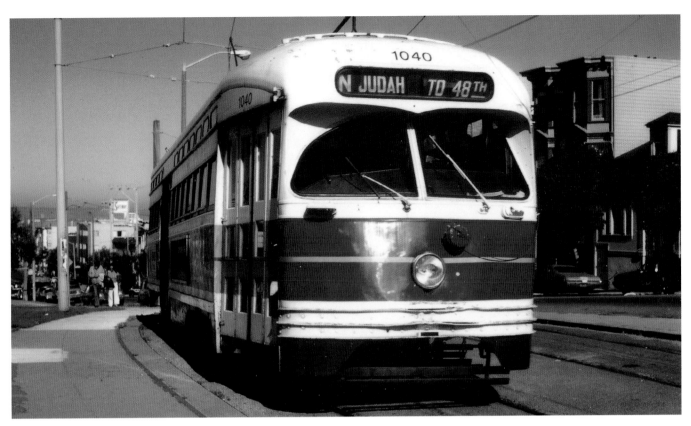

Westbound PCC car No. 1040, the last PCC car built in the United States, is near the Sunset tunnel for a route N trip on July 18, 1981.

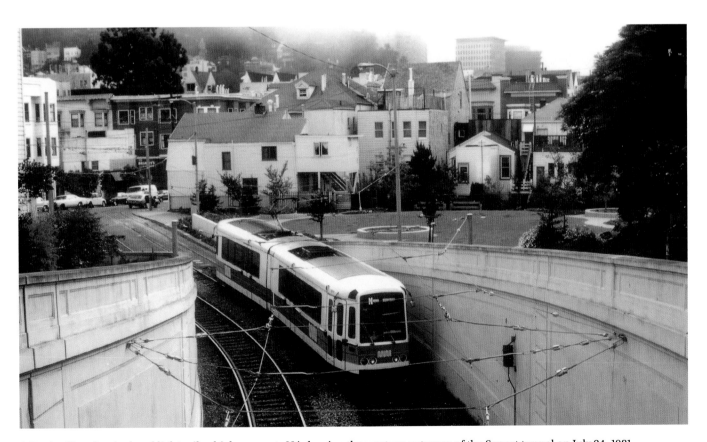

A Boeing Vertol articulated light rail vehicle on route N is leaving the western entrance of the Sunset tunnel on July 24, 1981.

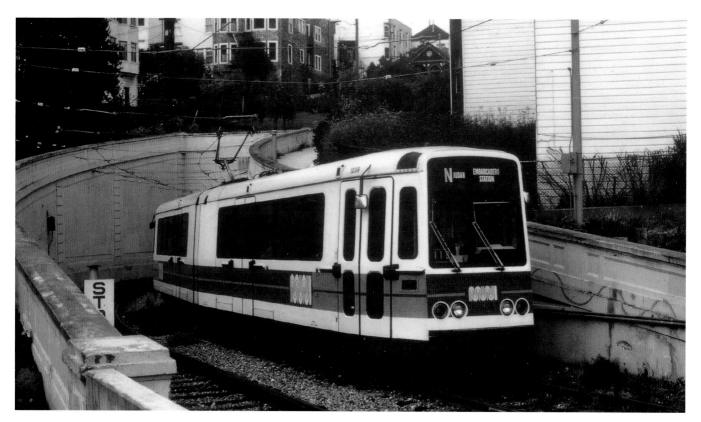

Eastbound route N articulated light rail vehicle No. 1239, built by Boeing Vertol, is entering the western entrance of the Sunset tunnel on July 24, 1981 for its trip to Embarcadero station in downtown San Francisco.

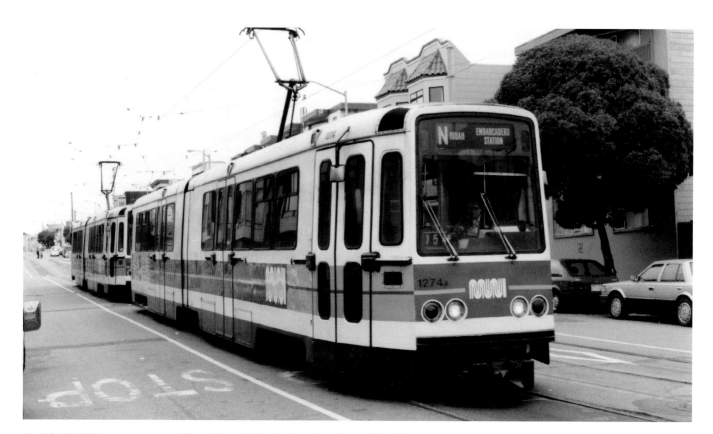

On July 27, 1991, a two-car route N train headed by Boeing Vertol articulated light rail vehicle No. 1274, seating 69 and having a maximum speed of 50 miles per hour, is on Judah Street at 48th Avenue on an eastbound trip to Embarcadero station.

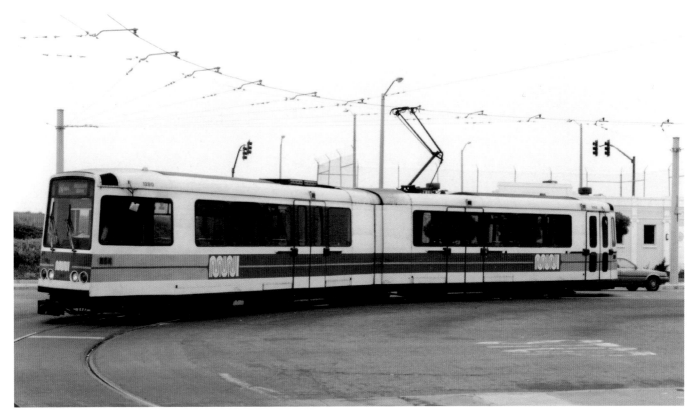

At the La Playa terminus of route N, articulated light rail vehicle No. 1290, built by Boeing Vertol, is rounding the loop for the next trip to downtown San Francisco on July 27, 1991. By the end of 2001, all Boeing Vertol articulated light rail vehicles were taken out of regular service.

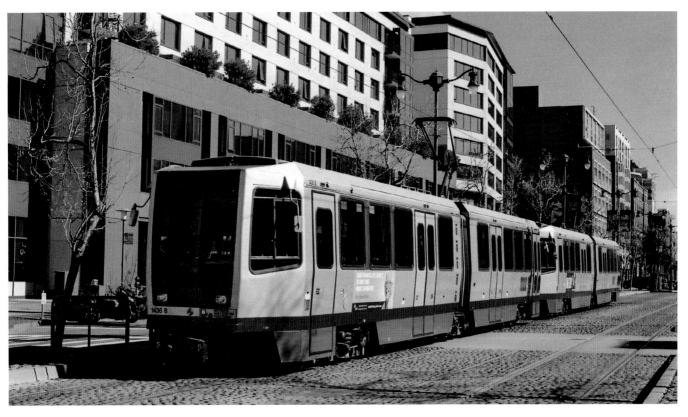

An AnsaldoBreda two-car articulated light rail vehicle train, with car No. 1436 in the lead, is at the 4th and King weekday terminus of route N on April 4, 2011.

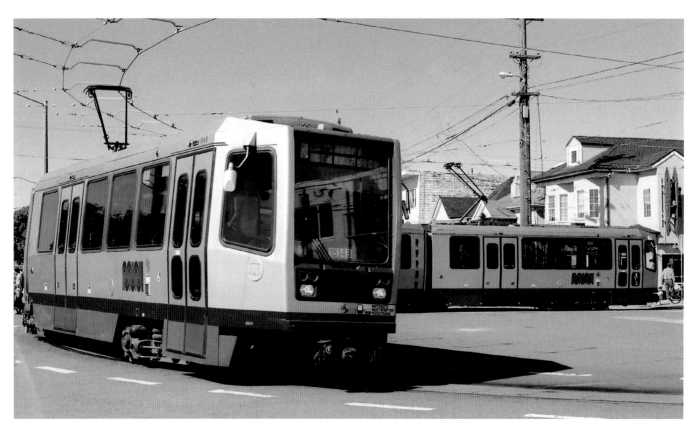

In the bright sunshine of April 4, 2011, a two-car train headed by articulated light rail vehicle No. 1514, built by AnsaldoBreda, is at the La Playa terminal loop of route N.

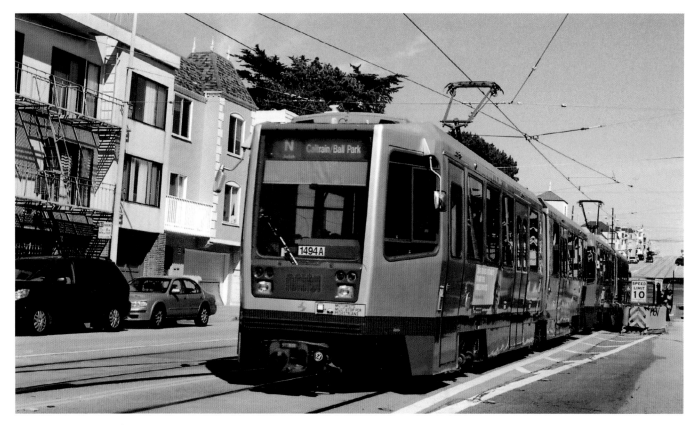

An eastbound route N AnsaldoBreda two-car train, with articulated light rail vehicle No. 1494 at the rear, is on Judah Street at the Sunset Boulevard passenger stop on April 4, 2011.

Chapter 7

Cable Cars

There are three cable car routes in San Francisco. The California cable car line inbound operates from California and Van Ness via California to Market. Outbound, it operates from California and Market via California to Van Ness. The Powell-Hyde cable car line inbound operates from Hyde and Beach via Hyde, Washington, and Powell to Market. Outbound, it operates from Powell and Market via Powell, Jackson, and Hyde to Beach. The Powell-Mason cable car line inbound operates from Taylor and Bay via Taylor, Columbus, Mason, Washington, and Powell to Market. Outbound, it operates from Powell and Market via Powell, Jackson, Mason, Columbus, and Taylor to Beach.

Andrew Smith Hallidie invented the cable car. After witnessing horses being whipped while they struggled on wet pavement to pull a horse car up Jackson Street, Hallidie had an idea for a steam-powered, cable-driven system in 1869. He entered into a partnership to form the Clay Street Hill Railroad, and construction of a cable car line on Clay Street began in May, 1873. The Clay Street Hill Railroad began cable car service on September 1, 1873.

Other companies opened cable car lines as follows: California Street Cable Railroad in 1878; Geary Street, Park and Ocean Railroad in 1880; Presidio and Ferries Railroad in 1882; Market Street Cable Railway in 1883; Ferries and Cliff House Railway in 1888; and Omnibus Railroad and Cable Company in 1889. However, the successful development of the electric streetcar by Frank Sprague in 1888, together with the 1906 San Francisco earthquake, resulted in the decline of the cable car service. In 1947, San Francisco Mayor Roger Lapham commented that the city should eliminate cable cars, but Friedel Klussmann founded the Citizens' Committee to Save the Cable Cars and began a public campaign that showed their value to San Francisco. The Committee successfully placed Measure 10 on the November ballot and public support rallied for the cable cars. Measure 10 passed in a landside. The cable cars were designated a National Historic Landmark on January 29, 1964 and were placed on the National Register of Historic Places on October 15, 1966.

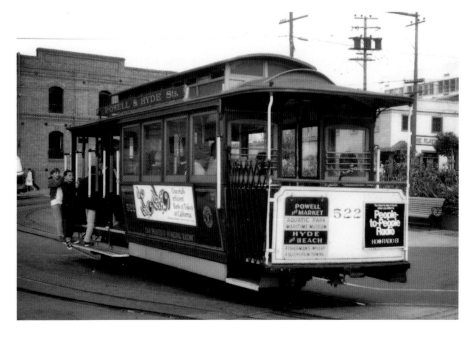

Powell-Hyde cable car No. 522, built by Mahoney Brothers in 1887, is at the turnaround at Beach Street on August 7, 1967. This car was renumbered as No. 22 in 1973 and was extensively rebuilt at the San Francisco Municipal Railway's Elkton shops in 1956. The Powell-Hyde and Powell-Mason cable car lines use 28 cable cars that operate from only one end, necessitating a turntable at the end of each line to reverse direction.

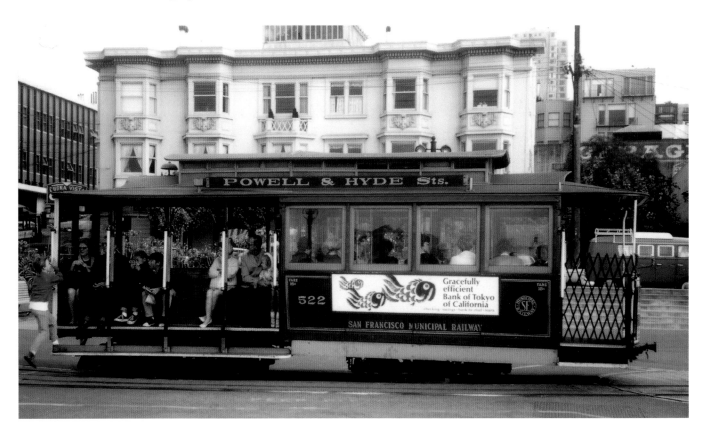

Above: On August 7, 1967, cable car No. 522 is at Hyde and Beach Streets. The 28 cable cars for the Powell-Hyde and Powell-Mason lines are 27.5 feet long, 8 feet wide, weigh 15,500 pounds, seat 29, and have a total seating/standing capacity of 60. In 1982, the cable car system was shut down and was completely rebuilt. It reopened on June 21, 1984.

Left: Cable car No. 508 was built by Carter Brothers in 1893-94 and extensively rebuilt by the San Francisco Municipal Railway's Elkton shops, being renumbered as No. 8 in 1973. On August 9, 1967, it is climbing Hyde Street with Alcatraz Island in view. In 1850, Alcatraz was declared a military reservation by United States President Millard Fillmore. While Alcatraz Island was originally planned as an army defense site, it became a military prison in 1861, and from 1934 to 1963 it was a federal prison. In 1972, Alcatraz became a national recreational area and was designated a National Historic Landmark in 1986.

At the cable car barn located at the corner of Mason and Washington Streets, car No. 507 is being turned manually on the hand-operated turntable on August 9, 1967. The car was built by Carter Brothers in 1893-94 for the Sacramento-Clay cable car line and was transferred to the Powell Street cable car lines in 1907. This car was extensively rebuilt by the San Francisco Municipal Railway's Elkton shops, and renumbered as No. 7 in 1973.

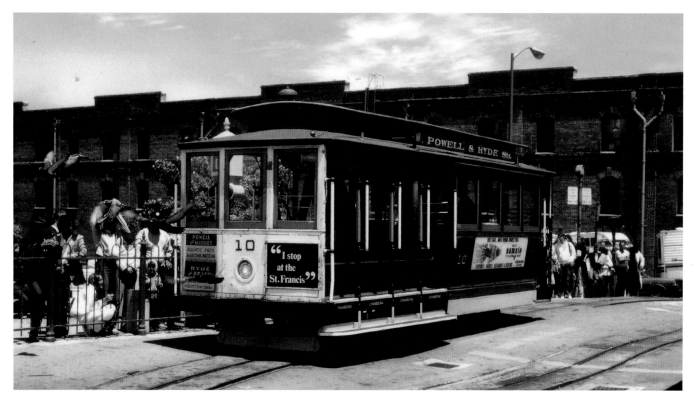

Passengers are waiting to board cable car No 10 (originally No. 510 until it was renumbered in 1973) at the Hyde and Beach Streets terminus on July 22, 1981. This car was also built by Carter Brothers in 1893-94 for the Sacramento-Clay cable car line and was transferred to the Powell Street cable car lines in 1907. It was extensively rebuilt by the San Francisco Municipal Railway's Elkton shops during 1960.

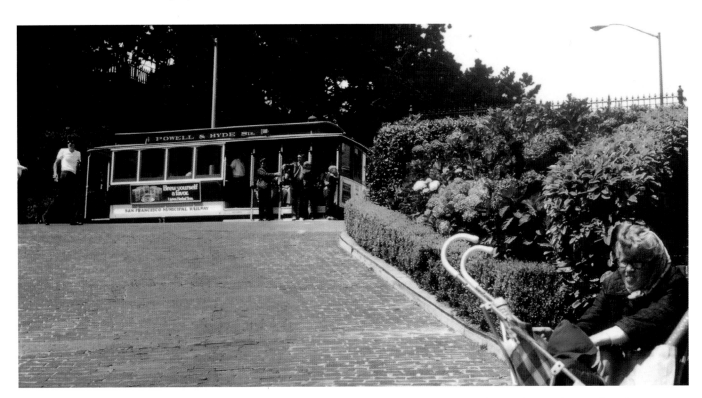

Cable car No. 11 was built by Carter Brothers in 1893-94 as No. 503 for the Sacramento-Clay cable car line and renumbered in 1973, before being rebuilt by the San Francisco Municipal Railway in 1977. On July 22, 1981, it is on Hyde Street passing Lombard Street which is known for the one block from Hyde to Leavenworth Streets where eight sharp turns make it a very crooked street. Built in 1922 and named for Lombard Street in Philadelphia, the street was designed to reduce the hill's 27 percent grade which was too steep for most vehicles. The author's wife Virginia is watching their young son Peter.

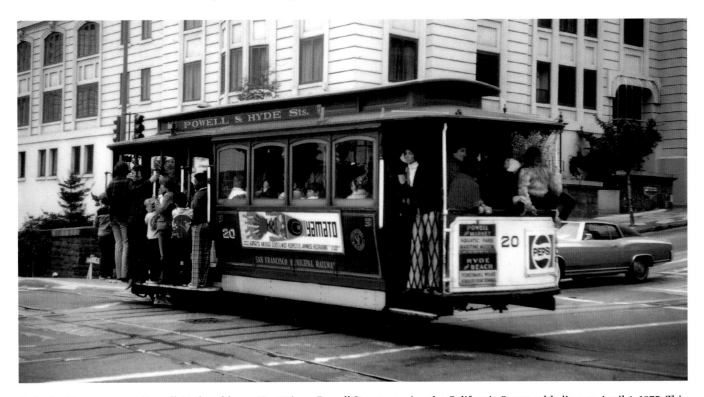

Packed with passengers, Powell-Hyde cable car No. 20 is on Powell Street crossing the California Street cable line on April 4, 1975. This car was built for the Sacramento-Clay cable car line as No. 520 by Carter Brothers during 1893-94 and was transferred to the Powell Street cable car lines in 1907. Extensive repairs on this car, using the original roof and seats, were completed on November 17, 1967. It was renumbered as car No. 20 in 1973.

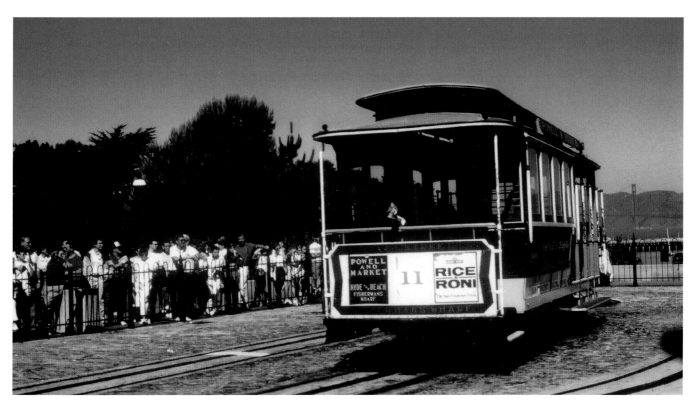

A July 20, 1988 summertime crowd is in line to board cable car No. 11 at Hyde and Beach Streets. During 1982, the cable car system was shut down for a complete rebuilding which involved replacement of track and cable channels, rebuilding of the car barn and power house, and repair or rebuilding of 37 cable cars. The cable car system reopened on June 21, 1984.

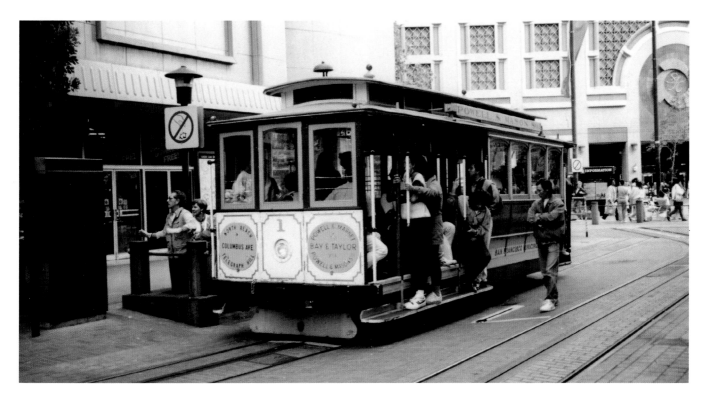

On July 30, 1991, at Powell Street just north of Market Street, cable car No. 1 will shortly depart for a trip on the Powell-Mason line. This car was completed on May 2, 1973 at the Elkton shops of the San Francisco Municipal Railway using the roof and seats from the original car No. 506. For fiscal year 2011-12, the cable cars had an average weekday ridership of 21,005 according to the June, 2013 Statistical Summary of Bay Area Transit Operators.

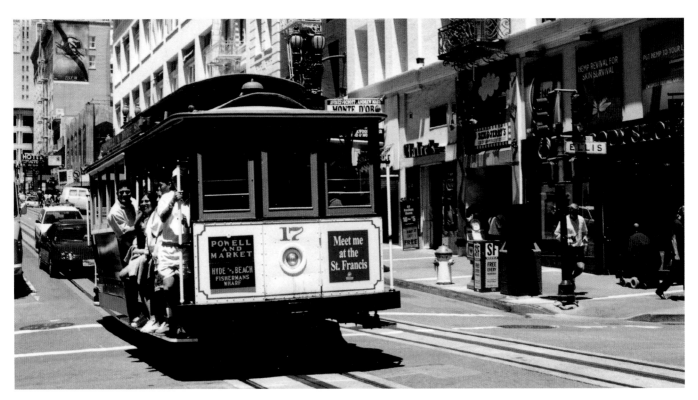

Cable car No. 17 is coming down Powell Street crossing Ellis Street on June 30, 2001. This car was built by Mahoney Brothers in 1887 as No. 532 for the Sacramento-Clay cable car line and was transferred to the Powell Street cable car lines in 1907. The Market Street Railway renumbered it as No. 517 in 1929. It was extensively rebuilt at the Elkton shops of the San Francisco Municipal Railway in 1956 and became No. 17 in 1973.

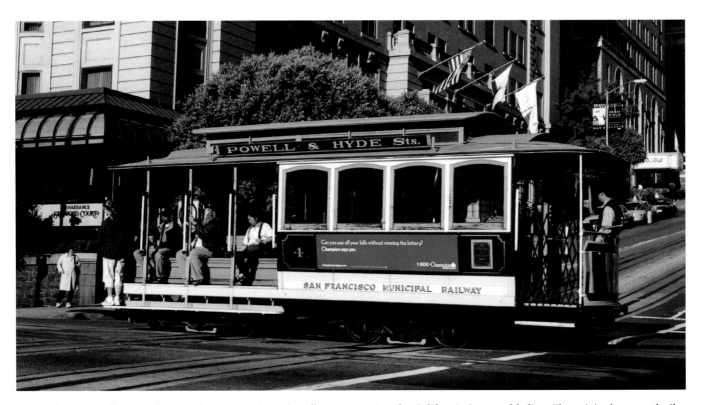

In the afternoon of June 30, 2001, cable car No. 4 is on Powell Street crossing the California Street cable line. The original car was built by Mahoney Brothers as No. 543 in 1887, but was rebuilt and renumbered as No. 504 in 1915 by United Railroads of San Francisco. It was renumbered as No. 4 in 1973. The San Francisco Municipal Railway built a new No. 4 which was presented to the public at a ceremony on September 15, 1994 at Market and Powell Streets.

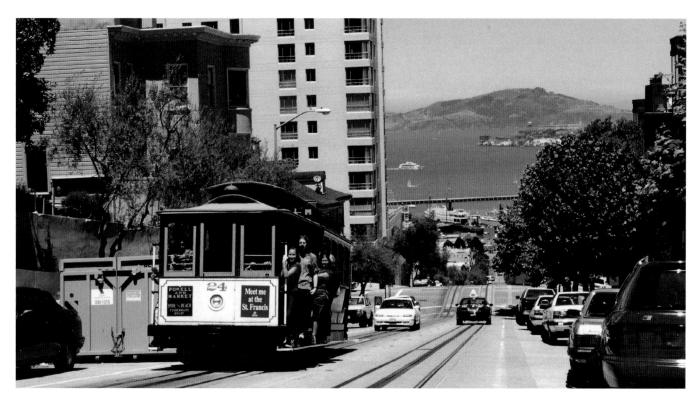

Hill-climbing cable car No. 24 is on Hyde Street and will shortly cross Lombard Street on July 1, 2001. This car was built by Mahoney Brothers in 1887 as No. 534 for the Sacramento-Clay cable car line. On December 16, 1929 it was renumbered as No. 524 and later became No. 24. Alcatraz Island, located 2 miles north of the shoreline in San Francisco Bay, can be seen in the distance. This is the Russian Hill neighborhood of San Francisco which received its name when settlers discovered a Russian cemetery at the top of the hill. The cemetery was later removed.

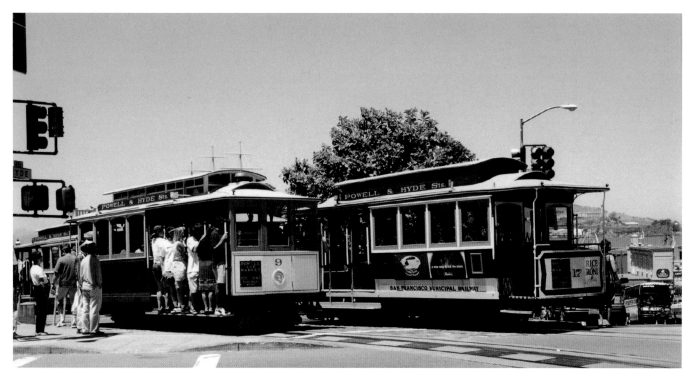

On July 1, 2001, at the intersection of Hyde and Beach Streets, cable car No. 9 will soon depart for Powell and Market Streets. The original car No. 9 was taken out of service in 1995 and replaced by this new car, built by the San Francisco Municipal Railway, which went into service on April 24, 2000. Cable car No. 17, built by Mahoney Brothers in 1887 as car No. 532, renumbered as No. 517 in 1929, and as No. 17 in 1973, awaits its turnaround at the turntable.

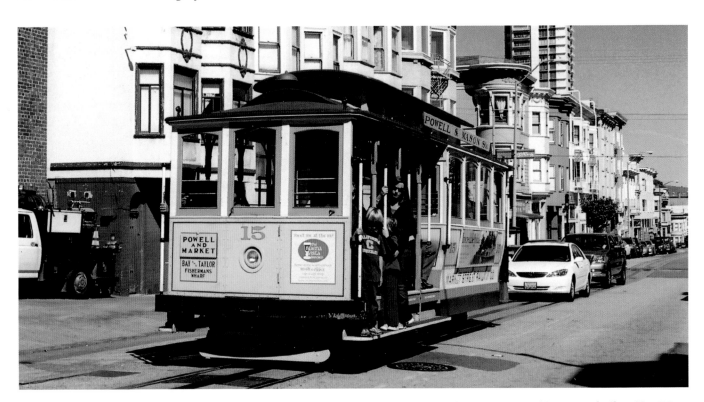

Basking in the sunshine of April 4, 2011, cable car No. 15 is on Mason Street north of Washington Street. This car was built as No. 515 by Carter Brothers during 1893-94 for the Sacramento-Clay cable car line. It was extensively rebuilt by the San Francisco Municipal Railway's Elkton shops in 1954 and renumbered as car No. 15 in 1973.

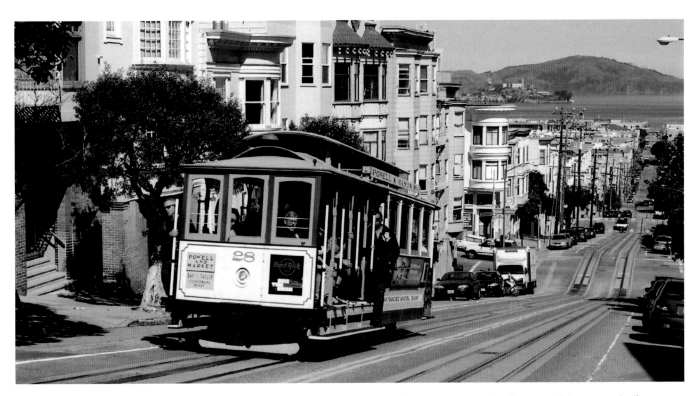

Cable car No. 28 is climbing the hill on Mason Street between Green Street and Union Street on April 4, 2011. This car was built as No. 544 by Mahoney Brothers in 1887 for the Sacramento-Clay cable car line and was transferred to the Powell Street cable car lines in 1907. Rebuilt and renumbered as No. 501 by United Railroads of San Francisco on December 13, 1912, it was extensively rebuilt by the San Francisco Municipal Railway's Elkton shops in 1951 and was renumbered as car No. 28 in 1973.

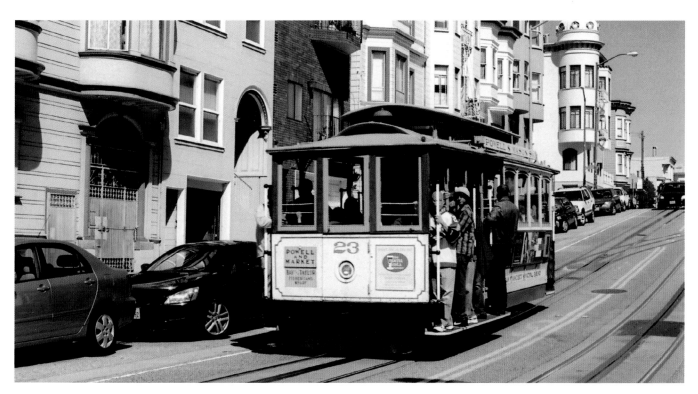

Heading for Powell and Market Streets, cable car No. 23 is southbound on Mason Street south of Vallejo Street on April 4, 2011. This car was built by the Ferries and Cliff House Railway in 1888-90 at the Washington-Mason barn. It was assigned to the Sacramento-Clay cable car line and was subsequently transferred to the Powell Street cable car lines in 1907. Elkton shops extensively rebuilt the car using the original roof in 1970, and it was renumbered as No. 23 during 1973.

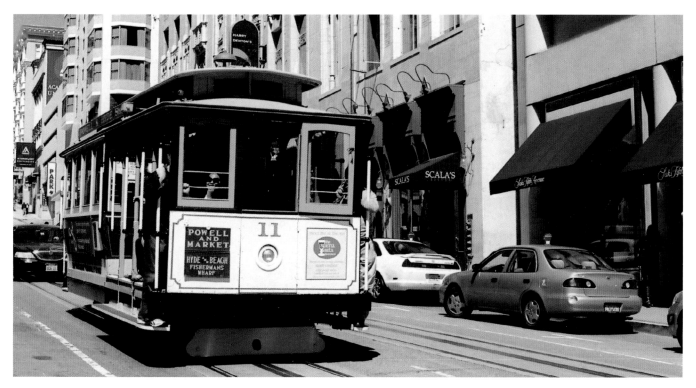

On Powell Street north of Geary Street, cable car No. 11 is southbound for Powell and Market Streets on April 4, 2011. Each cable car is pulled by a 1.25 inch diameter cable that runs at a constant speed of 9.5 miles per hour. To start the movement of the car the gripman closes the grip around the cable that works like a pair of pliers; to stop the car he opens the grip around the cable. There are four cables: one for the California Street line, one each for the separate parts of the Powell-Hyde and Powell-Mason lines, and one for the common section.

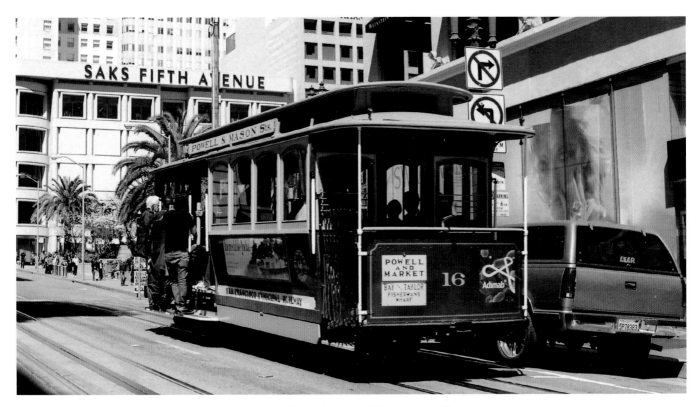

On April 4, 2011, Powell-Mason cable car No. 16 is northbound on Powell Street and will soon cross Geary Street. This car was originally built as No. 516 by Carter Brothers in 1893-94 and was renumbered as No. 16 in 1973. The San Francisco Municipal Railway built a new car (using part of the original roof) that was dedicated on April 10, 1990 and painted in a blue and yellow color scheme used by the railway from 1939 to 1947.

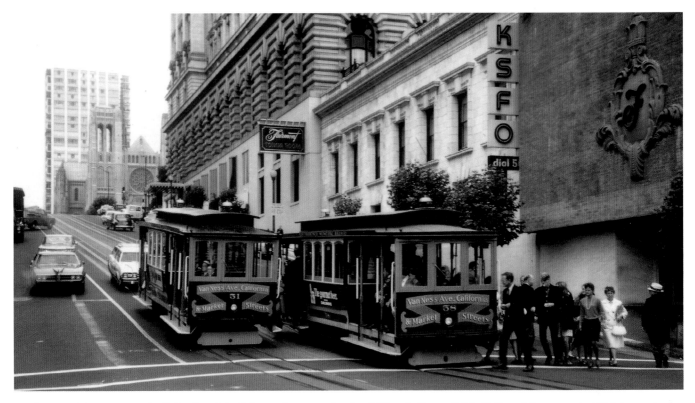

California cable car No. 51, built by the W. L. Holman Company for the California Street Cable Railroad Company in 1906, is coming down Nob Hill on California Street while cable car No. 58, built in 1914 by the California Street Cable Railroad Company shops located at California and Hyde Streets, has crossed Powell Street and is continuing the climb on California Street on August 9, 1967.

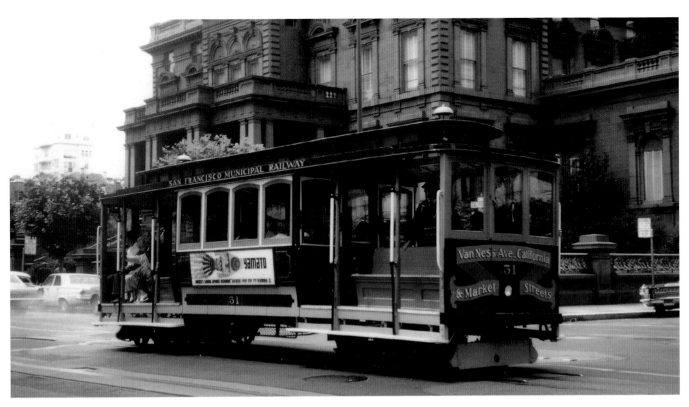

Cable car No. 51 is on California Street at Mason Street on August 9, 1967, passing by the James C. Flood Mansion, the ornate brownstone townhouse of the nineteenth-century businessman who made a fortune in silver mining. Structurally surviving the earthquake of April 18, 1906, it was purchased by the Pacific Union Club, a private social club. During 1966, it became a National Historic Landmark.

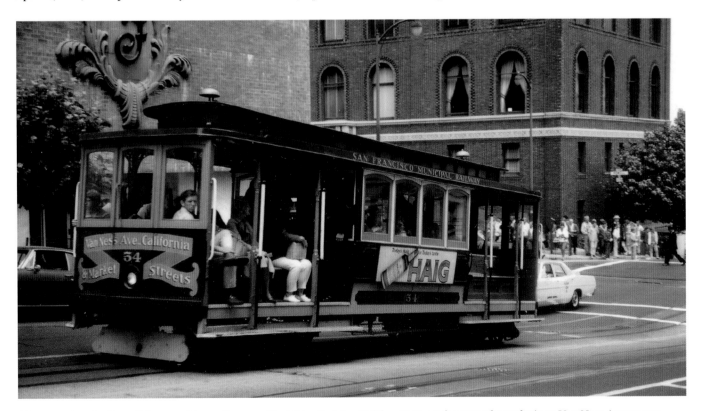

After crossing the Powell Street cable car line, car No. 54 is climbing California Street for a westbound trip to Van Ness Avenue on August 9, 1967. Originally No. 19, this car was built by John Hammond and Company for the California Street Cable Railroad Company in 1906 after the 1906 earthquake and fire destroyed its cars. In September, 1957, the San Francisco Municipal Railway renumbered the car as No. 4, and in October, 1957 as No. 54.

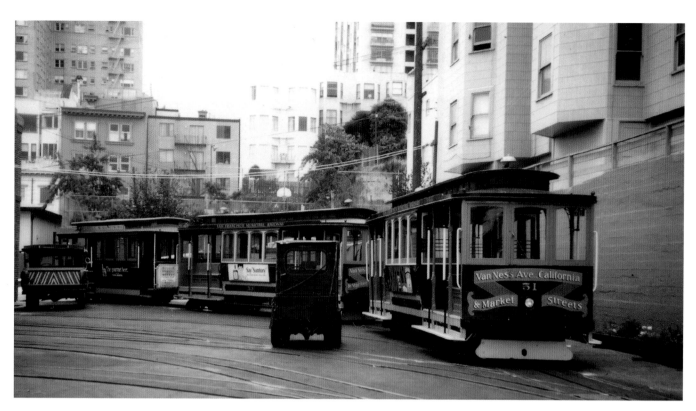

Car No. 51 is in the lineup of cable cars at the cable car barn on August 9, 1967. The California Street Cable Car line has 12 maroon cable cars which have an open seating section at each end and a closed section in the middle. As these cars are operated from either end they do not need a turntable. They are 30.25 feet long, 8 feet wide, weigh 16,800 pounds, seat 34, and have a total seating/standing capacity of 68.

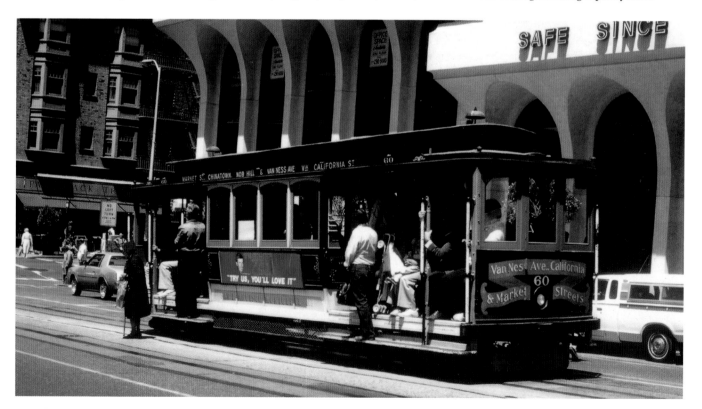

On July 22, 1981, cable car No. 60 is on California Street at Polk Street, one block east of the terminus at Van Ness Avenue. This car was originally built as No. 16 by John Hammond and Company for the California Street Cable Railroad Company in 1906. The San Francisco Municipal Railway renumbered it as No. 60 in October, 1957, and it was rebuilt during 1968-69 in the Elkton shops using the original roof and seats. A new No. 60 was built in 1998, which went into service in 2002.

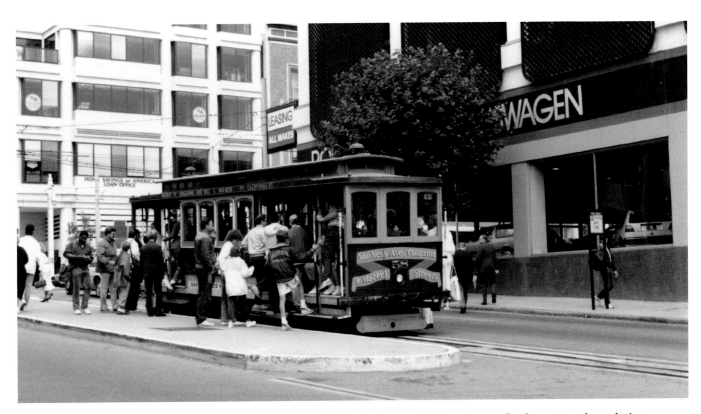

Passengers are boarding cable car No. 58 on July 20, 1988 on California Street at Van Ness Avenue for the next eastbound trip to Market Street. This was the last car to operate on the Jones Street Shuttle on February 6, 1954 which had operated since February 9, 1891 on Jones Street from the McAllister/Market intersection via Jones to O'Farrell.

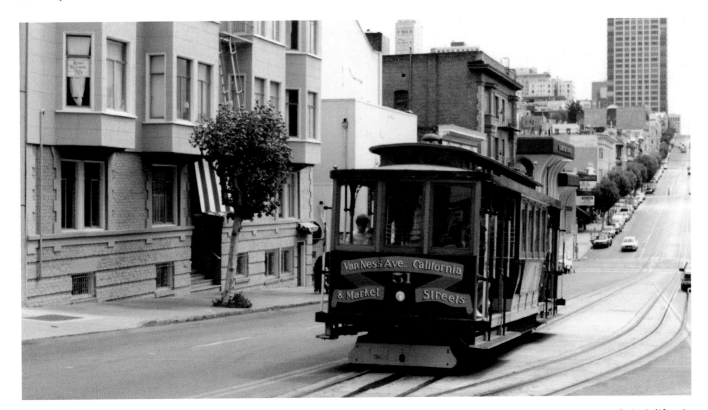

Cable car No. 51 is on California Street coming to the terminus at Van Ness Avenue on July 20, 1988. This line once operated via California Street to Presidio Avenue but was cut back to Van Ness Avenue on May 16, 1954. There are no turntables on the California Street cable car line as the cars are double-ended, and the line provides a great opportunity to get a cable car ride without long waiting lines.

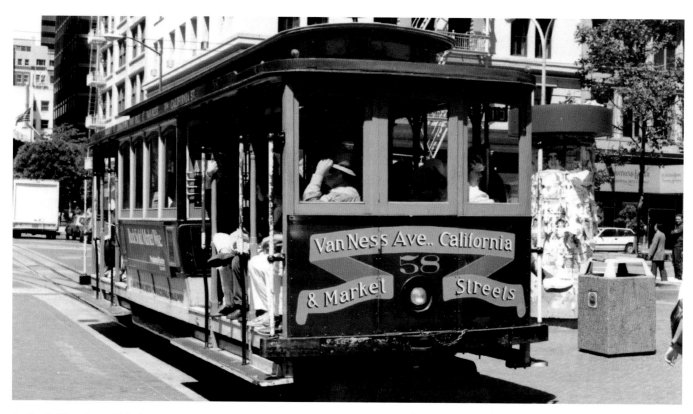

At the California and Market eastern terminus, cable car No. 58 is awaiting departure time on July 20, 1988 for the westbound trip to Van Ness Avenue. Since the California Street cable line does not go to Fisherman's Wharf, it does not have the large tourist ridership of the Powell-Hyde and Powell-Mason lines, but does have more local riders commuting to and from work.

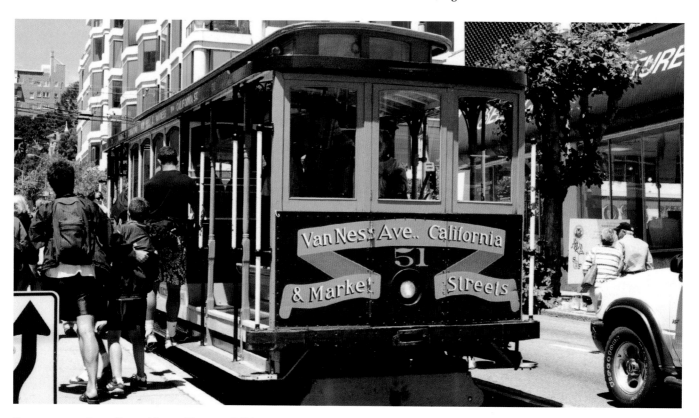

Passengers are boarding cable car No. 51 at California Street and Van Ness Avenue for the eastbound trip to Market Street on June 30, 2001. This car was the last to operate on the O'Farrell, Jones and Hyde line in May, 1954 which was shortened into what is now the Powell-Hyde line.

Chapter 8

Trolley Coaches

A trolley coach, also known as a trackless trolley or trolley bus, is an electric bus that draws its power from two poles each contacting one of the two overhead parallel wires generally suspended from roadside poles. The first trolley coach line in San Francisco was the conversion of streetcar route 33 (18th and Park) to trolley coach on October 6, 1935 by the privately owned Market Street Railway. On September 7, 1941, the San Francisco Municipal Railway placed trolley coaches in service on its South Van Ness line. The Market Street Railway became part of the San Francisco Municipal Railway on September 29, 1944.

Streetcar service ended on the E Union line on June 8, 1947 and following conversion to trolley coach operation became route 41. Streetcar route 22 Fillmore became a trolley coach line on January 16, 1949. Five streetcar lines became trolley coach lines on July 3, 1949: route 5 McAllister, route 6 Masonic, route 7 Haight, route 8 Market, and route 21 Hayes. During 1950, streetcar route 9 Richland was converted to trolley coach. On January 21, 1951, streetcar routes 1 California, 3 Jackson, rush hour 4 Sutter, and 30 Stockton became trolley coach lines. The H streetcar line became the 47 Potrero trolley coach line on October 14, 1951. On January 6, 1952, the 14 Mission streetcar line became a trackless trolley line, followed by route 12 Mission-Ocean on May 18, 1952. The newest trolley coach line is 31 Balboa which began operation during 1994. For fiscal year 2011-2012, average weekday trolley coach ridership was 213,512 according to the June, 2013 Statistical Summary of Bay Area Transit Operators.

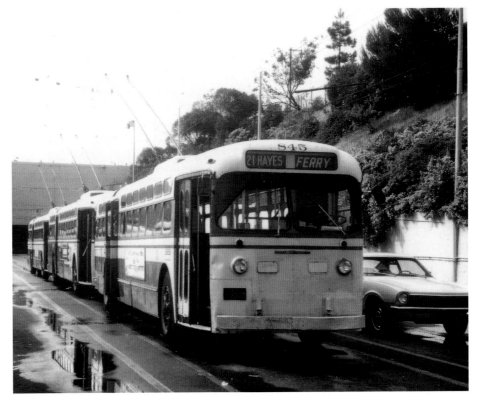

A lineup of trolley coaches built by Marmon-Herrington, with No. 845 in the lead, is awaiting the next assignment at the Presidio trolley coach yard on April 3, 1975. This was one of 110 model TC48 trolley coaches, numbered 740 to 849, delivered to the San Francisco Municipal Railway during 1950-51. Seating 48, trolley coaches numbered 740 to 789 had General Electric motors, while numbers 790 to 849 had Westinghouse motors.

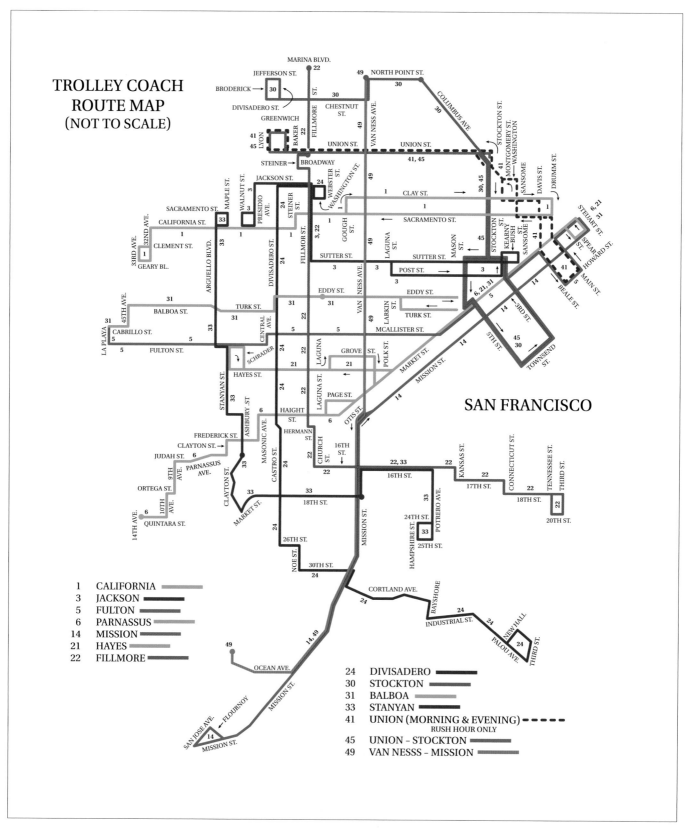

TROLLEY COACH ROUTE MAP (NOT TO SCALE)

SAN FRANCISCO

1	CALIFORNIA
3	JACKSON
5	FULTON
6	PARNASSUS
14	MISSION
21	HAYES
22	FILLMORE

24	DIVISADERO
30	STOCKTON
31	BALBOA
33	STANYAN
41	UNION (MORNING & EVENING) RUSH HOUR ONLY
45	UNION – STOCKTON
49	VAN NESSS – MISSION

San Francisco operates the largest trolley coach system in North America, with about 300 trolley coaches operating on 14 lines in 2013. According to the SFMTA Transit Effectiveness Project (TEP) issued in 2013, average weekday ridership for the trolley coach lines was as follows: route 1 California – 26,028; route 3 Jackson – 3,443; route 5 Fulton – 17,269; route 6 Parnassus – 8,462; route 14 Mission – 19,489; route 21 Hayes – 12,426; route 22 Fillmore – 16,818; route 24 Divisadero – 11,374; route 30 Stockton – 32,353; route 31 Balboa – 7,982; route 33 Stanyan – 6,233; route 41 Union – 3,699; route 45 Union/Stockton – 11,735; and route 49 Van Ness/Mission – 26,756.

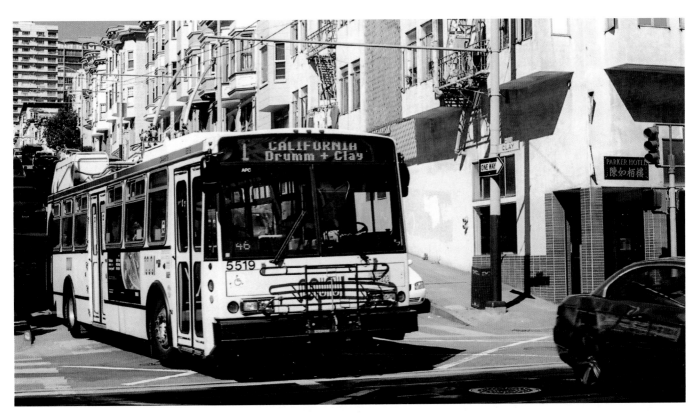

Route 1 trolley coach No. 5519 is on Clay Street crossing Hyde Street on April 4, 2011. This was one of 240 model 14TrSF trolley coaches, numbered 5401 to 5640, built by Electric Transit with electrical equipment by Vossloh Kiepe between 1999 and 2003. Electric Transit was a joint venture of the Skoda group in the Czech Republic and AAI Corporation in the United States.

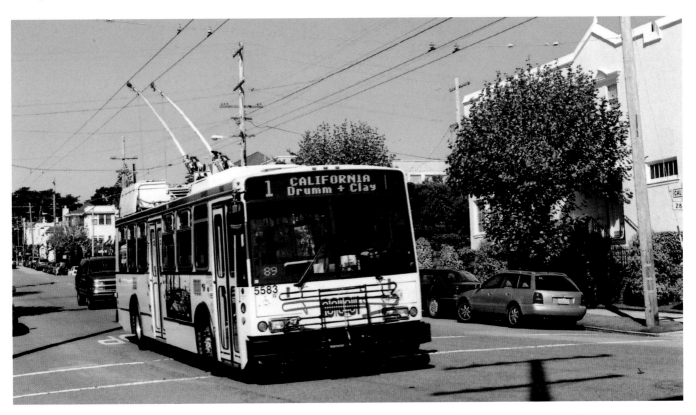

Eastbound route 1 model 14TrSF trolley coach No. 5583, built by Electric Transit, is on California Street crossing 28th Avenue on April 6, 2011. Route 1 was originally a streetcar line that began on May 26, 1905 and at its peak operated from the Ferry terminal to 48th Avenue and Point Lobos Avenue. Its last day of streetcar operation was July 2, 1949.

Sansome Street and Sutter Street is the location of route 3 trolley coach No. 5103 on July 20, 1988. This was one of 343 model E800 trolley coaches, numbered 5003 to 5345, built by Flyer Industries and delivered to the San Francisco Municipal Railway between 1975 and 1977. They were retired during 2003-07 and replaced by new trolley coaches built by Electric Transit. Route 3 was a streetcar line that began operation on July 4, 1906 and operated from the Ferry Loop to California and Presidio. Its last day of streetcar operation was July 2, 1949.

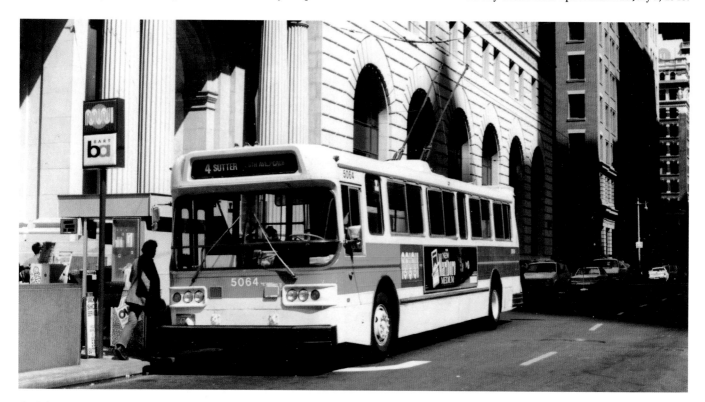

On July 30, 1991, route 4 trolley coach No. 5064, a 40 foot long and 8.5 foot wide model E800 built by Flyer Industries, is on Sutter Street at Sansome Street. Route 4 operated from here to 6th Avenue and California Street beginning in 1948, but was discontinued in 2009 because of low ridership. This route was previously a streetcar line that operated from the Ferry Loop to 6th Avenue and Fulton from February 1, 1897 to July 31, 1948.

Right: Westbound route 5 model E800 trolley coach No. 5012, built by Flyer Industries, is on Market Street at Powell Street on July 27, 1991. The advantages of a trolley coach over a diesel bus include its better hill-climbing capability and being quieter, and longer lasting. However, its disadvantages include the need to slow down at turns and through switches in the overhead wire system, and dewirements when the trolley poles come off the wires.

Below: Route 5 model 14TrSF trolley coach No. 5551, built by Electric Transit, is at Cabrillo and La Playa on April 5, 2011. This route was a streetcar line that had replaced a cable car line on August 12, 1906, and at its peak operated from the Ferry Loop to La Playa and Balboa. Its last day of streetcar operation was June 5, 1948.

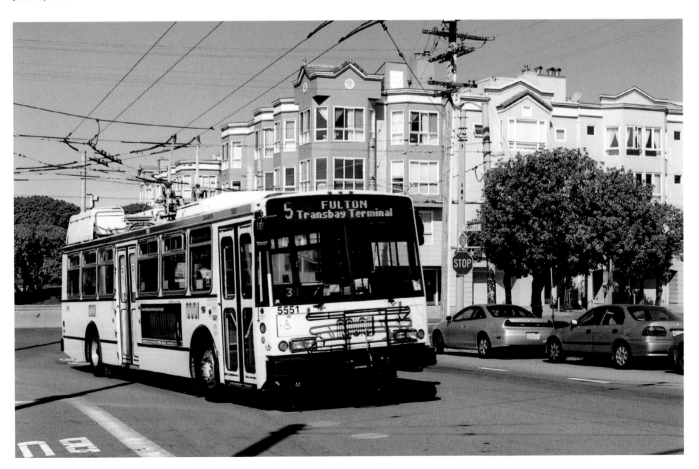

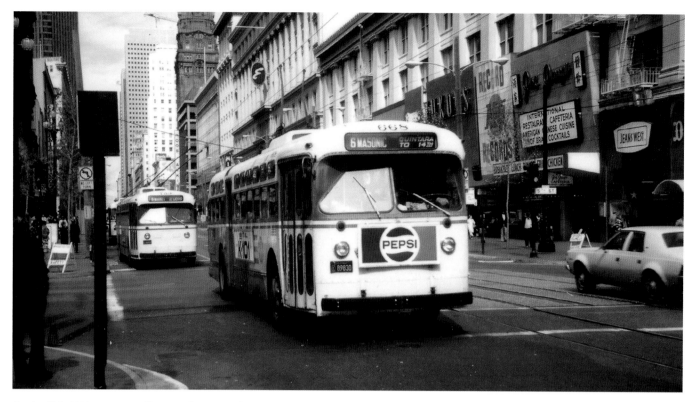

On April 3, 1975, route 6 trolley coach No. 668 leads several trolley coaches on Market Street. This model TC44 trolley coach was built by Marmon-Herrington as part of number series 660 to 739 during 1948-49. Route 6 was a streetcar line that began operation on June 10, 1906 and at its peak operated from the Ferry Loop to 9th Avenue and Pacheco. Its last day of streetcar operation was July 3, 1948.

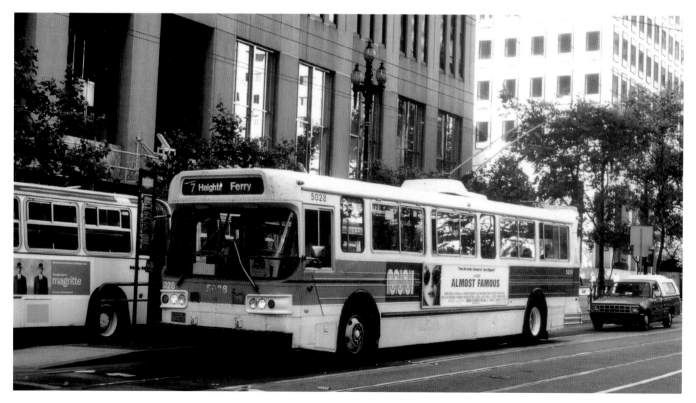

On August 14, 2000, Market Street at 1st Street is the location of route 7 trolley coach No. 5028, a model E800 built by Flyer Industries. This route operated from Mission and Main Streets to Haight and Stanyan Streets beginning in 1948 and was discontinued in 2009 because of low ridership. The route 7 streetcar line began operation on December 26, 1906, and at its peak operated from the Ferry Loop to La Playa and Balboa. Its last day of streetcar operation was July 3, 1948.

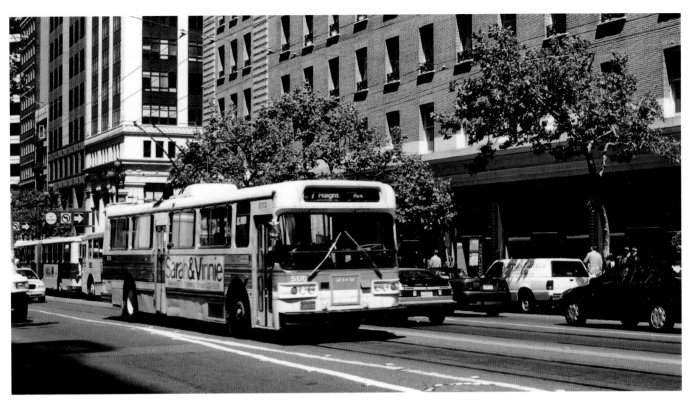

Model E800 Flyer Industries trolley coach No. 5170 is westbound on route 7 at Market Street near Powell Street on June 29, 2001. The trolley coaches' quieter, cleaner service outweighs the look of the overhead wires that are necessary for their operation.

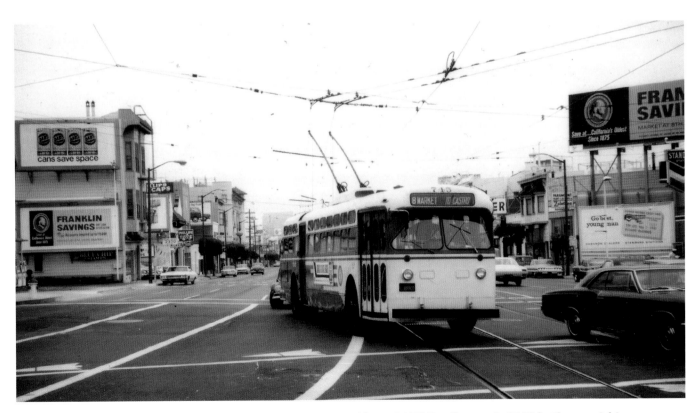

Route 8 trolley coach No. 745 is on Market Street on August 8, 1967. This model TC48 trolley coach, 38.92 feet long, weighing 18,000 pounds, and seating 48, was built by Marmon-Herrington as part of number series 740 to 789 with General Electric type 1213 motors in 1950. Route 8 began as a streetcar line in 1906 operating on Market Street from the Ferry Loop for the most part to 18th and Castro. Streetcar service on this line ended on July 1, 1947 when route 8 became a trolley coach line.

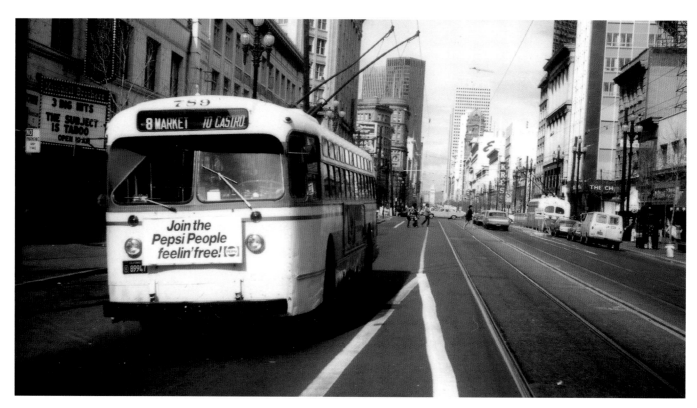

Westbound route 8 trolley coach No. 789, a model TC48 built by Marmon-Herrington, is on Market Street in downtown San Francisco on April 3, 1975. It was sold to Mexico City in 1977. The successful Trolley Festival operation on Market Street from 1983 to 1987 resulted in rebuilding the streetcar trackage on Market Street and permanent operation of the F streetcar line on Market Street beginning September 1, 1995.

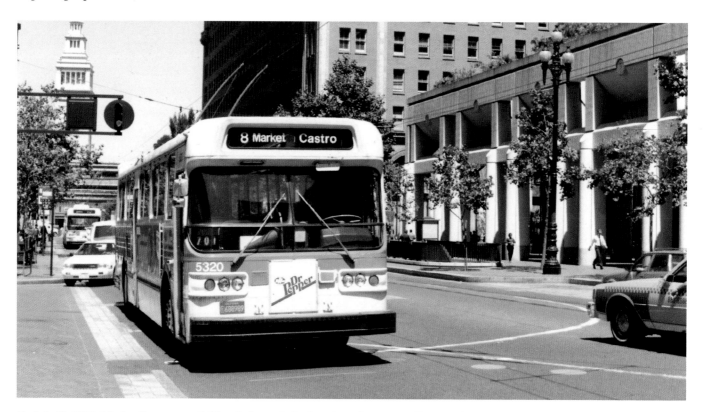

On July 20, 1988, Market Street near California Street is the location of route 8 trolley coach No. 5320, a model E800 built by Flyer Industries. With the new F streetcar line on Market Street exceeding all expectations, the route 8 trolley coach line made its last run in January, 1996.

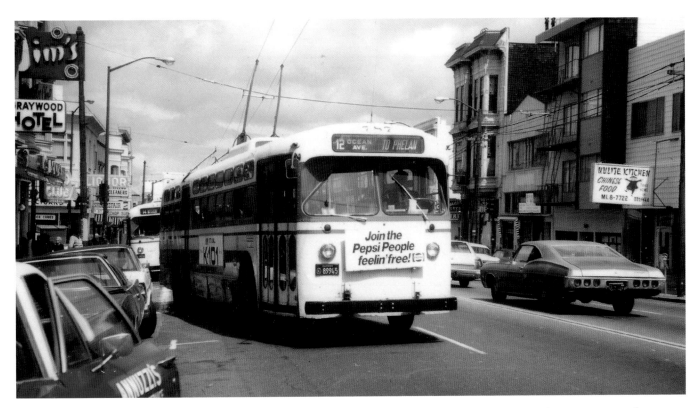

Model TC48 Marmon-Herrington trolley coach No. 787 is westbound on route 12 at Mission Street on April 3, 1975. Route 12 began as a streetcar line on May 6, 1906 from the Ferries on the Embarcadero to Sloat Boulevard and the Great Highway. The 10.25 mile line was the longest in San Francisco, but it was cut back to Geneva and Mission on April 8, 1945 and its last day of streetcar operation was October 31, 1948.

On July 18, 1981, route 12 trolley coach No. 5302, a model E800 built by Flyer Industries, is seen leaving the Ocean Avenue and Phelan Avenue loop.

Model E800 trolley coach No. 5314 is on route 14 at the Ferry Terminal in downtown San Francisco on July 20, 1988. Route 14 began as a streetcar line on May 6, 1906 operating from the Ferries on the Embarcadero via Mission Street to Daly City. The last day of streetcar operation on this 7.83 mile line was January 15, 1949.

On August 12, 2000, route 14 articulated trolley coach No. 7016 is on Mission Street at 1st Street. This model E60 trolley coach in the number series 7000 to 7059 was built by Flyer Industries from 1992 to 1994.

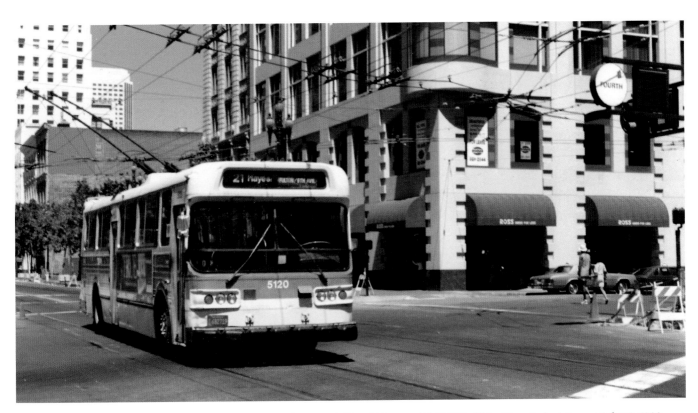

Market Street at 4th Street is the location of route 21 trolley coach No. 5120, a model E800 built by Flyer Industries, on July 16, 1988. Route 21 was a cable car line that became an electric streetcar line on June 10, 1906. For much of its existence, it operated from the Ferry Loop to Hayes and Stanyan. The last day of route 21 streetcar operation was June 5, 1948.

On August 12, 2000, westbound route 21 model E800 trolley coach No. 5138 is on Market Street at Spear Street. Just left of the trolley coach is the San Francisco Ferry Building (still used for ferries) located on the Embarcadero with its 245 foot high clock tower. Designed in 1892 by New York architect A. Page Brown, the building opened in 1898 and survived both the 1906 and 1989 earthquakes with slight damage.

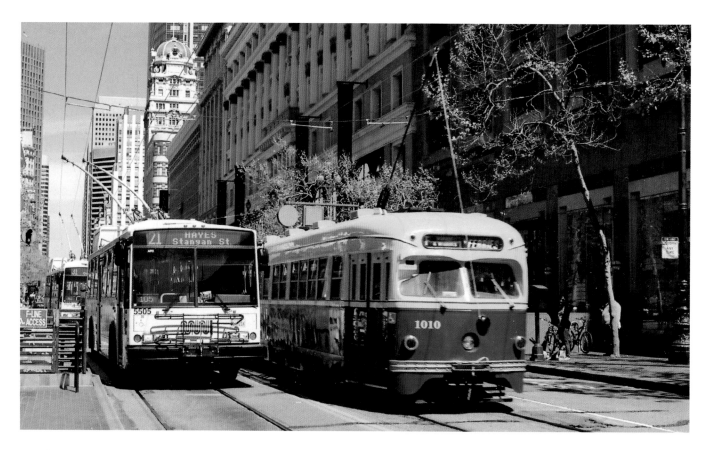

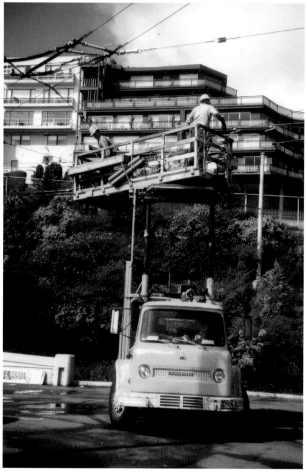

Above: Route 21 model 14TrSF trolley coach No. 5505, built by Electric Transit, is on Market Street at Powell Street on April 4, 2011 passing PCC car No. 1010, built by the St. Louis Car Company in 1948, on route F. At Powell and Market Streets, and California and Market Streets, there are three different track gauges: the F line is 4 feet 8.5 inches standard gauge; the cable car gauge is 3 feet 6 inches; and the BART system is 5 feet 6 inches broad gauge in the lower-level subway. The San Francisco Municipal Railway is 4 feet 8.5 inches in the upper-level subway.

Left: On April 3, 1975, a San Francisco Municipal Railway line crew is on the work truck doing repairs on the trolley coach overhead wire at the Presidio yard. Trolley coaches are operated from the Potrero and Presidio Divisions. The 4.4 acre Potrero facility, located at Mariposa and Bryant and built in 1914, has a paint shop and accommodates articulated coaches; the 5.4 acre Presidio facility, located at Presidio Avenue and Geary Boulevard, was built in 1912. Both handle maintenance and heavy repair.

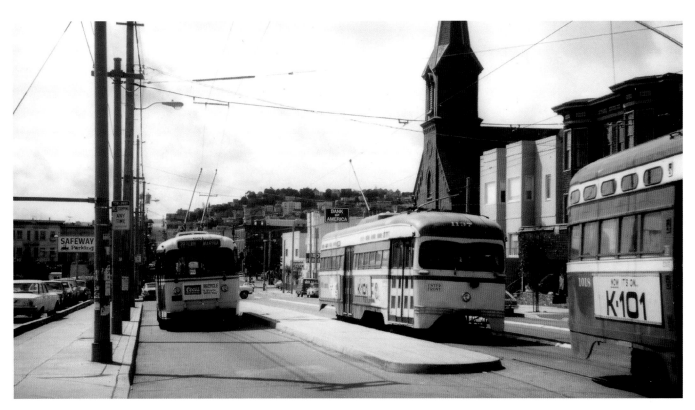

Route 22 trolley coach No. 691, a model TC44 built by Marmon-Herrington, is parallel to route J PCC car Nos 1018 (built by the St. Louis Car Company in 1951) and 1137 (built in 1946 by the St. Louis Car Company as No. 1747 for the St. Louis Public Service Company) on Church Street at Duboce Avenue, on April 3, 1975. Marmon-Herrington had one basic trolley coach design and lengthened it to meet customer requirements. San Francisco had three versions: model TC40 seating 40; model TC44 seating 44; and model TC48 seating 48.

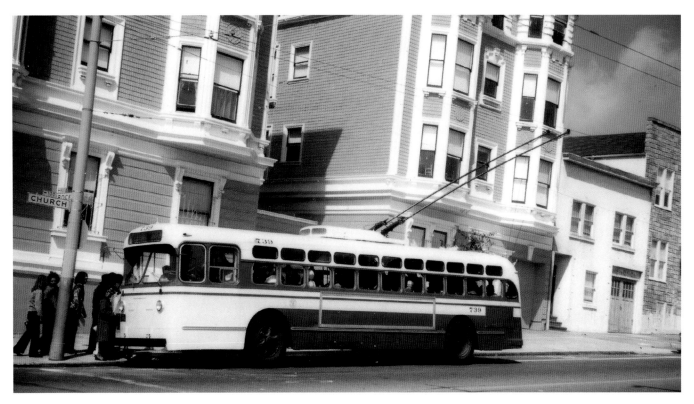

On April 3, 1975, route 22 model TC44 trolley coach No. 739 is on Church Street at Duboce Avenue. This trolley coach was sold to Mexico City in 1977. Route 22 began streetcar operation in 1895 and operated for much of its existence from Bay and Fillmore to 16th and Bryant. Its last day of streetcar operation was July 31, 1948.

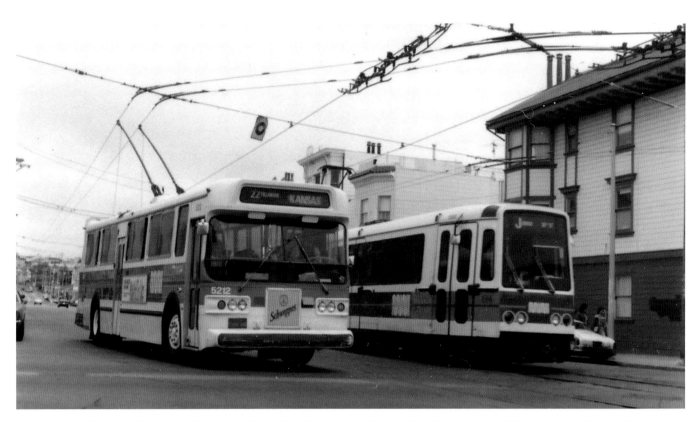

Route 22 model E800 trolley coach No. 5212, built by Flyer Industries, will turn from Church onto 16th as noted by the double overhead trolley coach wire, while the route J articulated light rail vehicle, built by Boeing Vertol, will continue south on Church Street on July 22, 1983.

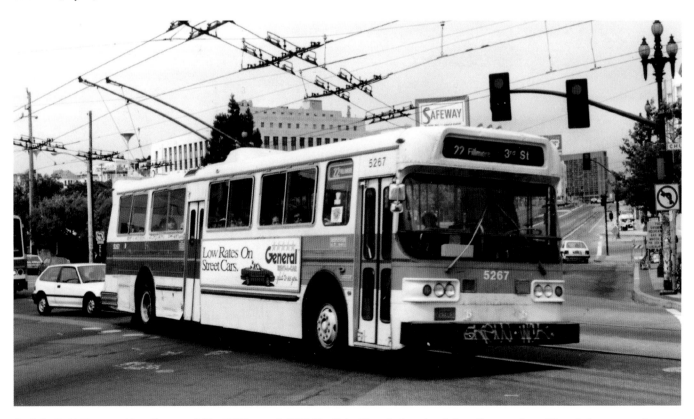

On July 27, 1991, route 22 trolley coach No. 5267, a model E800 built by Flyer Industries, is heading south on Church Street crossing Market Street.

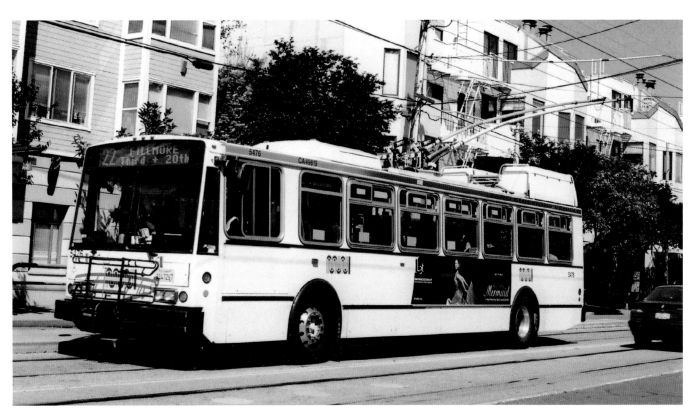

Model 14TrSF trolley coach No. 5476, built by Electric Transit, is on route 22 at Church and 16th Streets on April 6, 2011.

On the side of a Marmon-Herrington trolley coach parked at the Presidio trolley coach yard on April 3, 1975 is a descriptive advertisement depicting the arrival of the new Boeing Vertol light rail vehicle. The San Francisco Municipal Railway had a planned phase-in of the new cars and the Market Street subway.

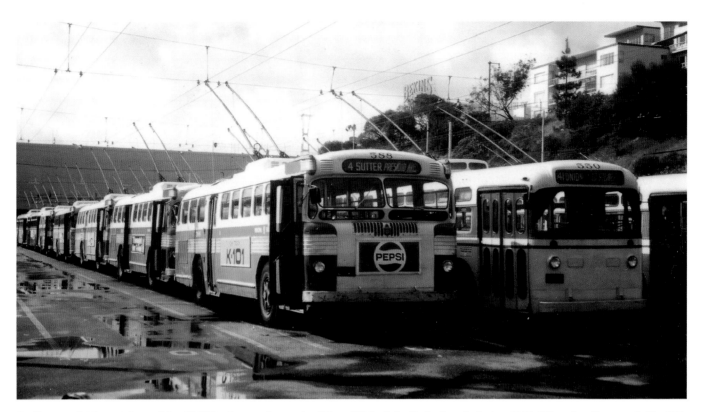

Trolley coach No. 588 (a model 44TTW in the number series 570 to 659 built by Twin Coach during 1949-50) and trolley coach No. 550 (a model TC44 in the number series 550 to 569 built by Marmon-Herrington in 1948) are heading the lineup of vehicles at the Presidio trolley coach yard on April 3, 1975.

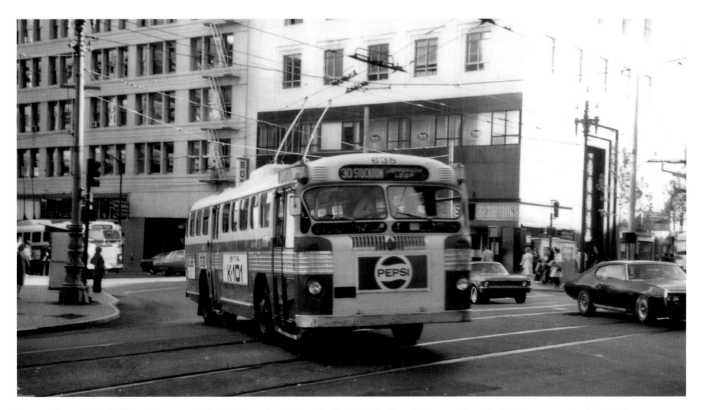

Route 30 model 44TTW trolley coach No. 638, seating 44 and built by Twin Coach, is crossing Market Street on April 2, 1975. There were 90 of these trolley coaches, numbered 570 to 659, built for the San Francisco Municipal Railway during 1949. These Westinghouse powered vehicles remained in service until the late 1970s.

On July 27, 1991, route 30 model E800 trolley coach No. 5129, built by Flyer Industries, is at 4th Street near Townsend Street. This line began as the route F streetcar on December 29, 1914. For much of its existence, the line operated from Stockton and Market to Scott and Chestnut. The last day of streetcar operation was January 19, 1951. It became the route 30 Stockton trolley coach line. Today, route F is the designation of the Market & Wharves historic streetcar route.

With the Powell-Mason cable car line tracks in view, route 30 model 14TrSF trolley coach No. 5467, built by Electric Transit, is on Columbus Avenue crossing Mason Street on April 4, 2011.

At Market Street near Powell Street on June 29, 2001, westbound route 31 articulated trolley coach No. 7031, a model E60 built by Flyer Industries, passes eastbound trolley coach No. 5014, a model E800 built by Flyer Industries. This line began as the route 31 streetcar on May 15, 1932, and for most of its existence operated from the Ferry Loop to Balboa and 30th. The last day of streetcar operation was July 2, 1949.

On June 29, 2001, model E60 trolley coach No. 7031 on route 31 is turning from Mason Street (having passed Turk Street) onto Market Street for an eastbound trip to the Ferry Plaza at Steuart and Market Streets.

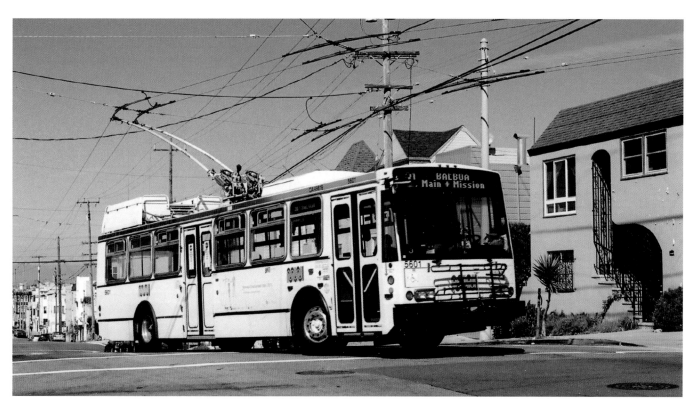

Electric Transit model 14TrSF trolley coach No. 5601 is on route 31, turning from Cabrillo Street onto 45th Avenue, on April 5, 2011.

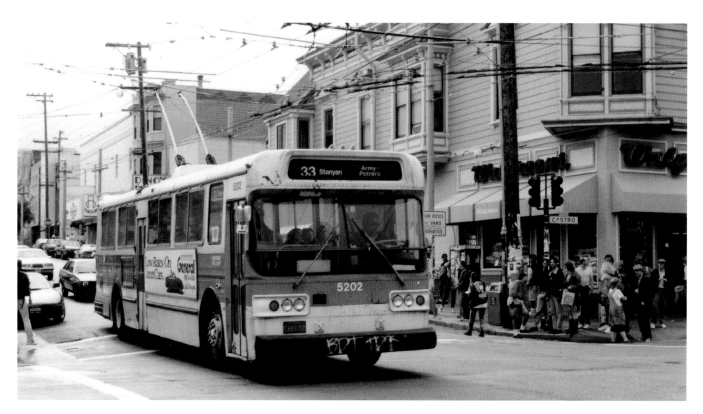

On July 27, 1991, route 33 trolley coach No. 5202, a model E800 built by Flyer Industries, is on 18th Street crossing Castro Street. This is in the Castro neighborhood of San Francisco which extends along the business district on Market Street from Castro Street to Church Street, and on Castro Street from Market Street to 19th Street. Route 33 began as a streetcar line in 1892 from 3rd and Harrison to Stanyan and Waller. Its last day of streetcar operation was October 5, 1935.

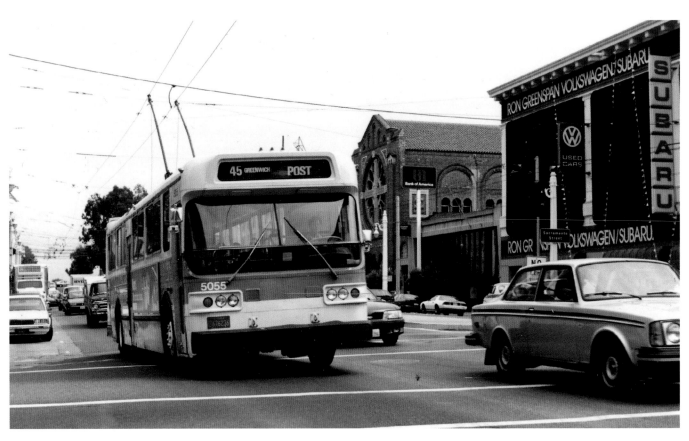

Route 4 Flyer Industries model E800 trolley coach No. 5055 is on Van Ness Avenue on July 20, 1988.

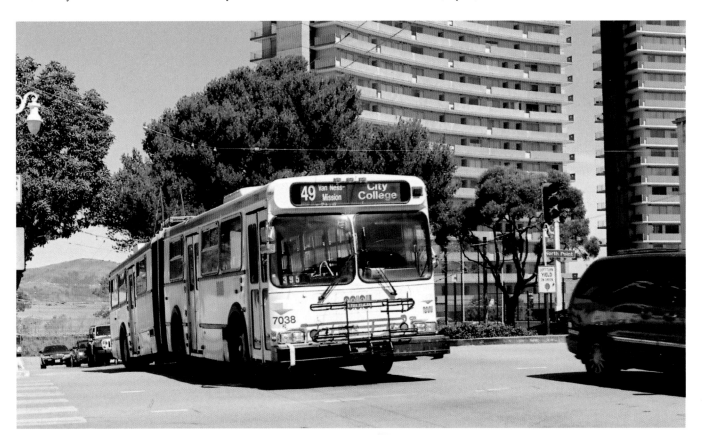

Southbound route 49 model E60 articulated trolley coach No. 7038, built by Flyer Industries, is on Van Ness Avenue at North Point Street on April 4, 2011.